ALAN RACH is a poet and the Professor of Scottis
Glasgow. He was born in Airdrie in 1957 and stu
versity 1976–79. He completed his PhD in the D
at Glasgow University in 1986. His academic ca
post-doctoral research fellow, senior lecturer an
versity of Waikato, New Zealand 1986–2000 ar
or keynote speaker at universities around the world. His most recent books of
poems are *The Winter Book* (2017) and *Homecoming* (2009).

ALEXANDER (SANDY) MOFFAT RSA is an artist and teacher. Many of his paintings
grace the walls of Scotland's National Portrait Gallery, including the wellknown
Poet's Pub and other portraits of significant Scottish writers. Born in Dunfer-
mline in 1943, he studied painting at Edinburgh College of Art. He was the
Director of New 57 Gallery of Edinburgh 1968–78, later joining the staff of
Glasgow School of Art, where he became Head of Painting 1992–2005.

JOHN PURSER is one of Scotland's most important cultural ambassadors. His
award-winning radio series and book, *Scotland's Music*, is widely regarded as
the essential authority on the subject. He is an award-winning composer, play-
wright and author, as well a champion of Scottish Gaelic, and continues to
bring new passion to the Scottish cultural landscape.

Arts and the Nation

A critical re-examination of Scottish Literature,
Painting, Music and Culture

ALAN RIACH

with ALEXANDER MOFFAT and JOHN PURSER

and a rediscovered essay on Scottish education by

HUGH MacDIARMID

Best wishes,

Alan Riach

Luath Press Limited
EDINBURGH
www.luath.co.uk

First published 2017

ISBN: 978-1-912147-10-6

The authors' right to be identified as author of this book under the Copyright, Designs and Patents Act 1988 has been asserted.

The paper used in this book is recyclable. It is made from low chlorine pulps produced in a low energy, low emission manner from renewable forests.

Printed and bound by Bell & Bain Ltd., Glasgow

Typeset in 11 point Sabon by Lapiz

For Callum Baird, and Richard Walker and Roxanne Sorooshian, and all the editorial team at *The National*.

The National is 'the worst newspaper in the world.' – Michael Gove

Contents

Preface: *The National* and the Arts of Scotland

When a new daily newspaper was launched in the wake of the Scottish independence referendum in 2014, it might have seemed doomed to failure: sales of hard-copy papers were sharply declining throughout Britain. Also, the distinction of *The National*, displayed on its front cover, 'The newspaper that supports an independent Scotland' branded it, for some, as a political cyclops. Both presumptions were proved wrong.

The National picked up a respectable readership and published articles and letters both approving and criticising Scotland's potential as a resumed nation-state. First under the editorship of Richard Walker, then of Callum Baird, *The National* showed no allegiance to any political party but addressed a major democratic deficit in the press. In the referendum, 45% of the electorate voted for independence but almost every mass media news outlet, all the daily papers and television news programmes explicitly or implicitly favoured the union.

In January 2016, Alan Riach, professor of Scottish literature at Glasgow University, began writing a weekly essay for the paper which has now appeared every Friday for more than a year, covering different areas of Scottish and international literature and the arts, sometimes in collaboration with the artist and former Head of Painting at Glasgow School of Art Sandy Moffat, sometimes introducing work on Scottish composers of classical music by composer and musicologist John Purser. This book gathers a selection from the first 12 months of them. Each is printed here as they were first published, except for a few minor corrections. The article on Jackie Kay was not a Friday essay but commissioned as a salutation on her appointment to the post of Scots Makar, or poet laureate of Scotland, and because it indicates the complementarity of present and historical cultural practices, it seemed worth including. The Hugh MacDiarmid essay is published by permission of the MacDiarmid Estate.

The first essay is about one of the first Scots Makars, William Dunbar, but then less familiar Scottish poets like Duncan Ban MacIntyre, Alasdair Mac Mhaighstir Alasdair and Elizabeth Melville, are considered alongside modern and contemporary international authors such as Wole Soyinka and Edward Dorn. Scottish artists like J.D. Fergusson, Joan Eardley and John Bellany are introduced along with American Alice Neel and the art of the ancient Celts. Composers like John Blackwood McEwen, Cecil Coles and Helen Hopekirk are there beside discussions of education, political and social priorities, the role of TV and mass media, different genres of writing and a panorama of ideas about nationality and culture.

We'd like to acknowledge the risk taken by *The National* in publishing these essays. No other daily newspaper in Britain has covered arts subjects to such an extent and so regularly.

Let that sink in.

Target audiences are the object of commercial planning today to a degree unthinkable 50 years ago. Financial strategies endorse categories to help sell things: you know what you're getting, with specific papers, magazines, films, TV programmes, box sets, online information quests, so forth. But what about serendipity, going into a library and finding something you weren't looking for that turns out to be far more valuable than whatever you were trying to find? Boxed knowledge is what passes for professionalism these days, and we've always been more interested in opening things out. Unanswered questions, confident uncertainties, the spirit of enquiry, the optimism of curiosity, all seemed worth affirmation and practise. So the arts essays might be, but wouldn't have to be, prompted by an important event, an exhibition, the release of a CD, the publication of a book, a birthday or a death. They might just be something we fancied writing about that week. Who knows what next?

Newspapers don't usually allow this degree of freedom. Maybe it's something we can say about the movement for independence. It was certainly there in the Yes movement running up to the referendum in 2014. Once you are united in a common cause, and the cause is good, and once you're among people with a degree of professionalism and expertise you can trust, you can allow things to happen in concert without micromanaging and controlling everything to such an excessive degree that paranoia rules over energy. The latent liability in energy is anarchy, but when it's working in a direction with a sense of purpose like the independence movement, and according to the priorities of the arts, and not violence, there's a lot you can do. There's a lot of self-respect to be regained. There's a lot of fun to be had. There's a lot to be learned. And that's what we trusted to.

Our argument has always been that news of the arts is vital, the work of understanding what truths the arts can bring to people takes effort and time, is at odds with the instant gratification to which 'rolling news' 24/7 is not just dedicated but enslaved. Newspapers rarely publish material that requires more than one read-through. Even the classy weekend supplements of the self-important London-based broadsheets are usually done with by Monday. The distinction we were proposing, and that *The National* took on, was that all news of the arts, and pre-eminently literature, music and painting, would not only be helpful educationally, because most formal education in Scotland still tells pupils and students next to nothing about the nation's cultural history, but it would also be a crucial complement to 'news of the day'. Or, whatever the 'news of the day'

is, its significance might be measured against what the arts have to tell us about humanity in its historical depth and geographical range.

Writers from Africa or America are sometimes going to be more relevant to immediate, pressing Scottish political questions than contemporary local commentators. And surely, calling on such resources is more useful, literally, than the embarrassment of 'vox pop' soundbites TV and radio so stupidly gives us. When the newsreader says, 'And what do the people in the street think?' and the microphone is thrust into the mouth of someone who knows nothing but has an opinion, the only sane response is to switch off. But the question remains: why do the programme makers do this? And why do they edit these responses to give a micro-climate of opinion not only at odds with informed opinion but incalculably different from anything a majority or even a fair variety of people might say? The obviousness of the manipulation is so blatant it's taken for granted, and as such, becomes even more dangerous.

So we set ourselves to oppose this, in however small a degree. And *The National* took it on. It started with a promise to deliver essays irregularly but it quickly turned into a regular feature.

And the response has been astonishingly positive, from a range of people. The very first essay prompted a letter to the editor: 'How fantastic to see an article about William Dunbar in a mass circulation paper.' One Member of the Scottish Parliament commented: 'To think we have lived to see cultural writing in a Scottish newspaper again – a time of marvels.' Over the year, there were further approvals. A poet and university professor said: 'I'm glad we have a paper capable of running such articles [especially when teaching] bewildered students who sense there is/was a Scottish culture, but know of nothing beyond the last decade.' Another London-based poet and librarian wrote: 'It is incredible that work like yours can actually be published in a national newspaper. I say it with a great sense of the fragility of such discourse, and knowledge of not just the thin-ness but the disgusting assumptions of other kinds of news commentary. A lot of folk say ''twas ever thus' (a phrase I particularly dislike, it seems so historically illiterate), but these times are especially different and frankly vile. Well done for work of this kind.' Another writer emailed: 'We don't get enough well-thought out analyses like [this] of the Scottish cultural and linguistic world and explanation of our myths...' There were many others.

Set against these, the comment by the Edinburgh-born, Aberdeen-educated Westminster Conservative Member of Parliament for Surrey Heath, England, Michael Gove, 'tweeted' to the public at 11.44pm on 6 December 2016 and placed as an epigraph to this book, and our priorities and commitments are firmly and happily reconfirmed.

So for taking the risk, staying with it, and making great use of illustrations and layout in their paper, we'd like to say thanks to the editor and the editorial team, as noted in the dedication.

Each essay in this book is a fresh take on new and old subjects, addressed to as wide a readership as possible. They arise from the conviction that the new Scotland we might imagine and help bring into being can never be really democratic unless it gives the arts the priorities of place and attention they demand.

As Ed Dorn said of his shorter poems, 'Take them in the spirit of the Pony Express: light but essential.'

– A.R.

Introduction: Making Sense of Things

Alan Riach

THE FIVE SENSES are our first modes of perception: hearing, sight, touch, smell, and taste. Together, and in language, intellectual apprehension of the world becomes possible. They connect. They are different things, but not entirely separate from each other, just as the arts are different things, but never entirely cut off from each other. Writing and reading employ and evoke all five senses, literally. Words on the page are visual signs, and read aloud carefully they become structured musical notations. Classical music might evoke scenes, as in Beethoven's Pastoral or McEwen's Solway symphonies, or embody qualities that have no necessary literal visualisation implied, as in Nielsen's fourth symphony, 'The Inextinguishable', Sibelius's string quartet, 'Voces Intimae' or Mackenzie's 'Benedictus'. Paintings and drawings might represent narratives, offer visions that hold forth aspects of nature beyond specific locations, or depict locations in ways that allow us to see them more deeply, or sharply, with greater understanding. All the arts involve writing and reading, in the widest sense: writing as in composition, creation, production, publication, and reading as in attentive analysis, interpretation, conversation, comparisons and contrasts. Specialists abound in each specific area, but we should never overlook the connections between all the specialisms, the fact that they arise from our common human being, our senses and our sense.

So much may be to state the obvious, but the obvious is easily overlooked, and if we want to keep our critical faculties working, we don't want to neglect, or be diverted from, the fact that nowadays the arts are addressed to everyone. In some cultures, in certain historical periods, their primary audience was defined by church or court or class. This is no longer true. Specialist knowledge might have to be acquired to get the full wealth of some works, but none are exclusive. All are open to our best approaches. Some are harder work than others but all are there to yield understanding.

John Berger famously began his seminal work, *Ways of Seeing* (1972) by noting that seeing comes before words. But hearing comes before seeing. If there is a normal natural sequence of biological development in human sensual

sensitivity, it has to be from sound, through visualisation, to verbalisation and the use of language. This is not to suggest hierarchies of authority, but it is to root our intellectual work in the physical and creatural reality of our humanity.

Touch, taste, and smell, are literally immediate, but hearing, seeing and reading meanings – whether in literature, musical compositions or paintings – admits metaphoric understanding, analogy, simile, metaphor: in short, connections between literal things. These connections might emphasise the differences between things, or they might demonstrate the affinities between things, and sometimes they'll do both.

All this is to explain partially why, at the heart of this book, pre-eminence is given to three forms of creative expression: literature, music and painting. Each embodies a vital aspect of human creativity, each arises from common human creatural life, and each connects to the others in ways we often take so much for granted that we forget the complex investment required in experience and education to make good sense of them.

The modern world is dense with signals: constant streams of sounds and images, information false and true: these water-board us all the time. Most of them are decoys. Most distract us from the real. Art commands its own time, our submission to its lasting authority, our healthy appetite to engage with its manifestations directly, to ask questions of it, both irreverently and respectfully, to learn what it has to give. That's the essential difference between art and advertising: the latter is designed to take, the former to give – but you have to learn how to get the most from its gifts.

This book is a collection of essays in appreciation, thankful introductions and interpretations of works and creators of literature, music and art, and further speculations on the roles of education and the state in helping to make these works not only available but appreciated among the people of a country. The country is Scotland, and the particularities of this country's national condition inform all the essays in the book.

That national condition is multiple and slant. Multiple, in that it's multi-linguistic, connected through the English language not only to the southern neighbour but to the western continent of North America and other former colonies of Empire, connected though the Scots language to vernacular idioms internationally, and through Gaelic to different traditions again; slant, in that these traditions and co-ordinates have lasted through history and into the prehistory of the Celts, and this connects us to Europe and all that entails. If Scotland is a deeply European country, whatever the political imperatives of the era, for better or worse it's also been a major component part of the history of the British Empire. Scotland has had a foot in both camps and in 2014 the people of the

country were more cautious than bold. The essays collected here all appeared in the aftermath of the 2014 referendum on Scottish secession from London rule, when 45% of the electorate voted for independence and 55% voted to remain part of the U.K. Nothing ended at that point, of course, and a great deal of rethinking and reconfiguration of priorities and purposes has been taking place since then, and continues to do so. These essays are part of that continuing process.

Our title – *Arts and the Nation* – might suggest a comprehensive overview or a coherent single argument but this is a selection of individual essays, discretely arranged, rather than consecutively ordered. There are major areas of pre-eminent activity in the arts we haven't addressed, including plays and the work of theatres, or traditional music and storytelling, or film and television, practices that might be deemed central in the cultural production of any modern nation, and of key importance in Scotland. Partly, this is because our focal areas, classical music, literature and painting, are at the core of all these activities anyway. Stories and songs, mass media broadcasting, everything produced in theatres, visualisation of any kind are impossible without them and their history. And the oral tradition runs under all these things, the carrying stream.

Moreover, our own areas of expertise are what we rely on, professionally in our various roles in education, personally in our preferences and dispositions. And the book is only a selection, and maybe a different selection made sometime in the future will extend into other areas, or include essays by writers whose greater experience and knowledge lies there. The important point is that while we believe our chosen subjects are at the heart of any sense of what the words of our title mean, that meaning is decidedly not exclusive. In the essay on Modernist Montrose in the 1920s, for example, it's imperative to understand that not only poetry and literature, but music, painting and sculpture (in the still vastly undervalued work of F.G. Scott, Edward Baird and William Lamb), the whole range of creative activity at the highest level is the essential thing. Openness is always necessary, and possible, but sometimes it has to be fought for.

John Berger, in his essay 'Steps Towards a Small Theory of the Visible' (1995), asks, 'Consider any newsreader on any television channel in any country. These speakers are the mechanical epitome of the disembodied. It took the system many years to invent them and to teach them to talk as they do. No bodies and no Necessity – for Necessity is the condition of the existent. It is what makes reality real.' Today, 'Necessity' no longer exists: 'All that is left is the spectacle, the game that nobody plays and everybody can watch. As has never happened before, people have to try to place their own existence and their own pains single-handed in the vast area of time and the universe.'

So what does the 'work' of art (in this case, painting) offer?

Berger answers: 'Painting is, first, an affirmation of the visible which surrounds us and which continually appears and disappears. Without the disappearing, there would be perhaps no impulse to paint, for then the visible itself would possess the surety (the permanence) which painting strives to find. More directly than any other art, painting is an affirmation of the existent, of the physical world into which mankind has been thrown.'

We might describe music from a different corner, paraphrasing Berger: Music is, first, an affirmation of the invisible which surrounds us and which continually appears and disappears. Music never really ends, though, it simply becomes inaudible, then it rises again from the depths like the beginning of Sibelius's Seventh Symphony, or comes to you as if with the dawn, light slowly rising out of darkness, emptiness and space, as in the opening of Wallace's 'Creation' Symphony, or it comes at you suddenly, unpredicted, unexpected, like the opening of Mahler's Third Symphony, with the great god Pan awakening, or of Chisholm's 'Pictures from Dante', taking you through the gates of Hell and down. Without the invisible movements of sound and what we take as silence, there would be perhaps no impulse to compose, for the rhythms, counterpoints and all the complex relations within musical composition could not be structured. More directly than any other art, music is an affirmation of the potential which such movements enact, of the immaterial world we can sense beyond, and crucially through, the material world of performers, conductors, concert halls and audiences, real people in real places with real instruments, working.

Literature, poetry especially, but all stories and songs, partake of both that permanent sense of the visible that painting affirms, and that equally – perhaps even more – permanent sense of the invisible movements we can hear affirmed by music. It is both still structure and always moving, always at play.

In the same essay, Berger goes on to say something crucial that applies to all artists, composers of music, writers of literature, alike: 'The modern illusion concerning painting (which post-modernism has done nothing to correct) is that the artist is a creator. Rather he is a receiver. What seems like creation is the act of giving form to what he has received.'

The great Irish artist Jack Yeats said something similar in more vernacular terms: 'The novelist who respects his workshop more than life, can make breasts heave, and arms wave, and even eyes flash, but he cannot give his people pulses. To me, man is only part of a splendour and a memory of it. And if he wants to express his memories well he must know that he is only a conduit. It is his work to keep that conduit free from old birds' nests and blowflies.'

This book is in the service of that freedom.

Part One: Authors and Literary Contexts

Not Burns – Dunbar! So who was William Dunbar?

Alan Riach (Friday 22 January 2016)

'NOT BURNS – DUNBAR!' was one of two slogans Hugh MacDiarmid came out with in the 1920s, advising all Scots they'd be better off spending time reading the poems of William Dunbar rather than indulging in the annual monster-fest of self-indulgence commonly known as 'Burns Night'.

He was right then and even more so now.

Many Burns suppers have as little to do with poetry as they can get away with, and nothing to do with Scottish poetry at all. If you find yourself at a bad one, the best you're likely to get is a potted biography of the Bard, an exaggerated recitation or two, a plate of offal and a washout of whisky. I speak from experience.

Of course, the best Burns suppers deliver real illumination, songs that take you deep into the words and the meanings of the words, poems that give the Scots language full rein, where you can hear what range Burns has, from the most intense sympathy to devastating satire and from utmost tenderness to bodily humour of the coarsest kind. He is the quickest poet there is, shifting nuance and insight brilliantly or wielding the scalpel of scorn with surgical precision.

But there's more to it than Burns, and more Scottish poets worth your attention, and some just as good – or even better!

William Dunbar is one of them. He is not simply to be read as a poet of the distant past, irrelevant to modern times, but rather as a major figure at the foundations of Modernism. Just as Charles Rennie Mackintosh went back to the architecture of medieval castles to design the Glasgow School of Art, just as the artist J.D. Fergusson in Paris from 1907 to 1914, embracing Cubism, looking at Picasso and Braque, stated boldly that Modernism was simply a matter of getting back to fundamentals, and went looking for copies of Dunbar's poetry to read in this context, just as Stravinsky's quintessential Modernist work, *The Rite of Spring*, is subtitled 'Pictures from Pagan Russia', going back even further than Dunbar, the great artists, writers and composers of the Modern movement regenerated their work through return to their earliest sources.

Dunbar lived from around 1460 till around 1513. He was a churchman, a chaplain at the great Renaissance court of James IV, widely travelled in England, France, Denmark and elsewhere. His poems range just as widely as Burns. Formal poems for state occasions, squibs and satires of daily life at court, playful, topical, colloquial poems, verbally dexterous, 'enamelled' verse or vulgar, downmarket rhymes of more popular purpose. He moves from the flippant comedy of 'How Sir John Sinclair Began to Dance' (one foot always gets it wrong) to the steady, heavily-paced 'Lament for the Makars', a lengthening list of predeceased poets and friends, written in the pressing knowledge of his own mortality. From the most carefully poised love poem: 'Sweet Rose of virtue and of gentleness, / Delightsome lily of every lustiness, / Richest in bounty and in beauty clear / And every virtue that is dear / Except only that you are merciless...' to the Quentin Tarantino hell-dance vision of the Seven Deadly Sins, from the sexually explicit 'Twa Marriet Wemun and the Widow', where three ladies discuss the relative merits of men, to the sheer ferocity of the religious poems in praise of God and condemnation of evil.

Sins are awful realities in Dunbar's poems, and their meanings apply today as much as ever. When temptation rises, prompting greed, lechery, drunkenness, violence, the threats are as much with us now as in the 16th century. Date rape, drunk driving, bullying, gluttony. The sensual apprehension of the attractiveness of self-indulgence is vivid in Dunbar, and countered by the shields of self-knowledge and active defence against its allure. This is central in his poem 'The Golden Targe', where male desire is roused by the approach of a host of beautiful women. The conflict is as intense as any you'll see in *Star Wars*. The force awakens, indeed!

The value he puts upon the ideals of social justice is central to 'The Thrissil and the Rose', the poem he wrote in celebration of the marriage of King James to Margaret Tudor of England in 1503. The union he affirms can only be maintained, he says, if the king himself is virtuous, as the lion, king of beasts, the eagle, king of birds, or the thistle, crowned above all plants. He must 'do law alike to apes and unicorns' and is in Dame Nature's charge, at her ultimate command. With hindsight, of course, we know how that union failed, James leading his army to slaughter at Flodden in 1513. But the ideals remain, brilliantly expressed in Dunbar's poem.

When MacDiarmid recommended Dunbar back in the 1920s, he was saying that not only is there another poet of vision and technical brilliance equal to Burns, but that there is a whole history, a tradition of Scottish poetry that opens its doors to all sorts of human experience. To celebrate only one poet in this tradition is not good enough. It's a big world, pilgrims, so come on, take a big bite!

More than that, he was indicating a rich culture in Scotland that common popular currency neglects or ignores, or even suppresses. When was the last time you heard of Dunbar anywhere in the mass media?

In his 1943 book, *Modern Scottish Painting*, J.D. Fergusson described his attempt to buy a copy of Dunbar's poems: 'I went to every bookshop in Paris, London, Glasgow and Edinburgh, and got the only one existing at a reasonable price in Edinburgh, and of course *not at all complete*. This means that the Calvinists have kept the work of Dunbar from the poor student of Scottish poetry, from the time of the Reformation till the time I asked for it – from say 1565 till 1914.'

It's not only Calvinists who suppress one's knowledge of the arts, though.

In 2014, the politician George Galloway and the former NATO chief George Robertson publicly derided the very idea that there was such a thing as Scottish culture. That position is too easy to assume. As Paul Kavanagh has pointed out to readers of *The National* ('There's nae need tae cringe', 9 January 2016): 'The most common complaint about Scots is that it's not a language at all. People whose knowledge of linguistics fills a dictionary from A to Aa all of a sudden turn into Noam Chomsky when the subject is Scots.'

In MacDiarmid's beautiful poem, 'Homage to Dunbar', he notes that anyone can visit the graves of Burns or Walter Scott, but nobody knows where Dunbar is buried, lost in an older Scotland, abandoned, unexplored. Like Atlantis drowned beneath the ocean, Dunbar and his Scotland remain almost unknown. And yet, as if from the bells of the cathedral under sea, sometimes a strange and haunting sound can indeed be heard across the distance: 'Still, like the bells o' Ys frae unplumbed deeps, / Whiles through Life's drumlie wash your music leaps / To'n antrin ear, as a'e bird's wheep defines / In some lane place the solitude's ootlines.'

There is even more than that. The phrase, 'Not Burns – Dunbar!' suggests a different way of approaching poetry, culture, and all the arts. As a medieval and early Renaissance poet, Dunbar lived in a world where all art was didactic. Paintings, music, architecture, poetry: all art was made to teach, seriously. Serious lessons all folk need to know, about what virtue is, about what hurt and pain will come when certain temptations are surrendered to. The arts, in this understanding, are not merely entertainment. Underestimate their worth at your peril.

This is neither pious nor solemn, neither sentimental nor sanctimonious – as some of the worst Burns suppers can be! Rather, it is an affirmation that poetry and all the arts are there to help people to live, to tell us things we need to know about immaterial life. Economic realities are not the only ones. There are these qualities of what, for want of a better word, we might call the spirit. They can

raise things up, as in 'high spirits' (and Dunbar can be a very funny poet indeed), they can help with formal occasions of great moment, or they can help us deal with grief at times of irreparable loss. And they're not just with us one night every year, they're essential to all of us, every day.

Burns is a great poet and songwriter – praise him, enjoy, and learn from his best work – but don't neglect the whole inherited world that helps make Scotland so rich a nation. Burns didn't. He honoured Robert Fergusson and many more, emphatically. To do Burns justice, we should learn from his example.

William Dunbar's 'To a Ladye' is a different kind of poem from Burns's 'My love is like a red, red rose' but it's every bit as poignant, sharp, yearning, and subtle in its suggestion of material and emotional realities. 'Rew' is a pun on the word 'rue' or sorrow, regret, pity, and the same word meaning the evergreen garden-grown herb, supposed to repel venomous snakes, diminish amorous desire in men, and encourage it in women. The phrase 'that I of mene' signifies, 'of which I speak'.

To a Ladye

Sweit rois of vertew and of gentilnes,
Delytsum lyllie of everie lustynes,
Richest in bontie and in bewtie cleir
And euerie vertew that is deir
Except onlie that ye ar mercyles.

In to your garthe this day I did persew.
Thair saw I flowris that fresche wer of hew,
Baithe quhyte and rid, moist lusty wer to seyne,
And halsum herbis vpone stalkis grene,
Yit leif nor flour fynd could I nane of rew.

I dout that Merche with his caild blastis keyne
Hes slayne this gentill herbe that I of mene,
Quhois petewous deithe dois to my hart sic pane
That I wald mak to plant his rute agane,
So confortand his levis vnto me bene.

From: *The Poems of William Dunbar*, edited by Priscilla Bawcutt, 2 volumes (Glasgow: Association for Scottish Literary Studies, 1998)

Not Burns – Duncan Ban MacIntyre!

Alan Riach (Friday 5 March 2016)

IN THE YEARS after the Jacobite rising of 1745, Culloden in 1746, and the violent reprisals against the Highland clans that followed, two Gaelic poets produced two long poems that should be familiar to anyone who cares about Scotland: 'Praise of Ben Dorain' and 'The Birlinn of Clanranald'. Especially in the light of Trevor Royle's new book, *Culloden*, they should be reappraised. These poems are among the great works of world literature.

I have loved them for many years but I have no Gaelic and no access to them other than through English translations. I read as many English-language versions of both poems as I could find, including that by Hugh MacDiarmid, made with the help of Sorley MacLean. All have fascination. None of them work. Or, they work in part, in different ways. I read essays, historical accounts, critical material relating to both poems and their authors, and went through them both with people who knew Gaelic, and who knew the poems and what they are about.

Their authors were older contemporaries of Burns (1759–96): Donnchadh Bàn Mac an t-Saoir or Duncan Ban MacIntyre (1724–1812) and Alasdair Mac Mhaighstir Alasdair or Alexander MacDonald (c.1693/98–1770) but you couldn't imagine three more different poets.

During the Jacobite rising the two Gaelic poets had been on opposite sides. The older man, Alasdair, fought with the Jacobites. The younger, Duncan Ban, fought on the Hanoverian side but reluctantly: he had to, as he was employed by the Hanoverian Campbells. At the battle of Falkirk, Duncan Ban had had enough, though, and famously discarded his sword, which had been lent to him by his chief. He would fight no more.

Duncan Ban MacIntyre was born and grew up in Glen Orchy, near Ben Dorain. He had no formal education. He could neither read nor write. From 1746 to 1766 he was a gamekeeper for the Earl of Breadalbane and then the Duke of Argyll, working among the hills and woods of the area. By 1768 he and his family had moved to Edinburgh; he joined the City Guard (the police), like many Highlanders. Robert Fergusson (1750–74), who was there at the same

time, called them 'the black banditti'. Here in Edinburgh, his poems were written down, published and sold well. In 1786, as Robert Burns's poems were being published in the Kilmarnock edition, Duncan Ban and his wife were back in the Highlands and islands. As Burns was being lionised in Edinburgh, Duncan Ban was being warmly welcomed in the north-west. He returned to Edinburgh, left the City Guard in 1793, and was a soldier with the Breadalbane Fencibles, though now in his seventies. He retired in 1806, died in 1812, and he and his family are buried in Old Greyfriars churchyard. In 1859, a monument designed by John Thomas Rochead (1814–78), who also designed the Wallace monument at Stirling, was erected in the hills near Dalmally, overlooking Loch Awe.

Duncan Ban was in Edinburgh precisely when James Macpherson, Henry Mackenzie and Adam Smith were flourishing, Enlightenment and proto-Romantic writers. There is almost no recognition of Duncan Ban's work or indeed of contemporary Gaelic literature in their writing. To English-language readers, the Highlands were becoming recognised – or branded – through the work of Macpherson and later, Walter Scott.

This division of perception is one reason, perhaps, why 'Ben Dorain' and 'The Birlinn' have been neglected. Yet there is another division implicit in 'Ben Dorain' itself, between the vision of the mountain and its plenitude of riches and the traditional Gaelic praise-poem for clan and clan chief. As the clans themselves had been violently put down after Culloden, so the ascendancy of English-language writing, and the gulfs between English, Scots and Gaelic worlds were opening up. These gulfs were not unbridgeable – Duncan Ban's contemporary, Alasdair Mac Mhaighstir Alasdair was familiar not only with Burns's work but also that of James Thomson, whose *The Seasons* (1730) was the most famous Scottish poem of its time and effectively triggered the tradition of English-language pastoral poetry. However, 'Praise of Ben Dorain' is very different.

Remember: Duncan Ban was illiterate. The poem was composed as a song in the poet's mind before it was ever written down on a page. The 'original' is not the written or printed version, nor any of the English-language translations, but something Duncan Ban made in his own head, that he would have made into sound through his own voice. There is no way to get back to that, and no way to replicate it. But when I decided to try to make my own English-language version of the poem, that's what I was trying to represent.

I was cautioned severely. If you don't know the language, what impudence, to think you could translate from it!

Well, yes. Sometimes you need impudence, to approach an immortal. It was a risky business, I knew, but the poem itself would not let me go. It had gone into my mind so deep, it seemed that the thing itself demanded expression.

Work like this should not be so hard to imagine. Bagpipe-players learn tunes through 'translating' them from sounds that can be sung by the human voice (canntaireachd) into music played on the pipes. Thus the accuracy of replicating written or printed annotation is of secondary importance to the primacy of conveying meaning through the music, whether in bodily human voice or a fashioned material instrument. This also relates to the teaching or transmission of a tune without written manuscript. So, I argued, the same might apply to the poem.

Its shape is essential to its meaning. It was composed to the musical structure of a pibroch – in Gaelic the spelling is piobaireachd – the classical music of the Highland bagpipe. It is also known as 'ceol mor' or 'big music' or 'great music'. The word for music, ceol, has nothing to do with the muses: it signifies sound made by breath moving through tubes or pipes, imagined or physical, constructed, bodily.

It is in eight parts, a base theme and variations on, or journeys around, it. (1) The opening gives the main theme or 'urlar': the mountain, the deer, and the first-person singular narrator of the poem, a young man who will hunt the deer, not for sport but for the nourishment of himself and his people; (2) then the first journey takes each of the preceding three main component parts and extends, expands, or elaborates some aspects of them; (3) then there is a return to the main theme; (4) then the second journey; (5) then the main theme once again; (6) then the third journey, or variation; (7) and then the main theme is returned to for the last time; and finally (8) there is the culmination of the entire poem, its crowning or bringing together of all the elements in the onslaught of the hunting dogs and the killing of the deer. In the last few lines there is a confirmation that the poem as given is not enough, and never could be, to encompass everything it sets out to describe.

Seen in this way, there is a cyclical, or seasonal, sense of repetition. The main theme is given four times, each time followed by a transitional 'variation' or journey between them, and at last the 'culmination' brings things to a conclusion, but with the promise of further repetition or regeneration – although, obviously enough, not for the particular individual deer killed in the last section. Yet at the same time, this structure, once experienced, may be read or listened to again and again with an increased awareness of tension. Even on a first reading there are clues that the end will be bloody and climactic. This balance or combining of a regenerating, cyclical structure and a linear, increasingly suspenseful, narrative, is stunningly achieved, and appreciated more deeply after several readings.

The question remains, whether 'Praise of Ben Dorain' may be read in the 21st century as a poem not only of praise, but also of sorrow, resistance and anger, a permanent protest against the devastation some folk bring upon others. This is not explicitly depicted in the poem, but its historical context implies it: after Culloden and before the denudation and exploitation of the mountain and the land all around it. In the 21st century, most of the deer and the forests, the natural plenitude of Ben Dorain, has gone. It is a beautiful, but bare mountain. In this, perhaps, it is comparable to that other great poem of sorrow, the persistence of memory and the demand for justice, Sorley MacLean's 'Hallaig'.

And that gets us to the question of land ownership in Scotland, which, as readers of *The National* know only too well, is in urgent need of redress.

So perhaps in the 18th century Gaelic poem there is an implicit political significance here for us now. 'Praise of Ben Dorain' is a register of loss: not a praise poem for a chief, hero, leader or clan, but a praise poem for a non-human source of economic health and human well-being, a politically balanced ecology, a mountain that is not simply the 'earth-mother' myth idealised but a reality, a promise of what health is, what regeneration requires. It is sublime, but it is also utterly realistic.

Let it be a manifesto for land-ownership in Scotland. Let it be read and held in mind and mortal memory. It warrants such, repays as much, every bit as richly as any songs of Burns.

The opening of 'Praise of Ben Dorain' by Duncan Ban MacIntyre, translated by Alan Riach
1. Urlar: The Main Theme

> Praise over all to Ben Dorain –
> She rises beneath the radiant beams of the sun –
> In all the magnificent range of the mountains around,
> So shapely, so sheer are her slopes, there are none
> To compare; she is fair, in the light, like the flight
> Of the deer, in the hunt, across moors, on the run,
> Or under the green leafy branches of trees, in the groves
> Of the woods, where the thick grass grows,
> And the curious deer, watchful and tentative,
> Hesitant, sensitive: I have had all these clear, in my sight.
>
> A herd of the deer: each startles at once,
> And they leap, as if one, and it starts!

The bounding of bodies, the weight in their forms,
In movement away, their white rumps up, bobbing,
Away in a spray, an array:
They are grace, in their movement, yet skittish.
Prompted by fear, carried by muscle, charged by instinctual sense;
Equally so, the shy, sombre stag,
In his warm brown coat,
The russet of fur, his antlers raised high,
Stately and slow, he walks by.

'Praise of Ben Dorain' by Duncan Bàn MacIntyre, the original Gaelic poem and the English translation by Alan Riach, is published by Kettillonia: www.kettillonia.co.uk

Not Burns – Alasdair Mac Mhaighstir Alasdair!

Alan Riach (Friday 12 February 2016)

AT FIRST READING, 'The Birlinn of Clanranald' is very different from 'Praise of Ben Dorain', the poem we looked at in the previous essay in this series. This is a poem which describes a working ship, a birlinn or galley, its component parts, mast, sail, tiller, rudder, oars and the cabes they are nestled in, the ropes that connect sail to cleats or belaying pins, and so on, and the 16 crewmen, each with their appointed role and place, and it describes their mutual working together, rowing, and then sailing out to sea, from the Hebrides in the west of Scotland, from South Uist to the Sound of Islay, then over to Carrickfergus in Ireland. The last third of the poem takes us through a terrible storm, and we make it – only just – to safe harbour. It was written sometime around 1751–55 and first published posthumously in 1776.

Its author, Alasdair Mac Mhaighstir Alasdair, also known as Alexander MacDonald, was a teacher and soldier, a Jacobite officer during the rising of 1745 and Gaelic tutor to Prince Charles Edward Stuart. His father was an Episcopalian Church of Scotland minister, who taught the boy and introduced him to Greek and Roman literature. He knew about sea voyages literally, in the Hebrides, but he also read about them in the poems of Homer and Virgil. In his poem, there is clear evidence that the author had experienced the sea, but there is also a supremely literary sensibility at work, especially when we come to the storm, where a wealth of poetic resources of hyperbole and imagery are drawn upon. The modernity of this passage is startling, and it could almost be described as psychedelic or surrealist.

Alasdair attended the University of Glasgow and grew quickly familiar with contemporary and classical literature and culture, Scots, English and European. In 1729, he became a schoolteacher, an English teacher, working in various parts of Moidart and the west of Scotland. In 1738 he was teaching at Kilchoan, Ardnamurchan. One of his most famous songs of this period was the lyrical, 'Allt an t-Siucar' / 'Sugar Burn'. In 1741, Alasdair's *A Galick and English Vocabulary*, effectively the first Gaelic-English dictionary, was published, commissioned by

the anti-Catholic, anti-Gaelic, Society in Scotland for the Propagation of Christian Knowledge (SSPCK), to help spread the English language and extirpate Gaelic. Alasdair had worked on it in the belief that it would help take Gaelic forward, but he soon came to oppose everything the SSPCK stood for. Making this book, if anything, confirmed his own commitment to his language and culture. His poems took on increasingly sharp edges. Called to account for satiric and inappropriate writing, it is said that he abandoned his teaching to join the Jacobite rising, and that he was among the first at Glenfinnan when the flag was raised on 19 August 1745. Many of his poems and songs openly extol the virtues of the Jacobite cause and satirise the Hanoverians and their Scottish supporters, the Campbells. He was a captain in the Clan Ranald regiment, in charge of 50 recruits, and taught Gaelic to the Prince himself. He converted to Catholicism, perhaps at this time, but perhaps much earlier. After Culloden, he and his family were fugitives. His house was ransacked by Hanoverian troops.

He and his family settled on the island of Canna in 1749 and stayed there till 1751, when he travelled to Edinburgh to publish a book of his poems, *Ais-Eiridh na Sean Chánoin Albannaich / The Reawakening of the Old Scottish Language*, replete with satires on the Hanoverian succession. In the poem, 'An Airce' / 'The Ark', he promises that the Campbells will be plagued and scourged for their treason to Scotland, while he himself will build a ship of refuge for those Campbells true to the Jacobite cause, and all moderates who, after swallowing an effective purgative of salt sea water, would be willing to reject allegiance to the British crown. The authorities were outraged.

Aware of the threat of prosecution, he moved to Glen Uig but then moved again to Knoydart, then to Morar and finally to Sandaig, in Arisaig. He often visited South Uist, where his friend Iain MacFhearchair (John MacCodrum) was bard to Sir James MacDonald of Sleat. The MacDonalds and Clan Ranald were his people, and their family connections extended throughout the west of Scotland and to Ireland, to Carrickfergus.

On his deathbed, his last words were addressed to friends watching over him, who were reciting some poems of their own. Alasdair awoke, corrected their metres and versification, showed them how to do it with some verses of his own, then quietly lay back and drifted away. He is buried in Kilmorie cemetery, Arisaig.

The poem is so visceral and grainy in its depiction of realities, it almost seems hostile to metaphoric interpretation, but, as with 'Praise of Ben Dorain', the historical context in which the poem was written suggests one.

As noted, both poems were composed in the aftermath of the Jacobite rising of 1745 and the massacre at Culloden in 1746. The poems, perhaps, reflect

upon this social and human disaster in ways that go further than their literal meanings.

'Praise of Ben Dorain' gives us a mountain, deer, and the hunt for the deer, in a world in ecological balance and a self-replenishing, self-sustaining economy. 'The Birlinn' presents a clan and a crew of men working in extreme co-ordination, disciplined and intuitive, in conditions of knowledge drawn from experience, but they and their vessel are subjected to a storm of unprecedented violence, a natural imposition that calls up inimical forces from well beyond anything that might have been predicted.

In 'The Birlinn', the courage and skills of the crew and the strength of the ship carry them through, but at a cost, and without any sense of inevitability. The safe harbour they come to connects the Celtic worlds of Scotland and Ireland. In 'Ben Dorain', the skills and stealth of the hunter on the mountain carry him through to the kill, but the beauty and treasure of the deer are valued at their true worth, in a world of natural balance sustained by both self-conscious design and intuitive understanding and sympathy.

The journeys that both poems take us on are, also, signals of an ancient kinship, across differences, of the Celtic peoples, of the human needs of all people, and of the relations between these and sea, earth and nature.

They are both emphatically and intrinsically opposed to the inimical forces in nature and the anti-human forces in the political world that intervene to wreak havoc and destruction on us all. Their triumph is in regeneration.

Their value now, in pre-independence Scotland, was never greater.

So much depends not only on what our education provides, but also what the current attitude to experience is, what we are encouraged to remember, and what our state of culture insists we should forget.

So now that Burns night is well and truly over for another year, let's think of his great Gaelic contemporaries and their poems, and ask why we know so little about them.

The kind of education in Gaelic and Scots languages needed in Scotland has never been more effectively summarised than by Emeritus Professor Ronald Black in his letter to *The National* (26 January 2016). It deserves to be quoted again: 'The Scotland I want to live in is one in which the speaking of languages other than English is not seen as an affliction of the elderly but as a wonderful gift which benefits the individual and society as a whole. Basic Scots and Gaelic should be taught in every primary school. Advanced Scots and Gaelic should be available in at least one secondary school in every local authority area. Ultimately it should be possible for pupils in any part of Scotland to be taught Scots or Gaelic for the entirety of their educational career. The teaching

of English grammar, spelling and literature should also be strengthened. Fluent Gaelic speakers should be tempted into education [...] And generally speaking, this sort of educational background should be sine qua non for applicants to culturally-sensitive posts.'

In a Scotland like this, these poems would be at least as familiar as Burns. So, show me the education minister willing to stand up for that.

From 'The Birlinn of Clanranald' by Alasdair Mac Mhaighstir Alasdair (Alexander MacDonald), translated by Alan Riach

From 'The Blessing'

May the great lord god of movement
 carry us safe,
on all the choral waters of this world,
the seas and oceans, currents and streams, enable us,
take this craft upon them, across them, and cradle us –
 We are launched on Day One
 this craft of my clan
 Each one of the crew
 being tough, strong and true
 Each man hears this call –
 Bless them all.

From 'The Storm'

Hoist sail at dawn on the day of Saint Bride,
bearing out from the mouth of Loch Eynort, South Uist.

 Furnace-gold, hot-yellow, yolk-yellow, brass-brazen sun, burning
 through fish-nets of clouds, trellises meshed, burning them open,
 emerges, and the clouds burn back, close in once again,
 cover all things, changing, sky becomes ash, blackening, and a blue
 splash there, and then thickening, bulging, effulging,
 turning sick, pale, brown, beige, tawny, impending, bellying
 down, and the fretwork rematches itself, closes in, hue
 thick as tartan, dark weaves, anger flashes, and there high in the west,
 a broken shaft, a dog-tooth of rainbow, colour stripes swelling,
 a fang of sharp colour, clouds moving faster to cover it over, and the winds
 pick up speed, toss the clouds as if showers of boulders,
 grey fragments of stone, chips of earth, avalanching in sky.

They lift up the sail, they spring up to stretch
the stiff-solid ropes to their places, secure now,
tough and unbreakable, there from the deck
to the high, hard, tapering, resin-red point of the mast,
secure all the knots, faultless all joints, rope connections between
all bolt-rings and hooks, made impeccable,
run up and tied down, tense and unflexing as iron,
assured, reassured, now firmly, secured.

* * * * *

The sea all lifts up, like a great black coat,
rising to cover the sky, like a shroud, thrown out,
soaring up, like a blanket, coarse stuff,
shaggy its surface, a big horse's pelt in black winter,
a cataract rising, a waterfall soaring, returning itself to its source,
unnatural, screaming and screeching and howling and yowling,
and ocean becomes: mountains and bens and valleys and glens,
all rough with the forest and bushes and grass.
Sea opens its mouth, is all mouth, all agape,
widening, opening, sharpened the teeth, all
crocodile-strong, hippopotamus tusks, and gripping and turning,
as if wrestling was fun, forcing over each one –
Sky shrinks and clenches long ribs on its brow –

It has turned to ferocity now –
The fight to the death has begun.

'The Birlinn of Clanranald' by Alasdair Mac Mhaighstir Alasdair, the original Gaelic poem and the English translation by Alan Riach, is published by Kettillonia: www.kettillonia.co.uk

Not Burns – Elizabeth Melville!

Alan Riach (Friday 19 February 2016)

'THOCHT TIRANNES FREAT, thocht Lyouns rage & roir: Defy them all and feir not to win out.' Or, in English: 'Though tyrants try to intimidate you and lions rage and roar, defy them all and fear not – we will win.'

Fine words from the first woman in Scotland to see her work published in a book of her own: *Ane Godlie Dreame*, printed in Edinburgh by Robert Charteris in 1603. Elizabeth isn't named on the title page. The book is credited to 'M.M. Gentelwoman in Culros, at the requeist of her freindis'. 'M.M.' is Mistress Melville and the epigraph reads: 'Introite per augustam portam, nam lata est via ducit ad interitum', from Matthew 7:13: 'Enter ye in at the strait gate, for wide is the gate and broad is the way, that leadeth to destruction, and many there be which go in thereat'.

The two-line quotation above is engraved in the paving stones in the Makars' Court, just off the Royal Mile in Edinburgh, unveiled with a flourish by Germaine Greer on 21 June 2014. Melville is commemorated alongside Burns, Fergusson, Ramsay, MacDiarmid and many others.

But she stands also in the company of other women, whose poetry too often has been neglected or obscured. No real poet will ever denigrate the value of what might be learnt from other poets – women or men – so the generation of women writing poetry since the 1970s acknowledged the generation of pre-eminent poets, all men, writing immediately after the Second World War. Their names are perhaps familiar: MacCaig, MacLean, Morgan, Garioch, Goodsir Smith, Mackay Brown, Crichton Smith.

Today, the names of those women writing great work in the later 20th, early 21st centuries might be equally – some even more – familiar: Liz Lochhead, Jackie Kay, Kathleen Jamie, Meg Bateman, Carol Ann Duffy, Anne Frater, Gerda Stevenson. But as with the older men, and as with Burns himself, secure critical evaluation of their work is ongoing.

There is one thing they all share, though: none are disciples. None follow blindly the styles or opinions of their fellows and predecessors. Influence is not the word. But there are climates of experience, attitudes and priorities that

change in time like gravitational tides and currents, while certain values stay true. MacDiarmid was an example to all, good, bad, ugly and beautiful, but he was never an idol and deplored the idea of 'followers'. Iain Crichton Smith once remarked that MacDiarmid's one really important example was to show that it was possible to be a great poet in Scotland. It could be done.

So instead of the familiar habits of our day, celebrity culture, the authority of money and media – the broad way through the wide gate – maybe it's worth picking a strait gate and a narrow path to approach some of these less familiar poets. And think of them in their own histories.

In the UK, it was only after the First World War in 1918 that men over the age of 21 and women over 30 were 'given' a vote. Equal franchise at 21 took until 1928. Democracy is a long time coming. In New Zealand it had happened in 1893. In Finland, in 1913. In Saudi Arabia, not until 2015. The political, social and domestic contexts – not to mention sexual, financial and religious assumptions and oppressions – affected the possibility – let alone the encourage-ment – of women writing poems, or painting, or composing, until very recently.

And if that's no more than a thumbnail sketch, it's easily forgotten. These simple facts are a context for the long haul towards acknowledgement that women, as much as men, might make works of art as valid as any by virtue not only of experience but also, and equally, of quality of judgement.

It's evident in Elizabeth Melville's poems. In our secular, materialist era, their pervasive religious context might seem at first glance to make them irrel-evant. This is wrong, for two reasons: first, religious convention is everywhere even now, in its worst aspects of sectarianism and violence. In its assumptions and exclusions it can be as dangerous as patriarchal sexism. In daily practice and social life, religion is always political. It was even more emphatically so in Melville's time. Society is not as secular as it seems.

More important, though, is that in literary terms, any belief system can be read metaphorically. The Welsh poet R.S. Thomas understood this and said so: as a church minister, he got himself into some trouble for saying that he thought God was a poet with a great mathematical mind who dreamed the world into being, and that the Bible was an enormous metaphor. Who can prove he was wrong? Sometimes literalism is the enemy. All literature works by metaphor. That doesn't mean it isn't grounded in reality or doesn't help us with the literal and lasting truths of what life is. Ultimately, that's why we still read Homer or Dunbar.

London will disappear. Troy did. Shakespeare will survive.

So when we read Elizabeth Melville, we have to understand her work entirely in her own history with its specific religious contexts but we can also appreciate its value in the 21st century. It has application.

Melville, or Lady Culross (c.1578–c.1640), was the second daughter of an aristocratic Fife family, in times when the gulf between rich and poor was not as great as it is today. She was an exact contemporary of Shakespeare, and witnessed the departure of King James VI to London to become James I of the abruptly united kingdom.

Her major work is 'Ane Godlie Dreame', a vision-poem taking us on a journey through Hell. She may have been familiar with Robert Henryson's 'Orpheus and Eurydice', in which Orpheus searches for his lost love through Heaven and Hell. She might even have read Dante's 'Inferno'. Her poem explores a similar metaphor and its meaning is familiar to anyone: you have to search high and low, untiringly, even though immense difficulties are set against you, to find the truth you're looking for. It's a cliché of cringing pulchritude in Harry Lauder's song, 'Keep Right On to the End of the Road' and politicians will trot something like it out flippantly whenever a soundbite is wanted. But there is a truth in it, and Melville's expression of it has lastingly serious force. Unlike Henryson or Dante, Melville was a staunch protestant but the imagery and linguistic energy in her poetry are not confined to any single faith.

> Thir ar the dayes that thou sa lang foretold
> Sould cum befoir this wretchit warld sould ende.
> Now vice abounds and charitie growes cald,
> The Devill prevaillis, his forces he dois bend
> Gif it could be, to wraik thy children deir.

It's all too familiar in a 21st century where instead of provision for the worst-off folk the prevailing political practice is to rob the poor and fill up the coffers of the richest.

For Melville, hope comes in the form of a benevolent angel:

> With siches and sobs as I did so lament,
> Into my dreame I thocht their did appear
> Ane sicht maist sweit, quhilk maid me well content:
> Ane Angell bricht with visage schyning cleir

who asks her, why all this grief, and advises, 'Lift up thy heart, declair thy greif to mee, / Perchance thy paine brings pleasure in the end.'

So the journey begins, through an infernal terrain so visually vivid the impression of filmic potential is emphatic.

> Fordwart wee past on narrow brigs of trie
> Over waters greit that hiddeouslie did roir:
> Their lay belaw, that fearful was to sie,
> Maist uglie beists that gaipit to devour.

And when she almost falls in weariness to rest, the Angel pulls her up: 'thou may not sit nor stand, / Hald on thy course and thou sall find it best, / Gif thou desyris to sie that pleasant Land.'

It gets worse:

> I luikit down and saw ane pit most black,
> Most full of smuke and flaming fyre most fell:
> That uglie sicht maid mee to flie aback,
> I feirit to heir so manie shout and yell.

The Angel confirms her fear: 'This pit is Hell, quhairthrow thou now mon go, / There is thy way, that leids the to the land'. The essential metaphor of the poem is clear enough: 'The way to Heaven mon be throw Death and Hell'.

Along with the 'Dreame' a selection of Melville's poems recovered from manuscripts by one of the finest scholars of early and Renaissance Scottish music and poetry, Dr Jamie Reid Baxter, was published in 2010 by Solsequium. This little book, carefully annotated with a glossary for the unfamiliar Scots words, is a treasure of Scottish poetry and a significant work in the history of Scottish women's literature.

So the story of women writing poetry in Scotland has a long tradition, despite our society's oppressions of it. Many, perhaps most, of the great Scottish ballads may have been composed by women. In the 20th century, Violet Jacob (1863–1946), Marion Angus (1865–1946), Helen Burness Cruickshank (1886–1975) and the novelist and translator Willa Muir (1890–1970), warrant reappraisal, because the conventions of denial and neglect continue to prevail.

As Edward Dorn put it in 1984: 'Poetry is where you find it, not where it says that it's at. Where it says it's at, I don't find a lot of poetry there – very often, mostly none.'

Keep looking. The truth is out there.

Sonnet by Elizabeth Melville, Lady Culross

> I will be as an elme that still doth stand
> and will not bowe for no kinkynd of blaist
> I will have my affectiouns at command
> and cause them yield to reason at the laist

In midst of all my paine I will hold fast
the herb of patience to cure my sore
No kind of greif sall mak my hairt agast
nor earthlie cairs torment my mynd no more
 Sould I lament I can not tell quhairfoir
It will be long or murning may me mend
altho I sould sit siching evermore
no sichs nor sobbs can caus my greif tak end
 Rejoyce in god my saull and be content
 then hes thou more than wealthie Cresis rent.

Modernist Montrose: Scotland's 1920s Capital of Culture!

Alan Riach (Friday 26 February 2016)

AFTER THE EASTER Rising in 1916 in Ireland, after the overthrow of the Tsarist Empire in Russia in 1917, and after the end of the First World War in 1918, poets, writers, artists of all kinds began asking serious questions in Scotland. The core group in the 1920s was in the east coast seaside town of Montrose. It was the original cultural capital of modern Scotland.

Just as the violence of the second decade of last century forced people back to question what were the essential values they lived by, so the artistic priorities of Modernism returned artists and writers to fundamentals.

Violence failed. It always does. The arts give us the lasting answers.

In art, as in politics, it was becoming clear that there is always more than one story to be told. This was not always so. After, let's say, 1920, no single imperial story could ever again be maintained as the 'only' one, the 'superior' one. No matter how prevalent that idea had been through the 'Great Game' of Empire, no matter how urgently people even today insist that the priorities of the Treasury, Westminster, London, the British economy, are finally the only ones that matter, after 1920, the knowledge that there are always other stories to be told, was inescapable.

Some welcomed that knowledge. Others ignored it. Some tried to suppress it.

The knowledge applied in different ways and contexts: gender and sexuality, language and class, social strata and economic exploitation, popular and commercial cultural forms and difficult, financially unremunerative works of art, all addressed this understanding differently. Some exploited its opportunities: film and music hall appealed to a wide audience. Some poets, composers, artists, knew that their work would be read or seen or heard and understood by few. The key element to all artistic production in the 1920s was that things were happening far below the surface of the visible. There were deeper currents than those you could see, working ever more inescapably.

The word 'culture' usually means one of two things: so-called 'high' culture like opera, classical music, difficult poetry, painting, sculpture; more broadly, it also means just everything you do and what brings it about, from what's on TV to how we set cutlery on a table for a meal, the languages we use, the politics we have. It is what defines us. It is what we deal with every day. It is also something we can change. It depends on what we remember, as much as what we do.

Montrose in the 1920s was the cultural capital of Scotland. There were certain women and men there then, producing works of art, generating new ideas, putting into social form political potential in ways that had radical, long-term effects that are still with us now, in the 21st century. The point is that sometimes demanding works of art with apparently minimal appeal draw deeply upon things of long historical tradition, and have lasting future influence.

In 1920s Montrose, this was striking in the work of Violet Jacob, Marion Angus and Willa Muir, and in that of artists and writers of all kinds.

For Jacob and Angus, both born in the 1860s, the essential source was the ballads. All literature arises from two human forms of expression: stories and songs. Ballads combine both. In the north-east of Scotland, the ballad tradition had its own provenance, distinct from, but related to, that of the Borders. Often, ballads tell of the experience of women: false promises, demon lovers, family loyalties betrayed, vengeance insisted upon, guilt, remorse, revenge. From this tradition, Jacob and Angus drew particular strengths and a range of imagery and reference, geographical locations and historical moments. They wrote themselves into the tradition while maintaining a modernist edge. Women made widows by war, lost love, casualties of the fishing industry, returning ghostly revenants, are recurring figures in their work.

They are often grouped together but were very different characters: Born into the landed family of Kennedy-Erskine, Violet married a soldier, travelling with him to India, South Africa and Egypt, returning in 1904. After their one son was killed in the First World War, she lived on as a lady in the House of Dun, an aristocrat, to that extent, but far closer to less well-off people than most of today's richest. As well as her poems, her novels *Flemington* and *The Interlopers* are well worth reading. Angus, by contrast, unmarried, looked after her mother and lived with her sister, yet the novelist Nan Shepherd wrote of her 'wild Gypsy side' and described her as 'impish as well as elfin...inhabited by the very Mischief'. She travelled at least as far as Geneva and possessed a sharp sense of humour, delighted to puncture dullness or pretentiousness. Both are easily underestimated as conservative, even establishment figures, yet as the edition of their poems edited by Katherine Gordon, *Voices from Their Ain Countrie* (Association for Scottish Literary Studies, 2006) demonstrates, there

is much more to it. Both were writing significant work in the 1920s: Jacob, especially in *The Northern Lights* (1927); Angus, in *The Lilt* (1922) and *The Tinker's Road* (1924).

Earlier, Jacob, in 'Poems of India' (1905), had produced perhaps the first really memorable subcontinental-Scottish verse. In her diaries of 1897, she had written: 'I never can make out what it is. Sacrifice, fate, perhaps death itself; something that is always close, everywhere. I suppose it is death, of which there is so much. But there is an exhilaration in it, I don't know why.'

In the 1890s, this key combination of sensitivity to the international world and profound understanding of distinctive Scots traditions was as much there in Jacob as in Robert Louis Stevenson. This was the central fact the 20th century would carry forward. In the 1920s, in Montrose, it comes through in all major cultural production in poetry, fiction, painting, sculpture and musical composition.

Let me risk a generalisation. The artistic – if not the social – context of 1920s Montrose was as revolutionary as Paris before the First World War.

Willa Muir published her proto-feminist study, *Women: An Enquiry* (1925) and began work on her Montrose-set, European-ranging novel, *Imagined Corners* (1931). Her husband Edwin published his book of Nietzschean essays *We Moderns* (1918), followed by *Transition: Essays on Contemporary Literature* (1926), and his poetry appeared in *First Poems* (1925) and *Chorus of the Newly Dead* (1926). Fionn Mac Colla began work on his novel, *The Albannach* (1932), which complemented the Highland fiction of Neil Gunn, *The Grey Coast* (1926) and *Morning Tide* (1930), while Lewis Grassic Gibbon was already thinking about *Sunset Song* (1932).

Meanwhile, international ideas of surrealism were touching the artist Edward Baird, a native of Montrose, whose *Figure Composition with Montrose Behind* (1926–27), *Birth of Venus* and *Portrait of a Young Scotsman* (Fionn Mac Colla) (both early 1930s), signalled a Modernism in painting that was being matched in different ways by J.D. Fergusson, William Johnstone, William McCance and William Crozier.

Not all these artists and writers were based in Montrose, but they were all connected, distantly or closely, with the one person who lived there and galvanised everything: Hugh MacDiarmid.

The sculptor William Lamb met Violet Jacob in 1924, sculpted a bust of her and both giggled over another bust he was making of MacDiarmid: 'When I do that portrait of him I shall revenge myself by making it look like him. He in many ways looks quite fearsome – indeed diabolical... His face contains a great amount of character – mostly bad.'

MacDiarmid was C.M. Grieve, a local reporter on the *Montrose Review*, who stayed in the town from 1920 till 1929 and, for better or worse, made modern Scotland possible.

He changed the whole scene. First, he published his poems: *Sangschaw* (1925), *Penny Wheep* and *A Drunk Man Looks at the Thistle* (both 1926). He was drawing on similar sources as Jacob and Angus and others, but his distinction was to take into full account all that the 19th century's most shattering thinkers and social analysts had delivered: Darwin for the priorities of biology, Marx for the pre-eminence of economics and society, Freud for individual and sexual psychology, Nietzsche for ideas about power, slave-mentality and self-determination. Once he'd swallowed the ideas that came from these boys, and grasped the literary value of the era's key-texts, Joyce's *Ulysses* and Eliot's *The Waste Land*, and made the long traverse through Jamieson's *Dictionary of the Older Scottish Tongue*, he produced the poems. Light and quick, dense and tortured, crazily funny and deadly serious, short lyrics or book-length philosophical excursions, they are hard work but, like all great art, the more you read them, the better they get.

MacDiarmid did a few other things in the 1920s, from his Montrose headquarters: he wrote an astonishing quantity of prose journalism, reportage for the *Review* but also essays on every possible topic in the world of Scottish cultural production. Many articles were for the *Scottish Educational Journal*, addressed specifically to teachers, collected as *Contemporary Scottish Studies* (1926). Issues would sell out regularly because people were so eager to see what establishment figures he was turning his metaphorical guns on next. But he was firm in his support of younger writers, as editor of the three anthologies *Northern Numbers* (in 1920, 1921 and 1922), and numerous short-lived periodicals. He also made time to found the Scottish branch of the international writers' organisation PEN (1927), and to be a founding member of the National Party of Scotland in 1928, which emerged as the SNP in 1934, and, as Hamish MacPherson reminded readers of *The National* on February 23, is not unfamiliar to us today.

MacDiarmid wasn't idle. And he wasn't alone. What happened in Montrose in the 1920s started the hunt that tracks us even now. Political reality needs poetry and the arts far more than some would have us believe. Because, in the arts, political honesty is defined by how clear meaning is made and given, even when it's hard work and difficult. Politics on its own, though, is usually no more than subterfuge and obfuscation. As Edward Dorn puts it: 'Either we define our allegiances to certain honorific aspects of human nature or we don't.'

That's the only revolution that matters. And the only one that really delivers the goods.

'Evening in the Opium Fields' from *Poems of India* (1905)
Violet Jacob

> As pageants, marshalled by a masterhand,
> So are the poppy-fields; in rose and red
> And foam of white and livid purple spread,
> Mile upon mile, they stretch on either hand;
> Dark by the well the heavy mangoes stand,
> Where labouring oxen pace with dusty tread
> And dripping water-skins climb up to shed
> Their gush upon the irrigated land.
>
> So cool the labyrinthine channels run,
> Flooding the grey stems with a maze of gold;
> For, as he nears his end, the dying sun
> Does all the plain within his arms enfold;
> Beneath the mango-trees long shadows creep,
> Like sleep's tread falling through the flowers of sleep.

Ideas o' Their Ain: Montrose and the Scottish Renaissance was an exhibition hosted by Montrose Museum & Art Gallery from 2014 to 2015. Copies of the catalogue of the exhibition are still available from the Museum.

BBC Scotland's 3–part television series, *Scotland: The Promised Land* was broadcast from mid-March 2016. It addresses post-First World War politics, international emigration and the cultural Renaissance of the 1920s. Find it online!

Modernist St Andrews: What Really Happened in the 1930s?

Alan Riach (Friday 4 March 2016)

'IN OR ABOUT December 1910, human character changed.' So wrote Virginia Woolf in 1924. Well, not everything changed in a single month, but you know what she means. Something very broad and deep had begun to shift forever. We looked last week at what was going on after the First World War in Montrose, the cultural capital of Scotland in the 1920s. By the 1930s, people had moved. A handful of dates and events give signs and indications of the currents of the decade.

In 1930, Freud published *Civilization and Its Discontents* and Gandhi began his civil disobedience campaign in India. In 1932, there were hunger marches in Britain and in 1933, Hitler was coming into power in Germany. In 1936, the Spanish Civil War began and the long fight against fascism started in earnest. In 1937, Picasso painted *Guernica*, Shostakovich completed his fifth symphony and in 1939, James Joyce published *Finnegans Wake* and the Second World War began.

If we want a historical period for the modern movement, it might as well be 1910–1939, though anti-fascism remained a necessity long after the Second World War became the Cold War, and has never really gone away.

In Scotland, in the 1930s, the cultural centre split and shifted, relocating from Montrose and fixing itself in two vastly different places: Shetland and St Andrews. Save Shetland for next week and let's look at St Andrews.

In 1930, a wealthy American, James Huntington Whyte, New York-born, Scots by adoption, opened a new art gallery in North Street and the Abbey Book Shop in South Street, specialising in contemporary European novels and magazines. He started publishing a new periodical, *The Modern Scot*, making a determined effort to encourage Scottish writers, artists and intellectuals to take up residence in the town and take forward the ideas of the cultural Renaissance MacDiarmid had started in Montrose in the 1920s. He invited the artists William McCance and Agnes Miller Parker. Edwin and Willa Muir arrived in 1935.

The composer F.G. Scott had taken annual summer holidays with his family in St Andrews since 1931. The art critic and journalist John Tonge, author of *The Arts of Scotland* (1938) also lived in North Street.

The Modern Scot was produced over six years, publishing poems and fiction, drama and essays on art and culture, economics and political commentary, history and music, as well as book and film reviews. Pro-independence political commentary aligned with new creative work of all kinds and essays on European literature and culture along with new translations of Franz Kafka, Herman Hesse and Paul Eluard. As Tom Normand notes in his study *The Modern Scot: Modernism and Nationalism in Scottish Art 1928–1955* (2000), Whyte wrote a number of editorials for the magazine which urged its readers to think 'fundamentally' about the principles of nationalism, and to consider how in Scotland it might be different from darker forms emerging in continental Europe. What distinguished Scotland, he argued, was and should be a refusal of racialist or supremacist overtones. Unity in diversity was the key to this ideal, and since some accounts have noted that Whyte himself was of Polish-Jewish descent, his opposition to the rhetoric of blood and soil and his commitment to contextualising art in a democratic political movement may well have had personal resonance.

Parts of Willa Muir's study of sexual, religious and class repression, *Mrs Grundy in Scotland* (1936) appeared in the magazine, and then in full as one of a series of books (with the generic title 'The Voice of Scotland') initiated by Lewis Grassic Gibbon and Hugh MacDiarmid. Their intention was to invite a range of contemporary authors to write book-length essays on contentious themes and questions of the day. Thus Compton Mackenzie wrote *Catholicism and Scotland*, reminding predominantly Protestant readers that their greatest Scottish heroes, Wallace and Bruce, were pre-Reformation Catholics. Neil Gunn wrote *Whisky and Scotland* rehearsing all the ceremonies, rituals and traditions whisky-drinking once entailed, intrinsically celebrating sensitivity and care alongside carefully applied intoxication and language at play. Victor McClure wrote *Scotland's Inner Man* about what good food and a healthy diet actually was and might again be in Scotland. Eric Linklater wrote *The Lion and the Unicorn: what England has meant to Scotland* and William Power wrote *Literature and Oatmeal*.

These book-length essays are still pertinent and worth searching for. It was the last in the series, Edwin Muir's *Scott and Scotland: The Predicament of the Scottish Writer* that triggered the rage. Muir concluded that the only way to take Scottish literature forward was to write exclusively in English. Gaelic would not serve, Scots was inadequate: only English could address an international

readership, as was evident in the literary triumphs of W.B. Yeats and James Joyce. Not only MacDiarmid, whose Scots-language poetry had been so revolutionary in the 1920s, but also the composer F.G. Scott, were furious. Scott's brilliant settings of MacDiarmid, Burns, William Soutar, George Campbell Hay and others, encapsulated a Scots musical idiom in compositions self-consciously drawing on modernist innovations from Schoenberg, Satie and Stravinsky, while keeping the traditional sense of Scots song in play: check out the 2007 recording *Moonstruck* on Signum Classics CD096. Scott saw both Edwin and Willa after the publication of Edwin's book, and wrote of their meeting: 'I had a long and very exciting talk with the pair of them, told them that I disagreed with everything in the book' and argued definitively that there were poems in Scots, not least those of Burns, that were by any standards 'major'. Edwin, Scott reported, could not contradict him. Willa 'turned extremely grave and silent'.

In the long run, Muir had a point: Yeats and Joyce have an international cachet still not fully extended to MacDiarmid, Soutar or Grassic Gibbon, and the letters pages of *The National* over the last month or so revealed that there are still many folk unwilling to recognise Scots as a language no less valid than English.

Yet MacDiarmid and F.G. Scott won the argument. Gaelic, Scots and English are undeniably the three languages most of our literature has been composed in for centuries. There is a significant Latin tradition, important poetry in French (by Mary Queen of Scots, for example) and the first poem we might identify as Scottish, *The Gododdin*, was written in what we call Old Welsh or Cymric. The understanding that multilingualism, a plurality of languages, is characteristic of Scottish literature in a way that distinguishes it from the more familiar 'one nation, one language' imperial ideal, is generally acknowledged, and open. The linguistic diversity of contemporary Scottish writing is proof. Such understanding and evidence would welcome the idea that new writing informed by Polish might become a vital part of the Scottish literary scene. Who can prove it won't?

Muir's argument was answered by MacDiarmid in his own writing, as we'll see next week. But it would be wrong to dismiss the work of the Muirs because of this incident.

Willa's two novels, speculative essays, a study of the Ballads and a memoir, *Belonging* (1968), secure her an important place in the story of modernist Scotland. They are fully discussed in Aileen Christianson's thoroughly-researched study, *Moving in Circles: Willa Muir's Writings* (2007). The novels *Imagined Corners* (1931) and *Mrs Ritchie* (1933) were both set in Montrose and published before she and Edwin arrived in St Andrews, but they inaugurate the decade memorably.

Imagined Corners takes place before the First World War, describing the marriage and constraints set upon Elizabeth Shand, who, when she meets Elise Mutze, begins to sense her own consciousness opening to all that Europe might mean, and sets off to the continent with her new friend at the novel's conclusion. Oppressions abandoned, they embark optimistically for new possibilities, but the date of the novel and the date of its publication insist that we must understand the devastation that will come on this world, and exactly what their hope will have to endure to survive.

Mrs Ritchie takes us through the war, centred on a character of increasingly monstrous presence, an inhabitant, both victim and perpetrator of the repressions Elizabeth and Elise fled from. Her husband, son and daughter, wreak tragedy upon her as she does upon them. The bleak, terrible strength of the novel hinges on the confrontation of the conservative Victorian world Annie Ritchie comes from and the post-war, shell-shocked, modern world her son returns into. The heroine ends in delusion, both her men dead, her daughter running for her life.

Both novels in different ways confront 19th-century conventions with Modernism. There is nothing easy in their challenges and they are all the stronger for that.

Born in 1890 in Montrose, Willa's parents came from Unst, in Shetland, and while she grew up in Montrose, her sense of displacement was to be a continual fact in her life. She married Edwin in 1919, and from 1921–22 she was with him in Prague, from 1922–23, in Dresden, then Italy; in 1924, Austria, and from 1924–26 back in Montrose. Here she produced *Women: An Enquiry* (1925), the first of the feminist essays. Muir identifies 'detachment' as one of the great liabilities of the modern world: people become 'detached' and what follows? 'Religion becomes a creed, morality a code of law, government a party machine'. Art loses the capacity to be art and is crippled by 'theories of aesthetics'.

Her feminism has been criticised because she identifies certain innate qualities as belonging intrinsically to men (self-conscious detachment) and women (unconscious sympathy). Yet the complementarity she proposes, of structured organisation and intuitive understanding, is real enough in broad terms and the power of her judgement still comes through: 'The financial machine in our own day is an excellent example of the masculine activity pushed to extremes: it has been successfully detached from human values so that it exists for the production of money and not for the production of goods and services to humanity. The mere individual has ceased to be of any importance, and even the inventions and discoveries of his intelligence are valued only in terms of money.'

We might argue that such 'detachment' is not only the provenance of men (any more than 'uncommon sympathy' is the sole provenance of women), but the effect Muir describes is nonetheless horribly familiar. The terrible thing is, of course, that we're now almost a hundred years further down the line: if anything, the situation is worse, and even more urgently needing redress.

From the opening of Willa Muir, *Imagined Corners* (1931)

That obliquity of the earth with reference to the sun which makes the twilight linger both at dawn and dusk in northern latitudes prolongs summer and winter with the same uncertainty in a dawdling autumn and a tardy spring. Indeed, the arguable uncertainty of the sun's gradual approach and withdrawal in these regions may have first sharpened the discrimination of the natives to that acuteness for which they are renowned, so that it would be a keen-minded Scot who could, without fear of contradiction, say to his fellows: 'the day has now fully dawned,' or 'the summer has now definitely departed.'...

The season for summer visitors was over, although summer still lingered, and the burgh of Calderwick was busy about its jute mills, its grain mills, its shipping, schools, shops, offices and dwelling-houses. The larks, the crows and the gulls, after all, were not ratepayers. It is doubtful whether they even knew that they were domiciled in Scotland...

On this clear, sunny day in early September – a good day on which to become acquainted with Calderwick – a bride and a bridegroom were due to arrive in the town, the bridegroom a native, born and brought up in Calderwick, the bride a stranger. Human life is so intricate in its relationships that newcomers, whether native or not, cannot be dropped into a town like glass balls into plain water; there are too many elements already suspended in the liquid, and newcomers are at least partly soluble. What they may precipitate remains to be seen.

Modernist Shetland: The Measures Taken in the 1930s

Alan Riach (Friday 11 March 2016)

OUR PREVIOUS ESSAYS in this series looked at Montrose in the 1920s and St Andrews in the 1930s, cultural capitals of Scotland. In the 1930s, the cultural scene was not only centred in St Andrews, though. Something new and essential was also happening in the Shetland archipelago.

Shetland, the island of Whalsay: five miles long, two miles wide, gentle to look at, bare of trees but benign and shapely, covered in summer in pink flowers, thrift and campion, the blue spring squill, the rare sea aster. Other islands are threaded and studded in the waters around it, and inlets and voes run in. Streams run over it, a maze of waters and landforms, layered in archaeological depths of human habitation across millennia, active with seabirds, gulls, duck, waders, red-throated divers on the inland lochs, migrating birds from Scandinavia by the high cliffs on the east side. The rocks are schist and the fragments of the original are xenoliths still visible, present in the granitic gneiss, with crystalline limestone on the north-east coast.

In May 1933, when Hugh MacDiarmid stepped off the boat here, the days were long and lengthening, the sunlight opening further horizons and subtleties of terrain and colour on all sides. Everything was new to him. He had gone from Scotland's cultural centre in Montrose to what seemed the furthest peripheral edge, from constant dynamism to utmost isolation. He was 41 years old and everything was left behind – or so it seemed.

How far do you have to go, how much do you have to surmount, to arrive at the perspective that allows you to see the whole world as islands in their archipelagos of connection? MacDiarmid once said that by going to Shetland he was trying to understand if the utmost diversity of Scotland could form a coherence, and that he discovered there that this was true. It delivered the potential of regeneration.

In his first year in Shetland, he explored the archipelago, immersing himself in the working economy of the people around him. He went aboard a haddock boat to the Out Skerries, five miles north east of Whalsay, with Thomas

Robertson, H.M. Survey Geologist, with whom he formed a friendship and learned the words for the stones. He went as an observer on the square-sail drifter herring boat the *Valkyrie* into Yell Sound, sailing into the deep waters north of Shetland with the herring fishers in June 1936, writing on board, lying in his bunk, paper pressed to the planks of the bunk above. He visited the Faroes on the steamer the *Tjaldur*, saw 'the monstrous shapes of Litla Dimun and Stora Dimun...pyramids rising to needle-points, sheer walls of basalt, fantastic ridges with razor edges'. He praised the Faroese, returning to reappraise Shetland as geologically deep, culturally negligible. This won him no friends in Shetland but it prompted his most necessary poem of the 1930s, 'On a Raised Beach'. This is one of the greatest poems in world literature.

The first draft was written in 1933, sent to MacDiarmid's boyhood teacher, the composer F.G. Scott, then revised into a musical structure of immensely challenging, complex coherence. Its premise is Miltonic, but materialist: How can you believe in human value, in the scale of geological time? How can you affirm it? Does it truly exist? In politics and culture, mankind in totality and any single life, what is all the struggle worth? What is ultimately at stake here? What measures must you take to count its cost?

'On a Raised Beach' evokes Eliot's *The Waste Land* only to reject it: this is not a heap of broken images, MacDiarmid tells us, but: 'All human culture is a Goliath to fall / To the least of these pebbles withal.' It is the central poem in the 1935 book *Stony Limits* (the title is from Shakespeare: 'stony limits cannot hold love out'). So what would it take, he asks, 'to rise from the grave – to get a life worth having'?

MacDiarmid wrote his poems, trying to learn and test what human value is, as Fascism and Communism were growing their perversions throughout Europe. From socialist and republican ideals in 1916 Ireland and 1917 Russia, by the 1930s, Spain was already Fascism's target, Stalin had begun his Terror in earnest after Lenin's death in 1924, and what had seemed to some like Mussolini's bright beginning in the early 1920s was caught and turned in Hitler's rising tide. MacDiarmid was aware of most, though not all, of this.

The radio was there, but not in every house. People would gather together to listen to the news reports, as the decade gathered its storms.

Such things as war impinged as they would but it was the life of the islands that mattered in the end. MacDiarmid came to praise Shetland folk as frank and kindly, but, he said, 'They are a secret people, not by active concealment, but because they are so natural and unselfconscious in their unobtrusive but very real differences that these habitually escape the observation of the impatient and uninstructed... This does not mean that the people are unsociable – they are far from that – but simply that they are independent and self-reliant.'

Visitors from the South may think their lives hard, but 'So it is with all the outward appearances in the Shetlands: a very vivid and generous life lies behind them' – 'a different tradition of existence'. This is what he called 'Halophilous living by these cold northen seas' – a halophile being an animal that requires the salt in the air.

> I was better with the sounds of the sea
> Than with the voices of men
> And in desolate and desert places
> I found myself again.
> For the whole of the world came from these
> And he who returns to the source
> May gauge the worth of the outcome
> And approve and perhaps reinforce
> Or disapprove and perhaps change its course

In 1939, MacDiarmid gave practical help to a group of Whalsay cottars, opposing the County Assessor's raising of rates. At their request, MacDiarmid argued forcefully for them, in meetings and in letters, pointing out that they shouldn't be charged any rates at all, as they had no public amenities. When the appeals were dismissed, the Assessor, Thomas Johnston, wrote a letter to the Lerwick paper to justify himself, and MacDiarmid replied, noting of Johnston and the 'reactionary Council' who supported him: 'I repudiate all the "conventional lies" which are used to dignify Mr Johnston's business – and mask his personal responsibility for what he does. I am simply and solely concerned with the ultimate fact that on no matter what specious pretexts in the home country of the wealthiest empire in the world, and at a time when national service is being appealed for on all hands or made compulsory, the administrative system finds it necessary to "put the screw" on the poorest of the poor and wring a few more shillings out of people below the subsistence level. That is what it all boils down to, and I have no hesitation in stigmatizing it as a shameful and intolerable state of affairs and condemning lock, stock and barrel the system under which it takes place and the officials who work that system.'

The same imperative is there in the poetry. In 'The Wreck of the *Swan*', the crew are facing 'the black-squall and the hurricane' while

> Up to their waists in water on the foredeck,
> And sweeping all hands in a heap on the lee-scuppers,
> Their arms and hands clawing up through the boiling surf
> Still grasping wriggling fish and gutting knives [...]
> Time the public knew what these men have to face.

There were then, MacDiarmid tells us, nearly 100,000 of them at sea, and if you consider the fishing industry to include shipbuilders, rope, net and box manufacturers, fish-friers, buyers, retailers, salesmen, railways and road transport, coal, salt and ice industries, you might say that around three million folk depended on the trawlermen for a living.

Again, the specific working economics connect to literary perception and social vision. Making these connections allowed MacDiarmid accommodate all Scotland in his vision. Towards the end of *Stony Limits* is the poem 'Lament for the Great Music', which takes us from Shetland south and west to mainland Scotland, out from the pre-eminently Norse influences and into the Gaelic and Celtic worlds, connecting beyond them with the archipelago of ancient Greece. As Greece once was, so Scotland's archipelagos and Highlands are now, a singular 'fold of value in the world'.

In 1937, MacDiarmid made an extensive tour of the Western Isles. His letters allow us to track his journey through the Hebrides, visiting Skye, Raasay, South Uist, Canna, Eigg, Barra, and Tobermory on Mull, and on. In 1939, he published *The Islands of Scotland*, the first book of its kind to shift the focus decisively away from the Hebrides. Up till then, they were the islands romanticised to the point of cliché and associated most in the popular imagination with the nostalgic and ill-fated destiny of Bonnie Prince Charlie. MacDiarmid devotes 50 pages to Shetland, 20 to Orkney and 25 to all the Hebrides – vastly disproportionate, you might argue, but also, perhaps, a necessary counterbalance, emphasising contemporary living conditions as well as lasting qualities of social life and spiritual identity to be found nowhere else in the world. This is anti-romantic, in one sense, but realism is not its only strength.

MacDiarmid's entire understanding of identity had been fashioned anew from his experience of the archipelagos of Shetland, the Faroes, Orkney and the Western Isles, and then as this applied to Scotland as a whole, and beyond that to all the world, through all time.

The major result of MacDiarmid's multi-faceted understanding of Scotland's plural, multilinguistic identity was his editing *The Golden Treasury of Scottish Poetry*, published in 1940. In this, poems in English and Scots appear alongside translations from Latin and Gaelic. In the same years as he was working on *The Golden Treasury*, he was putting together the pieces and passages that would ultimately form what he hoped would be the biggest poem in history, comprehensive yet open. He sent the typescript of an early version of what was to become *In Memoriam James Joyce* to T.S. Eliot in 1938, from Shetland, when he was 46 years old, though it was not to be published till 1955, when MacDiarmid was 63, and he had been working on it right up to its publication. This

magnum opus, what he called a 'vision of world language' – not a single language for all people but a multiplicity of forms of cultural expression changing through time across all nations and localities – had begun to come together in Shetland, and bridged forward across the Second World War, pointing towards where we are now in the 21st century, with so much information at our fingertips, and so much in the system so badly still in need of redress.

It was regeneration of another kind: archipelagic identity. Unity in diversity, indeed. Rejuvenation, after the Second World War. Another Renaissance.

MacDiarmid's Shetland writing should be balanced by Mark Ryan Smith's *The Literature of Shetland* (published by *The Shetland Times*, Lerwick, 2014), an excellent historical overview and analysis of the archipelago's own writers that also takes into full account famous visitors to the islands, including MacDiarmid and Walter Scott. Among the Shetland writers who repay full attention are J.J. Haldane Burgess, William J. Tait and contemporaries such as Christine de Luca, Robert Alan Jamieson, Jim Mainland, Lollie Graham and Jen Hadfield. This should be complemented by Simon Hall's *The History of Orkney Literature* (John Donald, 2010). See also the online resource: Writing the North: The Literature of Orkney and Shetland: http://www.writingthenorth.com/

One of Shetland's finest native writers was J.J. Haldane Burgess (1862–1927), blind poet, novelist, violinist, historian and linguist, who assisted Jakob Jakobsen's research into the Norn language in Shetland, some of whose findings found their way into MacDiarmid's 'On a Raised Beach'. Thus the indigenous tradition and the work of the 1930s modernist resident intersect.

J.J. Haldane Burgess

Da Blyde-Maet

> Whin Aedie üt da blyde-maet for himsell
> An her, pür lass, 'at dan belanged ta him,
> Whin nicht in Aeden wis a simmer dim
> Afore he wis dreeld oot ta hok an dell,
> Hed he a knolidge o da trüth o things,
> Afore da knolidge koft wi what's caa'd sin?
> Afore da world raised dis deevil's din,
> Heard he da music 'at da starrins sings?
> Some says 'at Time is craalin laek a wirm
> Troo da tik glaar dey caa Eternity,

A treed o woe an pain it aye mann be
'At Fate reels aff frae ever fleein pirm

Bit Joy an Hopp in aa dis life I see,
It's plain anyoch ta see ta him 'at's carin,
T'o Time is spraechin, laeck a fraeksit bairn,
Ipo da bosim o Eternity.
We'se aet da blyde-maet yet, an it sall be
O mony anidder, deeper, graander life,
An Time sall learn troo aa dis weary strife
Ta sook da fu breests o Eternity.

Or in English: The Glad-Food (the meal eaten when a woman first rises from child-bed)

When Adam ate the glad-food for himself / And she, poor lass, who then belonged to him, / When night in Eden was a summer twilight / Before he was evicted, / Had he a knowledge of the truth of things, / Before the knowledge tainted with what's called sin? / Before the world raised this devil's noise, / Did he hear the music that the stars sing? / Some say that Time is crawling like a worm / Through the thick slime they call Eternity, / A thread of woe and pain it always must be / That Fate reels off from the ever turning pirn. // But Joy and Hope in all this life I see, / It's plain enough to see by he who cares, / Though Time is screaming like a fractious child, / Upon the bosom of Eternity. / We shall eat the glad food yet, and it shall be / Of many another, deeper, grander life, / And Time shall learn through all this weary strife / To suck the full breasts of Eternity.

As Others See Us: John Keats, Herman Melville and Arnold Bax

Alan Riach (Friday 22 July 2016)

AN ENGLISH POET in Ayrshire in 1818, an American novelist in Glasgow in 1856, and an English composer, adopted son of Ireland, then adopting Scotland, on the west coast in 1928: three visitors to Scotland seeing the country in different ways, thinking about it with different sets of priorities, bring to our 21st century sensibilities new ways of returning to familiar territory: quickenings, new eyes on old questions, fresh perspectives.

John Keats (1795–1821), writing to his friend J.H. Reynolds from Maybole, 11 July 1818, pulls back from describing what might be predicted of Scotland, 'a dream' that might run: 'mountains, rivers, lakes, dells, glens, rocks, and clouds, with beautiful, enchanting, Gothic, picturesque, fine, delightful, enchanting, grand, sublime – a few blisters, etc. – and now you have our journey thus far'! Now, he says, 'I am approaching Burns's cottage very fast.' It will be a 9-mile walk to Ayr for tea, he comments, but things are not as he expected. Two days later he continues: 'We were talking on different and indifferent things, when on a sudden we turned a corner upon the immediate county of Ayr. The sight was as rich as possible. I had no conception that the place of Burns was so beautiful. The idea I had was more desolate, the rigs of barley seemed always to me but a few strips of green on a cold hill – O prejudice! It was as rich as Devon'. Keats notes: 'the mountains of Arran Isle, black and huge over the sea. We came down upon everything suddenly – there were in our way, the "bonny Doon", with the brig that Tam o' Shanter crossed – Kirk Alloway, Burns's cottage and then the Brigs of Ayr. First we stood upon the bridge across the Doon, surrounded by every phantasy of green in tree, meadow, and hill. The stream of the Doon, as a farmer told us, is covered with trees from head to foot – you know those beautiful heaths so fresh against the weather of a summer's evening – there was one stretching along behind the trees.'

Keats would have come along what is now the B7024 from Maybole, and you can easily imagine his eyes taking in the rural scene in its odd gentle pleasance.

The unpredicted wealth of Ayrshire's rolling landscape, more like Devon or the home counties than the Romantic wilderness, evidently surprised him. If this was delightful, though, his visit to the cottage delivers an unwelcome shock, and he seems to foresee the exploitations to come: 'We went to the cottage and took some whisky. [...] The man at the cottage was a great bore with his anecdotes – I hate the rascal – his life consists in fuzz, fuzzy, fuzziest. He drinks glasses five for the quarter and twelve for the hour, he is a mahogany-faced old jackass who knew Burns. He ought to have been kicked for having spoken to him. He calls himself 'a curious old bitch', but he is a flat old dog. [...] O the flummery of a birthplace! Cant! Cant! Cant! It is enough to give a spirit the guts-ache.'

Keats's notes on his visit to Ayrshire are poignant reminders of the liabilities of public fame, and the weight delivered by crudity, commercialism and exploitation. Such things weigh on all the sensitivities required and cultivated by great art, whether of Keats or Burns. They are a prophetic warning about the 'celebrity culture' we inhabit today, and that we should never take for granted. We might not agree that a birthplace is always 'flummery' but it demands something more nuanced and subtle in its interpretation and appreciation than the leaden words of a mahogany-minded jackass. Equally, if Scotland in Keats's time was becoming internationally familiar in caricatures of wilderness and ideas of the sublime and picturesque, his apprehension of the complexities of reality is salutary. No cliché does justice to reality. Keats's poems of the time, on Burns, Ailsa Craig, Staffa and the Highlands, demonstrate that.

Thirty-eight years later, five years after the publication of *Moby-Dick, or, The Whale*, and 20 years before the publication of *Clarel*, the longest poem in American literature, and possibly the least-read, Herman Melville (1819–1891) made a grand tour of Scotland, England, Europe and the Mediterranean, then east, to Constantinople and Jerusalem. In the seaside town of Southport, north-west England, he met up with his old friend Nathaniel Hawthorne, who wrote in his journal: 'Melville, as he always does, began to reason of Providence and futurity, and of everything that lies beyond human ken, and informed me that he "pretty much made up his mind to be annihilated"; but still he does not seem to rest in that anticipation; and, I think, will never rest until he gets hold of a definite belief. It is strange how he persists — and has persisted ever since I knew him, and probably long before — in wandering to-and-fro over these deserts, as dismal and monotonous as the sand hills amid which we were sitting.'

Melville had just come south from wandering in Scotland, arriving in Glasgow on October 26 1856. His aunt, Mary A.A. Melvill, noted: 'doubtless he will while in Scotland visit the places that have long been the homes of his name & family.' As he travelled up the Clyde, he saw 'places for building

iron steamers' and once in the city, wrote this: 'went to old cathedral, – tombs, defaced inscriptions – others worn in flagging – some letters traced in moss – back of cathedral gorge & stream – Acropolis – John Knox in Geneva cap frowning down on cathedral – dimness of atmosphere in keeping – all looked like the picture of one of the old masters smoked by Time – Old buildings about the hill, stone walls & thatch roof – solid & fragile – miserable poverty – look of the middle ages – west end – fine houses – the moderns – contemporary. The University. The park – the promenade (Sauchiehall street) – at night population in the middle of the street. High Street.' The next day, he took a steamer down the Clyde to Loch Lomond, in a thick mist, which allowed him to see just the outline of Ben Lomond: 'came back & stopped at Dumbarton Castle – isolated rock, like Ailsa – promontory at the juncture of the Clyde & Levern – covered with sod & moss – a cleft between – stone stairs & terraces – W. Wallace's broadsword – great cleaver – soldiers in red coats about the Rock like flamingos among the cliffs – some rams with smoky fleeces – grenediers – smoked by the high chimneys of furnaces in Dumbarton village – ' He travelled on to Edinburgh, noting the 'steep & crooked' streets, and visited Walter Scott's home, Abbotsford, before heading south.

What is so intrinsically curious about Melville's jottings regarding his visit to Scotland, brief as it was?

Perhaps it is that these notes, collected in *The Melville Log: A Documentary Life*, edited by Jay Leda in two volumes (The Gordian Press, 1969), prompt more questions than they answer. His aunt's speculation that he was looking for some traces of his ancestral identity seems fair. His visit to Abbotsford marks his knowledge of Scott's significance. Certainly, Scott's epic novels are in many ways important precedents for the epic imagination, annotation and sense of ultimate dramatic confrontation embodied in Moby-Dick. The white whale is Melville's Culloden for Ahab. What persists, and escapes, alone, to tell the tale, empowers Melville in his urge to find out more and pick up the traces, just as it drove Scott to write so voluminously of his country's history and geography. Melville's later influence on the late-Victorian Scottish poet Robert Buchanan (1841–1901) is quoted by Hugh MacDiarmid in *A Drunk Man Looks at the Thistle* (1926), as if to pick up on that sense of comprehensive scale: "Melville, sea-compelling man, / Before whose wand Leviathan / Rose hoary-white upon the Deep,' / What thou hast sown I fain 'ud reap / O' knowledge 'yont the human mind / In keepin' wi' oor Scottish kind...'

Just as Scott's fiction and MacDiarmid's poetry ranges from the Borders to Shetland, and then across Europe and further afield, so Melville, in *Moby-Dick*, crosses all the oceans of the world to bring us to a kind of final ending on the

rim of the equator, after the ultimate chase. Of course, the whale evades capture, escapes, and in fact may still be out there, a phantom, ungraspable. We'll meet that phantom again.

Seventy-one years after Melville's visit, someone else visited Scotland and perhaps we could say that he found answers to some of the questions he'd been asking about his own quest. Long before the classic film *Local Hero* (1983) made them familiar on screen, the composer Arnold Bax was looking out over the rocky shores, the seascapes, and the white sands of Morar, on the west coast of Scotland.

In his invaluable book, *Dear Sibelius: Letter from a Junky* (Kennedy & Boyd, 2008), Marshall Walker gives an account of all the major works of the great Finnish composer not in academic terms but in a quest to answer the question, How does the life's work of a great artist help people to live? He takes us through his own experiences and those of others, encountering Sibelius's music for the first time, finding it sustaining in different ways, what it means in itself and in its many interpretations. Other composers, poets, artists, natural phenomena in particular places, political imperatives, come into the story: Scotland, America's deep south, apartheid South Africa, and New Zealand are all in the narrative. Chapter 5 is largely devoted to Arnold Bax, whom Sibelius called 'my son in music'.

Walker describes what Bax delivered through the medium of his Third Symphony: 'The village of Morar sits in its stone houses on a ridge in Invernesshire above the silver sands. The young Bax had sampled the coasts of north-western Scotland and found in them echoes of his beloved Irish landscapes. So in the autumn of 1928, in the youth of middle age at 45, he packed the sketches for his Third Symphony and took the train from London to connect with the West Highland Line, bound for Morar. In summer it's the tourists' photogenic dream: the sands flash silver across the Sound of Sleat to the isles of Eigg, Rum and Skye. But Bax went there at the end of the year, when the sands would be pockmarked by rain, episodically visible in the mist or coldly lit by the short flare of a northern sun. In Room 11 of the Station Hotel he sat in polar conditions, wearing a heavy winter coat, looking across another ebony sea to the purple isles while he orchestrated his most frequently performed symphony.'

This, Walker tells us, is his 'most Sibelian symphony'. He had worked out a three-movement structure in his first two symphonies, but both ended with passages that moved out, pulling away from the argument of the symphonies into something else, summations perhaps, or retrospective contemplations. Now, in the Third, after the 'broodings and upheavals' of the first movement, 'the sea-music of the slow movement brings detachment without resolution' and the third movement, hammering out new questions and resolving them in a dance

of forced optimism, the music subsides and we are 'impressed by the effort, wish we could be convinced. The music subsides. What next?' The epilogue to the symphony brings us the answer, a final part extending, something going further. There have been hard questions, difficult answers, work of real conviction, deepening commitment, but now, somehow, this transformation. The heavy air has lifted off, the sands return to white, the sea is calm, the melody floats out on clarinets and oboes and through 'the endorsing pulse of a softly swinging rhythm', entering gently another world of harp, horn and solo violin.

Walker's conclusion is this: 'If we're to be fully human we are doomed to probe the mysteries of brutality and beauty in the world and in ourselves. We must exercise our wills in the quest for what Herman Melville calls "the ungraspable phantom of life". We won't grasp the phantom, of course, but if we're true to the quest, grace and repose may come at last from beyond the scope of human will, perhaps mystically from nature, like this.'

And perhaps it may come in a place like this, overlooking the white sands of Morar, or in Ayrshire, or even in Glasgow: somewhere in Scotland.

Alan Riach

Melville in Glasgow
from *Homecoming: New Poems 2001–2009* (Luath Press, 2009)

Consider it a sketch: charcoal on grain, white paper, black ash,
clouds and the Necropolis, the perfect size and shape of that Cathedral,
to see it from the south side of the Clyde and think of modesty and reach,
the country all around; to think of what was there, and what
that man was looking for, a past that might say more than all the risk
he'd known before he stepped up on that quay: what did he want?
A family? A line? A net? A country? A link in a chain he couldn't put down,
to haul up something far too deeply rusted out of sight; yet not too far:
he knew it was there, went looking for it, crossed the country, walked and
 rode and
came back in to Glasgow: his place, his port. The first and last he saw, of some-
thing then he must have thought ancestral, real as all the things he knew
 had happened
to him, in the South Pacific, visceral, in blood and muscle, yielding to delight,
yet also always fictional: build on that. On what? Where was he then?
What strength and what uncertainty, and what desire to know, dared push
 that pen?

Jackie Kay: Scots Makar

Alan Riach (Wednesday 16 March 2016)

FOLLOWING EDWIN MORGAN and Liz Lochhead, it's difficult to imagine a better choice for the new Scots Makar than Jackie Kay. It's true that a Gaelic poet would have been welcome to represent that component of our literature, and that the geographical areas of Scotland in the east, the north and the island archipelagos have given us a host of other contemporary poets who might have been appointed, but the term of the post is only five years – long enough for any poet! There is time for all the forms of representation Scotland needs to take their place in due course. In her commitment to poetry above all, Jackie Kay is, for many, a much wished-for and happy choice.

It's good, too, that the appointment has been made by politicians. They're taking a necessary risk. Poetry is not electable. The poet appointed can be pretty much guaranteed to do nothing sycophantic. In any nation, for such an appointment to be made by representatives of the state, whatever party they are of, is a public pronouncement of belief: poets are valuable creatures, and their words should be heard.

Jackie Kay's first book, *The Adoption Papers* (1991), was an autobiographical sequence depicting the child of a Scotswoman and a Nigerian man being adopted and welcomed into the home of a kindly, loving, staunchly communist couple living near Glasgow. Different voices and a range of characters – the daughter, the adoptive mother and the birth mother – speak of their experience. Tough as it is at times, the humanity of the story never palls or falters.

Jackie grew up in Glasgow, discovering her own sexual disposition as a young woman, and travelling later to Africa to meet her birth father. In her writing, she speculates on such apparently problematic aspects of identity, belonging and political desire. The themes of family, local, national and ancestral identity and questions of sexuality and social prejudice run through all her work.

All this might seem serious and maybe even sensational, outwardly-focused and explicit, and in her poems, plays, in her writing for children, in her short stories and the novel, *Trumpet*, she can be exactly that. *The Maw Broon Monologues* were a comedy blast, loaded with satiric intent. Yet the subtlety of her

versification, the nuanced deployment of individual voices and tones, the tensions and sympathies between characters realised through speech recorded in verse, are all carried along on a sustaining sense of good humour, humanistic sympathy and sheer eloquence.

Her further books – *Other Lovers* (1993), *Off Colour* (1998), *Life Mask* (2005), *Darling* (2007), *Fiere* (2011) and *Reality, Reality* (2012) – take her in all sorts of directions: public and personal, exploring politics and language, geography and history, motherhood, falling in love, racism, prejudice, pride, popular culture and Shakespeare, Scotland and Africa.

The epigraph to *Darling* is from Bertolt Brecht: 'In the dark times / Will there also be singing? / Yes, there will also be singing. / About the dark times.' As the state of Britain goes the way it's going, and the people of Scotland might increasingly need a poet to sing about the dark times, Jackie Kay has taken on a job that will require all her resources of humour and engagement. As Edward Dorn put it, the modern world is designed for entrapment, but laughter can blow it to shreds. Kay ends her poem 'Old Tongue' with a declaration of desire and intent: 'I wanted my old accent back, / my old tongue. My dour soor Scottish tongue. / Sing-songy. I wanted to *gie it laldie*.'

She has her old tongue and the moment starts now for the new Makar's voice to ring out. Gie it laldie, Jackie.

Part Two: Artists and Exhibitions

J.D. Fergusson – Art and Nationality

Alexander Moffat and Alan Riach (Friday 18 March 2016)

WHILE SCOTTISH POETS and writers gathered in Montrose in the 1920s, then in St Andrews and Shetland in the 1930s, an artist of an older generation, born in Leith in 1874, was to travel alongside and sometimes intersect with their work. He was one of the group known familiarly as the Scottish Colourists but his vision and purpose is seen not only in his style and subjects but also, emphatically, in his book, *Modern Scottish Painting*. This was and remains a manifesto for the distinctiveness of Scottish art, and of Scotland, internationally and independently. He is one of the major artists of the 20th century, fully in touch with international Modernism in Paris before the First World War, and committed to cultural and political regeneration in Scotland after the Second World War. His name was John Duncan Fergusson.

J.D. Fergusson's book, *Modern Scottish Painting* appeared in 1943, the same year as Hugh MacDiarmid's autobiography *Lucky Poet: A Self-Study in Literature and Political Ideas* and the major breakthrough volume of modern Gaelic poetry, Sorley Maclean's *Dàin do Eimhir*. Taken together, these three key books signal the co-ordinate points by which a new Scotland was to be created, and Fergusson, MacDiarmid and MacLean might be seen together as artists whose shared vision of what Scotland could be has nourished and inspired the nation's cultural and political regeneration, from the 1920s, through dark times in the middle of the Second World War, to the early decades of the 21st century.

Unlike any of his Scottish artist contemporaries, Fergusson gathered and wrote down his thoughts, beliefs and commitments about art and politics. *Modern Scottish Painting* is a declaration of the practice of painting as national intent.

Each chapter prompts variations on the central theme of painting and freedom – freedom from the tyranny of academic authority in taste, artistic conventions and social priorities, and increasingly, freedom from the coercive pressures to conform politically in British imperialism, as opposed to distinctively anti-imperialist Scottish national art.

Fergusson's political nationalism and repeated call for Scotland's independence is unmistakable, loud and clear, on almost every page of the book. Maybe this is one reason why it has frequently been passed over in silence or given only muted acknowledgement by most of his commentators.

Fergusson grew up in the port of Leith, near, but not part of, Edinburgh. In Fergusson's youth it was a town quite distinct from the polite establishment ethos of the New Town. As a young man, Fergusson had one eye on a world that opened out internationally, and the other looking at what was no longer the capital city of an independent nation.

He must have been impressed from an early age by the contrast between the austerities of Calvinism, Kirk elders dressed in black, and the colour and linguistic energy of the port. Language is the key. His parents were Gaelic speakers from Perthshire. He would have heard rich Edinburgh Scots spoken in the streets around him as a boy, and a range of other languages spoken by the seamen, and he would have been familiar with the polite, genteel English of the Edinburgh bourgeoisie. After attending the Royal High School in Edinburgh, he enrolled at Edinburgh University as a medical student, becoming familiar with the shapes and structures of bodily form. But he walked away from any formal academic programmes as quickly as he could.

He positioned himself as an independent artist from the beginning, acquiring a studio in Picardy Place at the top of Leith Walk in 1894. He began visiting Paris on a regular basis from 1897 onwards, and moved there in 1907, after a series of summer trips to France with his fellow Scottish Colourist, Samuel Peploe. He loved the place for a reason:

'Paris is simply a place of freedom. Geographically central, it has *always* been a centre of light and learning and research. It is a place that has always been difficult to dominate by mere deadweight of stupidity. It will be very difficult for anyone to show that it is not still the home of freedom for ideas; a place where people like to hear ideas presented and discussed; where an artist of any sort is just a human being like a doctor or a plumber, and not a freak or madman, and where he doesn't need to look fantastic. After going there over 30 years ago I have some right to speak – *Salut!* to Paris. It allowed me to be Scots as I understand it, and has *made* me so Scots that I am leaving it and coming home.'

In Paris, Fergusson eagerly embraced all the new discoveries being made in painting by Cézanne, the Fauves and the Cubists. He was in the company of Picasso, Léger, Matisse, Ezra Pound, James Joyce, Apollinaire, Stravinsky, Ravel, Fauré, Lenin, Trotsky, and others at the forefront of revolution in the arts, literature, music and politics. The Fergusson archive in Perth contains letters

from Picasso that clearly reveal the depth of affinity, affection and professional respect they had for one other.

We do Fergusson a grave disservice not to contextualise him fully among his great modernist contemporaries. It was in Paris around 1913 that Fergusson met his life-long partner Margaret Morris, the pioneering dancer and choreographer. It was here that he painted his masterpiece, *Les Eus*, a radical vision of a group of women and men dancing in a revolutionary self-expression of good health and freedom, a Scottish 'Rite of Spring'.

In 1922, when Eliot published *The Waste Land* and Joyce published *Ulysses* and MacDiarmid first appeared in print, Fergusson travelled around the Highlands seeking to address the landscape of Scotland in this modernist context. He was the first major artist in Scotland to do so.

Two key paintings from this trip are *A Puff of Smoke Near Milngavie* and *Storm around Ben Ledi*. They are contrasting scenes: one is of cultivated fields, farmland, a small town or village in the foreground. The hills are in sunshine, three big white clouds are passing in the blue sky, the puff of smoke looks benign, also white, perhaps from a passing train? Leaves on branches hang down from the upper edge of the frame, almost visibly swaying in the breeze. The address of the landscape – how people who live there might experience it, how it might affect the experience of people who live there – is in the painting itself. It invites the viewers' consideration of this. It is not merely a pretty picture.

This involvement with the vision of the inhabitants of a place takes the work into alignment with the great literary works of Modernism, especially in Scotland.

One of the key characteristics of Modernism was the repudiation of the security of the master narrative, the secure sense of where we are standing when we look at what is visualised before us. In classic realist fiction of the 19th century, there is a fixed hierarchy of author and characters. In Scottish literature for more than a century the authorial language had been English. In fiction, characters would speak Scots, but the master narrative was in English. In the 1920s and 1930s, pre-eminently Hugh MacDiarmid in poetry and Lewis Grassic Gibbon in novels and stories, use the Scots language. Gibbon creates a linguistic idiom that is tuned into the language of his characters. The hierarchy is abolished. The authority of judgement must be created out of the experience of life which the work of art brings into form. This is as true of F.G. Scott (1880–1958) in music, MacDiarmid and Gibbon in literature, and in painting with William Crozier (1893–1930), William McCance (1894–1970), William Johnstone (1897–1981) and William Gillies (1898–1973). They all build on the example of J.D. Fergusson.

Even less of a 'merely' pretty picture, and even more impressive, perhaps, is *Storm around Ben Ledi*. The dark greens of the forests and the disrupting shapes of the mountains; the storm clouds, the greys and blues of rain and wind, the dark blue loch in the foreground; the trees standing resistant against the weather's onslaught, all create a wilderness that is more attentive to geological and topographical reality than romantic encounter. The perspective is disconcerting, taking your gaze vertiginously down into the glens, through and over the woods, and up to the summits.

Looking at these paintings, the answer you might give to the question, 'What sort of place is this, Scotland?' would be very different from what could be imagined were you looking at a painting by any more conventional 19th-century landscape artist. These works are less about property than they are about experience.

As the Second World War was approaching, Fergusson chose to return to Glasgow from France because, he said, it was the most Highland city in Scotland. As soon as he arrived he set about invigorating Glasgow's art scene. Dissatisfied with the existing Glasgow Art Club because it would not admit women, he established the New Art Club in 1940. He was the founder-member of the New Scottish Group, holding annual exhibitions from 1943–48, and again in the 1950s. There was no jury selection. He based this procedure on his experience of the Salon des Indépendants in Paris. This openness encouraged influential European refugees such as Josef Herman and Jankel Adler as well as non-conformists like Ian Hamilton Finlay and William Crosbie to exhibit and participate actively. Alongside Fergusson's activities, Margaret Morris formed the Celtic Ballet in 1947, and in 1960, the Scottish National Ballet. She was, in a sense, the model for the female figures in the designs Fergusson contributed to the first editions of MacDiarmid's epic poem, *In Memoriam James Joyce* (1955), where visualisation, musical annotations, the ancient Celtic script known as Ogham and the endless variations of language and creative expressivity are the constantly exfoliating principles of human rejuvenation to which both Fergusson and MacDiarmid were comprehensively committed.

Fergusson consistently supported the work of contemporary women artists such as Louise Annand, Pat Douthwaite and Isobel Brodie. Their work formed part of the Scottish Women Artists exhibition that was held at the National Galleries of Scotland in 2016.

Like McTaggart and Patrick Geddes before him, and along with his close friends S.J. Peploe and Charles Rennie Mackintosh, Fergusson had a vision for Scotland. 'It is quite possible to turn Scotland into one of the most wonderful and vital countries in the world, but it has to be done by Scots.'

His vision was far-reaching and continues to inspire and instruct. That's his real legacy. In her biography, *The Art of J.D. Fergusson*, Margaret Morris remembers Antibes in the summer of 1924: 'One day we met Picasso at Eden Roc and we walked back to the hotel together. He said, "You do not fit into this place," and picked a sprig of bog-myrtle from a bush and handed it to Fergus, saying, "This is you".'

Picasso was only one of his friends and fellow artists to recognise and endorse Fergusson's love of his country and his desire for its independence.

Fergusson's greatest paintings can be seen at The J.D. Fergusson Gallery in Perth, the Hunterian Gallery at Glasgow University, the University of Stirling, and the Scottish National Gallery of Modern Art in Edinburgh. Admittance to all galleries is free of charge.

Modern Scottish Painting by J.D. Fergusson, edited and introduced by Alexander Moffat and Alan Riach, is published by Luath Press.

John Bellany, Elsie Inglis and the Scottish Women's Hospitals

Alexander Moffat and Alan Riach (Friday 25 March 2016)

IN THE SCOTTISH Parliament building at Holyrood, that magnificent structure designed by the Catalan architect Enric Miralles, punningly and happily described by the poet Kathleen Jamie as 'a watershed', an exhibition was held entitled 'John Bellany and the Scottish Women's Hospitals'. There was some serious provocation in this exhibition, an insistence that we do some deep thinking about the relations between politics, medicine, poetry and art.

Ezra Pound, in his essay, 'The Serious Artist' from 1913, said this: 'The arts give us a great percentage of the lasting and unassailable data regarding the nature of man, of immaterial man, of man considered as a thinking and sentient creature. They begin where the science of medicine leaves off or rather they overlap that science. The borders of the two arts overcross.' He went on: 'As there are in medicine the art of diagnosis and the art of cure, so in the arts, in the particular arts of poetry and of literature, there is the art of diagnosis and the art of cure.'

Nowadays, we would insist on saying, 'man and woman' but he has a point.

Approaching the exhibition with this in mind is revealing. In the 1890s, Elsie Inglis, who had been deeply involved and active in the suffrage movement, was pioneering her vision of medical treatment. Self-confident, her career continued in Edinburgh as a doctor and surgeon specialising in treating women and children. When the First World War broke out she marched into the War Office and offered her services to do something valuable. She was dismissed with the advice, 'My good lady, go home and sit still.' Instead, she offered her services to the French, who accepted them.

Liz Lochhead's poem, 'The Ballad of Elsie Inglis' tells her story. Born in India in 1864, she trained in the Edinburgh School of Medicine for Women when it opened in 1886. (Women students had been admitted to the Glasgow School of

Art for the first time only one year earlier.) She studied at the Royal Infirmary in Glasgow, becoming one of the very first women to qualify as a doctor and surgeon in 1892, at the age of 27. She worked in hospitals across the UK and set up clinics for women and children in Edinburgh, often paying for treatment for poorer patients who could not otherwise have afforded it. She joined the suffrage movement and was a member of the National Union of Women's Suffrage Societies. When war was declared in August 1914, she was nearly 50 years old.

She set up the Scottish Women's Hospitals throughout Europe, in France, Serbia, Macedonia and Russia, treating soldiers from the trenches, wounded by shrapnel and suffering from gangrene, frost-bite, infections of all kinds. More than 1,500 women signed up to work in these hospitals, from all sorts of social strata, from crofters to landowners, freeing themselves from the social constrictions of Edwardian Britain to do something worthwhile in the wider world of Europe, forming friendships and making new companions in foreign lands. These were new contexts for new priorities, very different from the ethos of the pompous conservative buffoon who had told Elsie to 'go home and sit still'. These were times of emancipation for women. Margaret Morris, dancer, lifelong partner of the artist J.D. Fergusson, was of the same generation. Lochhead's poem concludes that throughout the long years of the war, Elsie had 'always known / Exactly what she was fighting / And what she was fighting for.' In 1917, she died of cancer, which she had kept concealed from her colleagues.

The exhibition charts her life – physically, she bears a striking resemblance to Hugh MacDiarmid: a high forehead, features squeezed into the lower two-thirds of the face, curly hair frizzing straight out of her skull, a terrier-like aptitude and fighting-fit stance, eager eyes that seem to spark with intelligence – and the story of the hospitals is documented with photographs, maps and objects, kit-bags, medical instruments and bits of machinery. But what lifts all this into another kind of urgency is both Lochhead's poem and pre-eminently, John Bellany's paintings and drawings of wounded men and compassionate nurses and doctors.

Famously, Bellany underwent surgery for a liver transplant in 1988 and his gratitude towards the medical staff who looked after him was immense. He was overwhelmed with admiration when he heard the story of Elsie Inglis and her women's hospitals. In Helen Bellany's words, he saw 'their sheer courage, commitment and exhaustion in the relentless effort to give that vital comfort, hope and compassion to the desperately ill and dying.'

During the First World War, German artists were pre-eminent in the condemnation of the madness of what was happening: Otto Dix, Max Beckmann and George Grosz produced vivid, sometimes satiric, often horrific images that

have lasting effect. They had a language in painting that could represent the horrors of war in a way that was extremely unfamiliar to their audiences. There was nothing chauvinistic, heroic or simplistic about it: these were depictions of human beings slaughtering each other and no glorious fatherland was to be celebrated here. All the worst excesses of patriotism had been stripped away in a declaration of common humanity at its most vulnerable and self-destructive. Willing and ignorant people were murdering each other while bankers, weapons-manufacturers and the industries that supplied them, were raking in the profits.

Bellany never experienced the horrors of war at first hand but he did know the doctors and nursing professionals who treated him in the 1980s. This took further his understanding that the barbarous aspect of humanity most powerfully brought to his attention in the visit he made to Buchenwald in 1967, could be countered by strength of will, priorities of sympathy and compassion, hard work and humanism. His experience of what remained as a memorial to the Nazi death camps went deep, and produced some of his most distinctive, shocking works of the 1960s and 70s. These are the works that match those of Dix, Beckman and Grosz.

There is an older precedent for the depiction and response to war in paintings, stories and poems that is relevant here: Goya's series, 'The Disasters of War' from the early 19th century. These were politicised, polemical, passionate works, unmatched by any contemporary artist. Bellany knew them well, and his experience of the traditions of art was complemented by what he had seen on television in the 1960s: programmes about the First and Second World Wars, documentaries showing how war was an extension of particular activities and priorities in the social and business world, made at the expense of common humanity. He was able to bring his attentions to bear on the meaning and consequences of 20th-century war and his paintings show this. Therefore, after his experience as a patient close to death in hospital, he was able also to depict conditions of suffering, care, and recuperation and the value of human decency to set lasting value before our eyes. Beckman had seen death at first hand in a field hospital beside the trenches, Bellany had been close to death himself, in hospital. In both locations, people were dying every night. The experiences of Beckman and Bellany were threaded on the lines of their memories. After he left hospital, that personal experience and his memories of the art of the two world wars, the fact of such inhumanity and the fact of such human commitment to helping, to medicine, to caring, sustained Bellany deeply.

In the 60s and 70s, new critical questions were being asked about the First World War and an anti-war movement spoke to the people through Benjamin

Britten's War Requiem and equally powerful, desperately moving, desperately undervalued, almost unheard, so rarely performed *Dona Nobis Pacem* by the Scottish composer Ronald Center. There was republication and new familiarity with the English poets of the First World War, Wilfred Owen and Siegfried Sassoon. There were protests against Vietnam and the growing strength of the CND: the prioritisation of the virtues of peace came to the forefront in public discourse.

In the 21st century, to a fearful extent, this has been eclipsed. All the rhetoric of heroism, wars against terror, violence to match violence, is commonplace to a degree that probably resembles the public rhetoric of a hundred years ago more than that of the 1960s and 70s.

For example, think of the film *King and Country*, directed by Joseph Losey in 1964, on the 50th anniversary of the outbreak of World War One. Tom Courteney played a soldier in the trenches of World War One who is caught walking away from the conflict, tried for desertion, defended by a lawyer played by Dirk Bogarde, and executed by firing squad. The story is almost exactly parallel to that of Lewis Grassic Gibbon's Ewan Tavendale, in the novel *Sunset Song* (1932). The shock and impact of the film would remain with anyone who saw it in the 1960s, but the key questions are these: Could such a film be made in the 21st century? If not, why not? If it were, would it be shown widely? And if it were, what possible impact could it have?

Why is it that in 2016 we're being told so much that war is the solution? Even the anti-war protests that were visible when Tony Blair decided to bomb Iraq seem to have been flushed into historical oblivion. And when Labour politician Hillary Benn declared his approval of the Conservative Party initiative to bomb Syria on 2 December 2015, he was lauded and applauded as a potential leader of 'the Opposition'. Opposition to what?

In Scotland, there is a major body of work by poets who experienced the Second World War, which in quality and range is at least as great as that more familiar body of poetry relating to the First World War. Think of the war poems of Sorley MacLean, extending to the Cold War and the outrageous wrong embodied in nuclear submarines, as described in his poem 'Screapadal'. Think of George Campbell Hay's 'Bizerta', Edwin Morgan's 'The New Divan' and Robert Garioch's 'The Muir'. Think of Hamish Henderson's words, in *Elegies for the Dead in Cyreneica:* 'There were ourselves, there were the others... / why should I not sing them, the dead, the innocent?'

In this world, 'There were no gods and precious few heroes'.

Our politicians, as much as our poets, artists, composers and film-makers, need to make the diagnosis as tough as this. And compassion is only part of the cure.

Modern Scottish Women Painters & Sculptors 1885–1965

Alexander Moffat and Alan Riach (Friday 15 April 2016)

THE EXHIBITION, 'Modern Scottish Women Painters & Sculptors 1885–1965' was on at the Scottish National Gallery of Modern Art, Edinburgh, until 26 June 2016. It was a remarkable show, curated by Alice Strang, who has done sterling work in the National Galleries for a number of years, with pioneering exhibitions prompting serious revaluations of Scotland's art. This one shone new light on an impressive range of artists hitherto shockingly overlooked. It prompted a number of important questions about their political contexts, from the 19th century to now, especially regarding the practical difficulties they faced, including the notorious 'marriage bar' which curtailed the careers of many promising women teaching in art schools. Essentially, it meant that if you were a woman, and married, you could not be an art teacher. The marriage bar only ended in 1945: who invented that? Who came up with the idea that you couldn't have married women holding full-time teaching positions?

What's the context, politically and historically, for this exhibition? And how does it work in that context?

Now, the Director's Foreward to the book accompanying the exhibition notes that it's 'the first major exhibition of work by women artists to be mounted by the National Galleries of Scotland'. The time is ripe, we're told, 'to explore the contribution they have made to Scottish art history in their own right, examining the ebb and flow of opportunities for women to train and practise as artists, with particular attention paid to the effect of their gender on their experiences.'

What's missing from the book, though, and from the documentation that accompanies the exhibition, is a firm sense of the political world these artists worked in. More than ever, this is required to appreciate the works on show. Women were admitted to the Glasgow School of Art in 1885 but in the wider

political context, votes for women only arrived after the First World War. In 1918, women 30 years old who owned property were 'given' the vote; in 1928, equal franchise to women over the age of 21 was confirmed. The significance of this is simply the possibility that democratic political representation of people might be made possible through the franchise. These rights were hard won. They went along with developing ideas about what socialism might bring about, what had been happening in Ireland and Russia, political self-consciousness urgently necessary after the First World War.

Women as much as men had been politicised in Art Schools in Paris, Dublin and London. Roy Foster, in his book, *Vivid Faces: The Revolutionary Movement in Ireland 1890–1923* (2014), talks of the establishment of the Dungannon Club in Dublin, a students' society at which writers and intellectuals like W.B. Yeats, Douglas Hyde and Alice Milligan gave guest lectures. New generations were made aware of both national traditions and international political stirrings. The part St Petersburg students played in the Russian revolution of 1905 was well-known to the Irish students, and exemplary: they were to be 'neither Rome's nor England's slaves'. In Dublin's Metropolitan School of Art, many were moved and indeed attracted by 'images of martyrdom…the moral and aesthetic advantages of dying young' yet the proposition of student revolutionaries joining forces with 'the streets' in Russia and the 'hillside men' in Ireland delivered radical thinking. 'Connections in art schools and artistic circles generally linked together high-profile nationalists such as Maud Gonne, Constance Markievicz and Ella Young, all dilettante artists in their way' while poets, teachers and professional artists such as Patrick Tuohy were among those occupying the General Post Office in 1916.

Political as well as aesthetic dialogue would certainly have been going on in art schools in Scotland just as it had gone on in Ireland throughout the whole period. The folding-together of radical politics, artistic thought and practice, literary and educational ideals, feminist, socialist and republican hopes must have been deeply embedded in the discussions among contemporaries in Scotland, as much it was in Germany or in France.

For people in Scotland, there was a key question about what might be made possible through developing a national potential defined, on the one hand, by the legacy of the British Empire, or, on the other hand, suggested, sketched and explored in the work of R.B. Cunninghame Graham, Keir Hardie, John Maclean, Hugh MacDiarmid or Naomi Mitchison. Taking the risks of seeing the art of these Scottish women painters and sculptors arising within this world of political ideas is to begin to understand them in the larger context whose

effects we are living in now. Not to do so, leaves that context a tantalising pos-sibility, frustratingly denied the visitor.

Some might prefer it that way. Some will certainly assume that works of art have their own integrity and don't need any context other than what they make for themselves as works of art. There is some truth in that argument, but it's an evasion of the educational aspect of a public exhibition. Sometimes, the risks need to be taken to be true to the work being exhibited.

The exhibition, by concentrating on women working as painters and sculp-tors rather than in the applied arts, debunks the myth of women being more suited to 'craft' than art. In that sense, it is a courageous assertion of perspec-tive: we need to understand their work today as of equal value, intrinsically, to that of men. But we need to find out more about the history they had to work through.

The opening date of 1885 is a key: this was the year Fra Newbery took over as Director of the Glasgow School of Art and began a regime to redress former gender inequalities among staff and pupils. The exhibition takes us through to 1965, when Anne Redpath died. Redpath is essential, one of the major artists of modern Scotland, a vital member of the post-Second World War Edinburgh school, along with William Gillies, John Maxwell, James Cumming and Robin Philipson.

The book's one-page chronology gives dates and events from 1760 to 1965, but you can search in vain for any reference to the suffrage movement. Yet Scottish women artists were key figures in the field of political change. In the late 19th century, Phoebe Anna Traquair worked closely with Patrick Geddes, both promoting ideas that were revolutionary in terms of art, social living, gender relations and political power. In 1886, the Scottish Office was set up. Already there were the beginnings of a sense of the importance of devolution and, implicitly, even then, there were the stirrings of an ideal of independence.

Through this era, Margaret Macdonald, the artist who married Charles Ren-nie Mackintosh, and her sister Frances (bizarrely omitted from the exhibition on the grounds that she painted only in watercolour), would both have known and discussed questions about the relation between nationality and architec-ture, nowhere more clearly demonstrated than in Mackintosh's Glasgow School of Art itself. Seeing them as individual artists with their own distinctions is essential, but seeing them in the climate of debate and desire for new art which was also capable of drawing on older national traditions remains equally vital. Margaret, Frances and others would collaborate as equals with the men. They were not to be considered in any way inferior. Before 1914, they had demon-strated the enormous potential for what women painters might achieve, but

then after the war, women were back in their box, considered second-class and second-rate, especially by such institutions as the Royal Scottish Academy.

How were they seen by the male artists? James Caw, Director of the NGS (1907–30), described Bessie McNicol as 'probably the most accomplished lady artist that Scotland has yet produced' – which sounds like a compliment but is evidently constrained by its own form of reference: a 'lady artist' surely signifies a certain propriety and distance from vulgarity or vernacular life. Sculpture, it seems, was considered the most unlady-like art activity. Bessie died in childbirth in 1904, uncannily prefiguring the death in a parallel circumstance of the German expressionist Paula Modersohn-Becker (1876–1907).

Female students were not allowed into the life classes in the art schools – it was considered immoral for 'lady artists' to be drawing from nude figures, so they were encouraged to draw from plaster casts or partially draped models.

A few weeks ago, in *The National*, in 'John Bellany, Elsie Inglis and the Scottish Women's Hospitals' (25 March 2016), we discussed the relations between medical and artistic work in the exhibition at the Scottish Parliament, and how Elsie Inglis had been advised to 'go home and sit still' by the British military establishment when she had offered her services. The artist Norah Neilson Gray enlisted with Elsie Inglis's Hospital Unit and her work was exhibited in the exhibition at Holyrood. The connections are there.

Agnes Miller Parker, born in Irvine, studied at GSA 1911–17, met fellow student William McCance, who was imprisoned as a conscientious objector in 1917, and married him in 1918. They moved to London in 1920, got to know the novelist Naomi Mitchison and would come to know MacDiarmid and other writers and artists of the Scottish Renaissance in the 1920s. Arguably the most feminist painting in the entire show is Parker's *Round Pond (Serpentine)* (1930) in which children and elderly folk, mothers and the condition of motherhood, activities involving play in leisure-time, all combine in a kind of social overview. The men in the painting seem to be fooling around with toy yachts in the pond, while the women are doing the serious work of bringing up the next generation.

An infamous letter from Gustav Mahler (great composer though he is) to his wife Alma in December 1901 advises her to give up her hopes to write music herself: 'become "what I need" if we are to be happy together, i.e. my wife, not my colleague'. Such attitudes were slow to disappear in Scotland. In the 1940s and 50s, Louise Annand (1915–2012) had to submit work under the name of Richard or Dick Annand to subvert common prejudice.

In this exhibition, we have to ask, how many of the 45 women were Scots? There are some such as Cathleen Mann, Kathleen Scott Kennet and Ethel Walker, whose connections with Scotland are somewhat tenuous, given that they never

studied nor lived here. What about the sculptor Princess Louise, Duchess of Argyle? Born in London in 1848, died in London 1939: the sixth of Queen Victoria's children, she hardly spent any time in Scotland at all, other than a spell at Rosneath Castle, Dunbartonshire, the seat of the Dukes of Argyll. Including her sculpture of the young Queen Victoria in this exhibition is astonishing: what is it doing here? Is this some kind of ecumenical openness, a token gesture to the imperial context? Or is it the cringe, big-time?

Everything you see happening in this exhibition is coming into being as Scottish art itself begins the long story of self-determination, in a political context of enablement and self-esteem. That story is not fully told.

Pause for a moment with Dorothy Carlton Smyth. She was actually appointed Director of the Glasgow School of Art in 1933 but died suddenly of a brain haemorrhage. What might have happened had she taken up the post? Might she have forged a link with J.D. Fergusson and Margaret Morris returning to Glasgow in 1939? Smyth's appointment to the top job at the GSA was way ahead of its time, ten years ahead of the RSA where the first woman to be elected a full member was Phyllis Mary Bone, in 1944.

There are other connections, opening the story out. Margaret Mellis and Willhelmina Barnes-Graham were among the first women to embrace abstraction, going off to Cornwall in the 1940s, connecting traditions across geographies. Bet Low worked with the Unity Theatre Company, helping to design and construct the sets for Ena Lamont Stewart's seminal feminist, working-class play *Men Should Weep* (written 1956 but set in the 1930s Glasgow tenements). The connections implicit there between art, theatre and painting bring together Low, Stewart, Jankel Adler, Josef Herman and Hugh MacDiarmid, and a multi-faceted opposition to fascism in the Second World War. Socialism and self-determination remain ideals, while Russia's position in the 1940s and 50s becomes increasingly fearful.

Moving forward historically to the work of J.D. Fergusson and Margaret Morris in 1940s and 50s Glasgow, and taking into account the work of Joan Eardley, especially in the 50s, right up to her death in 1963, brings us to the edge of the late 20th and early 21st centuries. If Eardley emerges as the single most important artist in the exhibition, her immediate contemporaries and legacy after the 1960s become increasingly significant. How do we register that?

We're left wishing we could have seen the story taken forward to a contemporary scene, both in artistic achievement and in political development. After all, here we are in a new Scotland, long post-1965, with artists such as Moyna Flannigan, Sam Ainslie and Ruth Nicol, not to mention poets like Liz Lochhead and Jackie Kay, playwrights like Sue Glover and Rona Munro, novelists like

Janice Galloway and A.L. Kennedy. Change has happened, indeed, but we need to see it clearly to grasp its full value. This exhibition helps. Its worth is unquestionable. But it needs to be seen twice. Once to take in what it shows, and then once again, to consider how much further its implications go, and how much further they need to be taken.

There can be no doubt that the emancipation of women has been one of the great historical events of the 20th century. The problem for the 21st is to establish what still has to be done, and what will probably happen. In the 20th century, the emancipation of women was, in fact, confined to a part of the world and certain section of society. There are still large parts of the globe where this phenomenon has not occurred. There have been two great phases: the first was the battle for the same political and voting rights, the second was for equality in access to the professions.

Eric Hobsbawm, *The New Century* (1999)

What Can We Learn from Alice Neel?

Alexander Moffat and Alan Riach (Friday 2 September 2016)

ALICE NEEL (1900–84) was an American artist whose drawings and paintings, mainly portraits, were previously on show at Edinburgh University's Talbot Rice Gallery. The exhibition was curated by Pat Fisher, who has presided over the Gallery for the last ten years, and has done sterling work in a whole series of excellent exhibitions under the auspices of Edinburgh University, including that of John Duncan, a precursor of the National Museum's Celts exhibition. This was her final exhibition before she retired. It is a remarkable achievement, raising questions especially vital for us in Scotland today.

If we consider Alice Neel's work alongside that of the Scottish women we wrote about in *The National* (April 15, 2016), a similar story emerges of artists 'shockingly overlooked' and in need of revaluation. As with the Scotswomen, Neel demands not only an aesthetic appraisal but also full political contextualisation. Arguably the Scots were overlooked because they were women; Neel was neglected also because her work was intrinsically political, an active critique of social priorities inimical to human well-being. She moved from Philadelphia to New York in the late 1920s, where she lived and worked for the rest of her life. New York was her territory and ground base, ever after.

Moreover, after 1945, her commitment to painting portraits was deemed old-fashioned, as abstract expressionism gained ascendancy. The abstract expressionists such as Jackson Pollock were considered exemplary of American democracy in the anti-Soviet cold war. The State Department invested in abstraction because it seemed to oppose Stalinist socialist realism. Abstraction was the badge of freedom, opposed to totalitarianism, while painting portraits – especially of the poor people of Spanish Harlem – was not a good way to sell America. Neel was undaunted. She never stopped. This exhibition presents work from every decade, from the 1920s to the 1980s.

What did it mean to be a politically engaged artist, committed to socialism, indeed to communism, in the United States in the 20th century? Neel's

answer is a uniquely powerful blend of the highly personal, intimate, unhesitat-
ing depiction of people in various states of naked reality, in a political context
that permeates the domestic scenes. Priorities of gender, ethnic cultural history,
social conditions, are all inescapably vivid. Her mother is depicted in an old
people's home in *City Hospital,* 1954, isolated, lonely, reflective, in a drawing
of compassionate intensity. The fact that her mother was a direct descendant
of one of the signatories of the American Declaration of Independence might
suggest a quality of pathos in her vulnerable loneliness. It might also confirm
something of her strength. Children are one of Neel's main subjects, her own
children particularly. The contrast for us in Scotland is immediately with those
paintings of Glasgow tenement children by Joan Eardley. Neel's drawings are
compassionate portraits but without a trace of sentimentality. Affectionate, yes,
but never in any way saccharine. There is a sense that potential is more danger-
ous than definition.

 One of the most haunting pictures is *A Quiet Summer's Day,* 1963 in which
a group of adults stand helplessly before a mother leaning and crying over her
child, who has drowned in a canal of industrial waste-water, with a factory
building looming behind them all. This is a secular pieta, and the pathos is
understated. You have to look closely to see what's going on. Yet it balances
with strength and delicacy a social critique and a personal sense of involvement:
you're never in doubt about its reality. Nor is it exaggerated. Its nearest rela-
tions, and close to some of Neel's other drawings, might be the German artists,
Otto Dix, George Grosz and Max Beckmann, but the Germans normally infused
their work with what we might call sarcasm: a scathing quality of confrontation
inheres to their depictions of beggars, prostitutes, industrial workers. In Grosz's
case, the industrialists with their big cigars and smug faces, the sense of attack
is paramount. Not so with Neel. Her drawings expose the horrors but keep the
sense of common decency. They offer a human bonding in hard times that it
would be easy to caricature, except for their firm understatement. They do not
indulge in pastiche. These are permanent reminders of what compassion is for.

 What did American nationalism mean in the 1930s, at the time of the
Depression?

 Thomas Hart Benton represented the city and modern life in America and
is often considered the great artist of the Depression, mainly known for his
depictions of new arrivals, folk coming in on wagon trains. His paintings are
aspirational: people are setting out to make something of themselves and hop-
ing to do well. In huge murals, he depicted industrial workers in the cities in
the East, black workers in the South, farmers in the West, but the epic scale of
these works usually delivers an optimistic sense of striving for virtue. They are a

vision of the American Dream, but they don't confront the harsh realities of the Depression years as Neel does.

In a society where individuals were increasingly under pressure to conform, Manet, not Cézanne, becomes a key figure of influence. Direct engagement with reality rather than formal perfection in the work of art becomes the priority. The 'Ash Can' school of artists addressed such realities far more vigorously and in fact aggressively than any more polite groups with other formal preferences. Neel takes something of their aspect but adds patient critical attitude and depth of understanding. Her commitment to socialism and communism never wavered and was consistently processed through her art, so that no blind belief in state authority blinkered her sensibility. It was rather a political choice expressed through drawings and paintings, where honesty enacted its own self-criticism. She could never have done what she did without such self-criticism.

The cultural historian Jackson Lears began a review of Steve Fraser's *The Age of Acquiescence: The Life and Death of American Resistance to Organised Wealth and Power* (*London Review of Books*, July 16, 2015), with a pertinent quotation: '"Why is there no socialism in the United States?" the German sociologist Werner Sombart asked in 1906 – it was also the title of his most famous book. The question was misconceived. During the several decades before the Bolshevik Revolution, socialism was as American as apple pie. In the presidential election of 1912, nearly a million Americans – 6 per cent of the electorate – cast ballots for the Socialist Party candidate, Eugene Debs. There were two Socialist members of Congress, dozens of Socialist legislators, and more than 100 Socialist mayors. The leading socialist paper, the *Appeal to Reason*, had more than 500,000 subscribers. And this was only a portion of a much broader swathe of the electorate who considered themselves Progressives or Populists rather than Socialists, but were just as committed to challenging corporate power in the name of a "co-operative commonwealth".'

These people, Lears tells us, were farmers, artisans, small businessmen as well as industrial workers. They did not fit the Marxist model of opposition to capitalism. 'Many were small-town or rural folk from the Midwest or the South.' Their idiom came from republican tradition and Christian morality. Religion for them was 'not an opiate but an elixir' and 'rooted in concrete experience of the present and past, in older ways of being in the world, depending on family, craft, community, faith – all of which were threatened with dissolution (as Marx and Engels said), in "the icy waters of egotistical calculation".'

Lears connects this account to E.P. Thompson's *The Making of the English Working Class* (1963) and concludes that there was a common pattern on both sides of the Atlantic, After 'the grand bargain of 1950, when unions in the steel

and car industries traded their control of shop-floor rules in return for security and steady wages' there was a hidden cost: 'the erosion of any notion that organised labour could foster an ethos of solidarity – an alternative to the dominant culture of individual accumulation.' And the connection is there from this 'loss of a larger vision to the contemporary neo-liberal consensus.'

Alice Neel's work runs through this story, but looking at the drawings and paintings in the exhibition, there is a deep and constant sense of resistance to this 'sell-out': the essential and fundamental qualities of human worth are maintained and act as lasting resistance – as they can do so effectively in works of art – to the corporate world we seem to be immersed in today.

Moira Jeffrey, in the exhibition catalogue, tells us of the artist's life: 'Neel experienced loss after loss, personal mistakes, disasters, estrangements including the death from diphtheria of her first daughter Santillana just before the child's second birthday in December 1927 and the loss of Isabetta to [her first husband] Carlos's family in Cuba in 1930. Neel experienced crisis, hospitalisation and recovery. Neel painted these experiences as well as living through them. She drew the economics of her age, the grinding poverty of the Depression and the activism against it. Her life was marked by extremes of poverty, by domestic violence and by moments of privilege, by love affairs and sex, and the ordinariness of parental love for her two sons Richard and Hartley, born in 1939 and 1941, amidst the chaos. In the foreground was her painting. In the background the dreadful scrabble for survival and then for the attention and status her art demanded. And finally in the seventies, in *her* seventies, she found the art world at her door.'

A portrait, *Kenneth Doolittle (seated)*, 1933 is unsparing: the tortured mind behind the hopeless face is immediately present, but there is no outpouring of pity or idealisation of the victim. This is the lover who was to destroy 300 of Neel's works, which might have devastated any artist. Yet compassion is most evident in the drawing.

Her vexed relationship with John Rothschild is evoked in *Alienation*, 1935 and *Untitled (Alice Neel and John Rothschild in the Bathroom)*, 1935. Again and again, she presents double portraits, a couple, a father and son, a mother and daughter, pinning down both the differences and the connections between the sitters. Neel painted these characters and her own experiences with forensic objectivity that delivers the sense that she has lived with them, through their experiences of the world and each other, as well as observed them.

She wasn't an entirely isolated figure. Among her friends and associates were the Beat poets of liberation. A portrait, *Aaron Kramer*, 1958, depicts a poet and scholar whose work was published alongside that of Langston Hughes

and other anti-establishment writers in the anthology *Seven Poets in Search of An Answer* (1944). Neel herself appeared in the film *Pull My Daisy* with Allen Ginsberg, Gregory Corso and Jack Kerouac.

One of the most striking portraits in the exhibition is *Stewart Mott*, 1961, a bearded young man, seated, resplendent in white shirt, green waistcoat, tartan tie and full dress kilt, smiling out at the viewer. The Scottish component is immediate and strong. Who was he? A self-styled 'avant-garde philanthropist' who supported a whole range of liberal causes, and who in the 1970s featured on Richard Nixon's list of principal enemies. Apparently he helped fund the Democratic opposition to Nixon. Closer inspection reveals that his grandmother was Isabella Turnball Stewart, so the Scots connection is undoubted.

Neel's art of resistance is a contrast to the self-pity of many of today's celebrity artists and alerts us to the serious contemporary confusion about radicalism and value. What is worthwhile in what currently holds sway? How can anyone tell, without serious critical sensibility? When works of art are seen, not in terms of quality, but rather of novelty, their critical value is deeply undermined. How do we learn about this?

There are no Scottish artists of Neel's vintage we could name, who created anything like the work she produced. William Gillies and John Maxwell, two of Neel's Scottish contemporaries, whose work was on show concurrently in an exhibition at the City Arts Centre Gallery, produced major work of a completely different character. They were embedded in European traditions, and while they achieve real distinction in landscapes and still life paintings, their achievement is utterly different from Neel's.

Alice Neel is a unique figure in 20th-century painting. Perhaps it could be said that only America could have made her make her work. That's a permanent antidote to Trumpery.

Two Friends, Two Major Artists Revalued: William Gillies and John Maxwell

Alexander Moffat and Alan Riach (Friday 9 September 2016)

AN EXHIBITION THAT ran till October 23 2016 at Edinburgh's City Art Centre brought together a major collection of work by William Gillies (1898–1973) and John Maxwell (1905–1962), drawing on the collection of the Royal Scottish Academy. The City Art Centre has had a key role in consistently presenting, for many years now, a series of vital exhibitions exploring Scottish art and artists, both old and new, often putting our National Galleries to shame; however, the lack of catalogues or books accompanying such exhibitions is a disservice to the vital research done by staff and to the history of art and artists in Scotland.

Following from our essay on the American artist Alice Neel, we'd like to look at the work of Gillies and Maxwell. What does it have to say to us now? Both are often been dismissed as too tame in comparison with their great French counterparts. But this is to miss the point – they were amongst the first Scots to see themselves as modern European painters and their example of dedication and independence helped succeeding generations find a way forward.

William Gillies was born in 1898 in Haddington, about 20 miles east of Edinburgh, and John Maxwell in 1905 in Dalbeattie, on the Dumfries and Galloway coast, 90 miles south of Glasgow. During the First World War, Gillies was on active service near Arras. He was wounded twice, gassed, and hardly ever spoke of his experience there. Two of his most striking works in this exhibition are a landscape of his native place with the river Tyne in flood, a mass of swirling vivid colours, water, earth and sky tumbling around each other in evident fecundity of motion and potential, thick with life – and a small grey drawing of a desolate, war-shredded field with a bare-branched tree. The one word that summed up all that war meant for Gillies was 'waste'.

Just as J.D. Fergusson and S.J. Peploe had gone to Paris before the First World War, after it, both Gillies and Maxwell went there the 1920s, Gillies

studying with Andre Lhote, Maxwell with Leger. Both dabbled with Cubism but rejected it, and both became aware of Hugh MacDiarmid's modern Scottish Renaissance centred in Montrose in the same decade.

When the Edward Munch exhibition first came to Edinburgh the early 1930s, it was a revelation. The young William Gillies was bowled over by the work of the great Norwegian. This meant swimming against the tide of public opinion as the Munch exhibition was greeted with outrage in letters to *The Scotsman*.

That there was serious hostility to Modernism in Scotland wasn't in doubt following the scorn heaped upon Peploe's paintings on his return from France in 1913 and this climate of negativity persisted throughout the 1920s. The architect Robert Hurd (1905–1963), who later became President of the Saltire Society from 1943 to 1948, was one of the few who defended Munch's paintings. In a letter to *The Scotsman* (18 December 1931), Hurd concluded: 'The critical opinion recently displayed has indeed brought to the surface an unconscious narrowness of vision that seems to increase within us alongside the growth of that provinciality which threatens to make Scotland in some ways the most backward and philistine country in Northern Europe.' For Gillies to respond to Munch's work in the way he did and travel to Norway in 1932 to seek further insight into Munch's world tells us a great deal about his radical intentions and his position as a modern artist.

No major Scottish artist after Mackintosh was really able to connect with that central European, German-Austrian axis of what was happening in Berlin, Vienna and Prague: Expressionism, the *neue sachlichkeit* movement, the Bauhaus, the meshing of art and politics during the Weimar Republic. That was pretty much unknown in Scotland. Paris and France still remained the first port-of-call for Scottish artists venturing abroad, although by the mid-1920s, Berlin had become the centre for Modernist music (both composition and performance), for Expressionist art, theatre and film.

When Hitler came to power, most of the leading German artists emigrated to the USA, where they became hugely influential in the reshaping of western art after the Second World War. Because of its newly acquired superpower status, American cultural values dominated all over the world. Those German émigrés based in the USA – Gropius, Schoenberg, Bruno Walter, Beckmann, Albers, Thomas Mann, Adorno, Kurt Weill, Billy Wilder, Fritz Lang – all assumed leading roles within this cultural hegemony, paradoxically bringing about what was in effect the triumph of German Modernism. In Scotland, we missed out on all of that. And it took years to find out about it.

Immediately after seeing the Munch exhibition, however, new expressive tendencies became readily apparent in Gillies' work in both watercolours and

oils. Similarly, seeing the work of Paul Klee in 1933 had an immediate effect upon Maxwell. But there was also Scotland itself.

Just as Fergusson toured Scotland in the 1920s, Gillies and Maxwell together went on painting trips around Scotland throughout the 1930s, Gillies in his kilt, driving cars and motor bikes with a strengthening appetite for seeing. Georgia O'Keefe and her American landscapes are comparable. As Nancy Durrant said in *The Times* (July 5, 2016): 'The picture that emerges from a selection of her work, is of an artist whose intense love of her country's land underpinned everything, resulting in a body of work that is startlingly, authentically American.' We could claim the same for Gillies. He worked fast and produced painting after painting. Maxwell was the exact opposite: slow, careful, considered and pondered. Both were joined in firm friendship while diverging completely in their visions.

Both the friendship and the different visions come through powerfully in the exhibition. For Gillies, after the First World War, Scottish landscapes are of paramount importance. There are four big watercolours on show here, mountains and seas around Skye, epic in scale yet with nothing flashy or merely excessive: they are full of subtlety, nuance, movement. Others seem to occupy an almost Ibsen-like territory of foreboding, dark values, impositions. He paints trees and forests as though they are symbols of a psychological state, a place of continual conversation, like endless running water or evolving clouds. Mood inhabits all his works. After the Second World War, he predominantly produces still life paintings, marvellously arranged dynamics of colour and shape, texture and structure. Each is an indoor adventure in colour and form, with the outdoors visible through windows or doors. The only painting that doesn't seem to hold together in full coherence includes his mother and sister, as if the presence of people disturbed the authority of mood and objects.

For Maxwell, by contrast, symbol and dream motivate and propel the vision. Even the vase in the *Yellow Flower Piece* (1953) is covered with symbolic figures. People – in strange, dream-like garlands of flowers, with birds and animals around them – or latterly moths and butterflies, sinister-looking birds, sleek and streamlined, moving through thickly coloured air, all speak of a thoroughly different sensibility. He provided the frontispiece and cover illustration for *So Late into the Night* (1952) by the poet Sydney Goodsir Smith. In Maxwell's personal copy, Sydney's inscribed dedication reads: 'To John Maxwell / a poet in paint'. This was also John Berger's view in his *New Statesman* review of Maxwell (27 March 1954). The subtle eroticism of Maxwell's female nudes reinforces the sense of allurement and depth. Arguably, Maxwell remains more of a mystery, while Gillies, though we think we know what he's doing, inhabits

something of that mystery too. The psychology of landscapes, the working of inexplicable myths, figures, animals, life-forms, household objects, the internal and external forces at work in human seeing – all these are the material of the art of both men. And at different points of the compass from Alice Neel's social world. If Neel has her affinities with Bertolt Brecht, the modernisms of Debussy, Joyce, Rimbaud and the studies of Freud are the intellectual contexts for Gillies and Maxwell.

Both began teaching at Edinburgh College of Art from the late 1920s onwards. In 1935, Maxwell's big mural 'Children's Games and Amusements' was completed at Craigmillar Primary School, Edinburgh. In 1939 Gillies moves to the village of Temple, 14 miles south of Edinburgh. From here he could commute to the Art College and guests could visit easily.

Now a crucial event took place which has lasting importance for art education. Along with David Talbot Rice, Professor of Art History at Edinburgh University, Gillies introduced a new 5–year Degree Course combining studio practice with art history. This course helped practising artists gain knowledge and see into the history of their art, internationally and nationally, while encouraging them to work in their own distinctive ways. Sadly, the other art schools in Scotland either ignored or declined to follow this pioneering example and we now find ourselves in the deplorable situation where almost all students, after a four year course in Fine Art, graduate with little or no knowledge at all of the history of their subject.

And Gillies faced difficulties from the incoming ECA Principal, Englishman Robert Lyon, whose failure to comprehend why Scottish artists looked to Paris rather than London was a source of constant tension within the College. Gillies proved more than a match for him but the problems generated were painful. We could link this with a story recounted by Stanley Cursiter in his memoir of S.J. Peploe which took place at the annual examination of diploma work by the English external assessor Philip Connard RA in 1934: 'He [Peploe] was in great form, acute in his comments and occasionally outrageous in discovering unexpected qualities, leading the assessor up on questionable slopes and keeping the judging out of too obvious conventional ruts.' Once again, we are talking about examples of high ranking Directors of our cultural institutions arriving from England without any kind of knowledge of Scottish art or culture.

Gillies became Head of Painting in 1945 and Maxwell worked alongside him before returning to Dalbeattie to paint full-time. Working at the College made them influential and they might seem like establishment figures. Not so.

Maxwell died in 1962, leaving in his will instructions that Gillies should select from his estate which works should survive and which should be destroyed.

Gillies died in 1973, after receiving public honours and major retrospective exhibitions but this is the first time in more than 20 years that their work has been shown together.

In assessing their work today, and their legacy, we can see that both produced paintings of real stature. We can also see they were masters in the deployment of colour. Indeed, their paintings are more realised and with a greater range of painterly sensibilities than those of the Scottish Colourists. The paintings of Gillies, especially, possess not just the look of Scotland, but articulate the deeper urge to put Scotland onto the canvas, tangible and exact. It's a startling and profound accomplishment.

In the 1930s a serious debate about modern art and nationalism was taking place in Scotland culminating in a huge exhibition of Scottish art in the Royal Academy in London in 1938. In the book accompanying that exhibition, *The Arts of Scotland*, John Tonge begins with a chapter on the Celtic and Mediaeval legacy before launching forth on a brief historical overview of Painting, Architecture, Sculpture and the Plastic Arts, and the crafts: Furniture, Ceramics, Metalwork, from the 17th century onwards. He brought the story right up to date with mention of both Gillies and Maxwell: 'Edinburgh is once more a centre of experiment. Of the youngest generation, William Gillies, who brought back new ideas from the studio of André Lhote, and John Maxwell, who worked in the studio of Fernand Leger, have added to the liveliness of the capital.'

The St Andrews-based art historian Tom Normand, in his book *The Modern Scot: Modernism and Nationalism in Scottish Art 1928–1955* gives us the following outline of events: 'With the foundation of the National Party of Scotland in 1928, Scottish intellectuals began to consider the nature of national identity and the characteristics of a national art. The Scottish Renaissance Movement, under the voluble leadership of Hugh MacDiarmid, set out to articulate these interests, developing a vernacular poetry and literature. For Scottish artists the way forward was harder to identify, as they fought to reconcile the demands for a Scots national art with the stylistic revolution of international modernism.'

The importance of Tonge's book is that it set out to recover the history of Scottish art and rescue it from charges of provincialism. In this respect there was a real attempt to establish a meaningful tradition, tracing a lineage setting Scottish art firmly within a European context. The book, now long out of print, remains a crucial text for us today. If culture is to form part of a renewed independence campaign as it must, it's an excellent place to start. But first, see and study closely the great works in this exhibition.

Joan Eardley (Part 1)

Alexander Moffat and Alan Riach (Friday 3 February 2017)

THE MAJOR EXHIBITION 'Joan Eardley: A Sense of Place' at the Scottish National Gallery of Modern Art (Modern Two) in Edinburgh was the most detailed and informative presentation of the work Eardley addressed to the two essential subjects or locations to which she devoted her creative life: the children and tenements of Townhead in Glasgow in the 1950s and, simultaneously, the north east coast fishing village of Catterline and the seascapes around it.

The contrasts are forceful: it is almost as if we are looking at two different artists. In the Catterline paintings, there are no children, hardly ever any people, and in Townhead, no sense of the landscape or cityscape as panorama, no sense of the horizon opening. In the Catterline paintings, natural energy occupies vast space; in the Glasgow ones, it occupies small living people in enclosed places.

Eardley came to Townhead as an observer, studying, sympathising with, and catching, in energy and line, aspects of what she saw, but in Catterline, she was much more an inhabitant, a resident. On the coast, she identified with the forces and energies as present tense. She's an insider. This partly explains the differences made manifest in this exhibition. It's helpful to begin with that sense of contrast or even dividedness, rather than the idolisation of the role of star-artist 'celebrity'. Eardley was the exact opposite of the celebrity artist but unfortunately part of the publicity that seems to be required in the current climate overemphasises her iconic status. Let's put that aside and look at the paintings.

In the present exhibition and reproduced in the catalogue, the maps of Glasgow showing exactly where her studios were and the locations of the streets and city co-ordinates, are helpful. The cartographic detail complements the depths of feeling at work in the paintings, and they help us see something about Glasgow at that time which previous Eardley exhibitions only suggested. It's utterly shocking to be reminded that within 50 yards of the City Chambers in George Square, stretching up to the Cathedral, there was a huge slum area, bang in the city-centre.

With the maps of Catterline, we get a specific geographical sense of where she started working in an old Customs & Excise workhouse, and then of where she went, renting another cottage and then buying another one. We're given an overview of the village and more than that, a sense of what her perspectives were within it, from one place to another, moving through a fairly limited space and along quite narrow routes, and around a small piece of coastline, over about a quarter of a mile, but going up and down from hillcrest to seashore, from the fields opening out behind to the tightly-packed rows of buildings along the roads, to the bay below and the prospect of the tidal world out there, its 'long, withdrawing roar' (in Matthew Arnold's phrase) or inexorable rushing in.

In the 1930s, at the Glasgow School of Art, David Forrester Wilson was Head of Painting. According to David Donaldson, Forrester Wilson did not suffer fools gladly and was quick and severe to reprimand any sign of distraction from the serious business of painting. Donaldson said he himself was once hauled up to Forrester Wilson's studio and told in hard terms how important it was to be disciplined, to learn, how to paint, and what it meant to be an artist. Nothing frivolous here. No circus. This was your vocation.

In the legacy of that, Eardley arrived from London in 1940 in her late teens. She entered an art world with its own dynamics and legacies. Robert Colquhoun and Robert MacBryde had just graduated before the Second World War and were in the process of developing their quasi-cubist, Picasso-esque works while at almost exactly the same time, J.D. Fergusson returned from France to Glasgow in 1939. Polish-born artist Josef Herman arrived in Glasgow in 1940, having studied in Brussels through the late 1930s. And again, David Donaldson pointed out that at that time, 'We were looking to Brussels, not to Paris.' In other words, Paris was for aesthetes and fops, too much colour and too much light, when what was needed was a sense of the reality of the industries and coal-fields, working people, what conditions really were. The message was, 'We know what working people do, and are, and we're not confined to the salons and drawing rooms of the bourgeoisie!' Colquhoun and MacBryde's 'epic drabness' (the phrase comes from a *Listener* review by Wyndham Lewis) was perhaps the essence of this new aesthetic, emerging during the years of the Second World War in Glasgow, and it was this that Eardley walked into when she arrived. That was her milieux, from then on.

She was not alone. Edwin Muir, in *Scottish Journey* (1935), described a Scotland chillingly familiar when it was republished in 1979. T.C. Smout wrote an introduction to the new edition which ended like this: 'The question which exercises the planners in relation to Glasgow (after several failed attempts) is still, in Muir's words, "How is this collapsing city to be put on its feet again?"

The Scottish identity is still as Muir described it, that of a lethargic and divided people, quick to resent a trifling insult but incapable of action to remedy their plight. What other conclusion is possible, when, given the chance to obtain a legislative assembly [in 1979] for the first time since 1707, 32 per cent of the electorate said yes, 30 per cent said no and 38 per cent did not trouble to vote at all. It is still a country of nationalists with no clear or noble social purposes, of a Labour party with no vision except the retention of power, of Conservatives who know exactly how to play on the people's fear of change, and of drinkers who wrap themselves "in the safe cloak of alcohol". Muir held up a mirror to the face of Scotland 45 years ago. It is frightening to see so many recognisable features lingering in its glass.'

The Glasgow Muir wrote about was not so distant from the city Eardley arrived in. Muir described it in horrifically vivid terms: 'I have been told of slum courts so narrow that the refuse flung into them mounted and mounted in the course of years until it blocked all the house windows up to the second-top story and I have been given an idea of the stench rising from this rotting, half-liquid mass which I shall not reproduce here. I have been told of choked stair-head lavatories with the filth from them running down the stairs; of huge midnight migrations of rats from one block to another; and of bugs crawling down the windows of tram-cars. All these things, I have been assured, are true, and no doubt they are, but I shall not enter into a competition with the narrators of horrors of this kind for the appetite of moderately well-off and quite well-off people for these infamous morsels is one which has no connection with the sentiment of pity but is likely to check rather than induce it, creating disgust in its stead. Disgust is the coldest of human emotions, colder than hatred because more self-centred. If one hates the slums one may do something about them; but if one is filled with disgust of them there is nothing but to turn away.'

Yet the world of Eardley's Townhead children in the 1950s was not Muir's 1930s squalid, lurid, stench-sated and rot-packed Glasgow; nor was it epically drab. Eardley fused her subjects – not so much the city itself as the children – with dynamite energy. The paintings fill you with neither disgust nor hate but wonder at their liveliness, the colour, edge and fizz of the kids themselves. Eardley's children command respect and encourage affection. Edwin Morgan's famous poem 'To Joan Eardley' highlights the way in which the 'living energy' in her painting and his writing, and originally in the living children, is present in life and can be imaged in art, a permanent assertion of human potential.

But there is a liability. The temptation to read these paintings only emotionally, or only romantically, is real. If individualism is a key facet of the Romantic movement, it applies here, beautifully: each child is strongly individuated.

Collectively, they are a group but never depicted 'en masse'. They are never mere statistics, but this comes at the expense of a collective sense of the economic deprivation of their lives.

As a centrally-located city artist, her subject matter, the children of the dilap-idated tenements, came to her. She didn't have to search it out. She is quoted in the exhibition catalogue, writing in a letter that it was 'so easy to get the slum children to come up...' They were enjoying themselves acting as Eardley's mod-els, and she was enjoying her work, drawing and painting them, unstoppable, efflorescent, expressive. Her productivity was profligate. They were all having fun. In a BBC radio interview from 1963, she said: 'They are completely unin-hibited and they just behave as they would amongst themselves. They almost seem not to notice I'm there. The Samsons, they amuse me, they hardly notice me, they are full of what's gone on today: who's broken into what shop and who's flung a pie in whose face – it just goes on and on.' She concludes 'they are Glasgow – this richness that Glasgow has – I hope it will always have – a living thing, intense quality – you can't ever know what you are going to do but as long as Glasgow has this I'll always want to paint.'

Yet that didn't blind her to the facts. In a letter to her mother from 1951, Eardley wrote: '...my work is among the towny things, particularly places like the tenements which are around my studio. I know that now much as I love the country and country things my work does lie in the slummy parts – unfor-tunately.' And her feelings about Glasgow were mixed. In a letter written in Catterline to Audrey Walker probably from 1957 she says: 'I'll try and not be too complainy, when I do eventually have to contend again with that nasty place Glasgow.'

Pause for a moment and give some thought to another artist, Hilda Gold-wag (1912–2005), a Jewish refugee from Vienna who was painting Glasgow in the 1950s and 1960s, so exactly contemporary with Joan Eardley. It would be revealing and rewarding to exhibit their work together. Studying Goldwag's paintings alongside Eardley's is illuminating. Goldwag is clearly more deeply embedded in the European tradition and, coming from the city of Klimt, Schiele, Freud and Wittgenstein, as an outsider in Glasgow, she documents a city mov-ing from the old to the new. As well as people, she paints buildings, townscapes as designs, old tenements giving way to the modern. Goldwag's viewpoint is more objective than Eardley's, and Eardley's is more emotional and romantic. It's remarkable that Glasgow inspired both of these women as it did, and their work is complementary – this isn't a competition – but bringing them together highlights the contrasts between them and the limitations of each.

In an essay, 'Modigliani's Alphabet of Love', John Berger reminds us of something essential here: 'Only by considering a painting's method, the practice

of its transformation, can we be confident about the direction of its image, the direction of its image's passage towards us and past us. Every painting comes from far away (many fail to reach us) yet we only receive a painting fully if we are looking in the direction from which it has come. This is why seeing a painting is so different from seeing an object.'

Pause on that as you enjoy the paintings. These children, this Glasgow, the art gallery in which we study the canvases, are a long way from the city itself in the 1950s. We need to negotiate that distance to get a true sense of Eardley's value.

Eardley and Goldwag were both inspired by Glasgow, arrived in the city from different places and their work seems to go out in different directions, so our work, studying their paintings, means knowing their starting point. This isn't a critical diminishment but it helps explain why one is more modernist and the other more romantic.

And this is the crux of the matter. Eardley's great strength arises from this limitation, if that's the word: the limitation of a romantic vision. It sounds paradoxical, and it is, because if we're noting a limitation here we're also noting a potential power. Eardley's romantic vision becomes an enormous strength when she's faced with the right kind of challenge, standing on the shore, facing the vastness of the North Sea.

Joan Eardley (Part 2)

Alexander Moffat and Alan Riach (Friday Friday 10 February 2017)

JOAN EARDLEY'S ROMANTIC vision comes straight from Turner and William McTaggart, something both intrinsic to the energy of matter and the dynamics of life, exalted yet destructive, heroic yet costly. It will take your life indifferently. Your response to this is crucial: both accepting, and defying it, is essential.

The catalogue to the exhibition 'Joan Eardley: A Sense of Place' at the Scottish National Gallery of Art in Edinburgh tells us that, when asked, in 1961, she said she didn't much like Turner and didn't know much about McTaggart, and that regarding her immediate interests in the art world, she named Jackson Pollock and the Tachistes. It isn't surprising. The artist's job isn't to create a tradition in which she or he might comfortably settle, but to do the work. Certainly, the energy and painterly abandon of Pollock's American abstract expressionism and its European counterpart is related to what we see in the Catterline paintings, but how much more comforting, warmly settled, patterned to give pleasure, Pollock and his contemporary abstract expressionists are nowadays, when we return to them, compared to the still troubling, still imposing power of the real sea Eardley is delivering to us.

You have to get close to this dangerous energy to create anything worthwhile in art, but if you get too close, it can burn you badly. Hilda Goldwag, whose Glasgow paintings were previously mentioned, could never have painted the sea in such a way as Eardley because the constraints imposed by modernism, formalism, the priorities of control and planned futures, are everywhere in her work. These were aspects of the Europe she came from. They give her city paintings undeniable strengths. But for Eardley, a sense of abandonment is crucial. There is more to be said about this.

Where she came from is where we should go back to. Eardley was born on a dairy farm in Sussex in 1921, moved to Blackheath, London, when she was five, and her father committed suicide when she was eight. Her Scottish mother looked after Joan and her sister Pat while Joan attended Goldsmiths Art School

for two terms. In 1939, when she was 18, they moved to Auchterarder, near Perth in Scotland, then in 1940 to Bearsden, and she enrolled at the Glasgow School of Art. She met friends and mentors, including Margot Sandeman and Josef Herman, worked in 1944 as a joiner's apprentice in a small construction firm, and in 1947 spent time in London again, returning to study under James Cowie at Hospitalfield, Arbroath, and meeting her lifelong friend Angus Neil. There was an inevitable clash with Cowie and when she told him she was trying 'to tighten up a bit' in her drawing, he replied 'I'm very glad to hear it – this loose self-expression business is no good at all!'

From 1947–48 she won travelling scholarships and visited Italy: Florence, Venice, Assisi, and then to Paris. In 1949 she returned to Glasgow and set up her studio in Townhead. The story was about to begin.

Glasgow – indeed, Scotland – was in the doldrums in the 1950s. There was no overtly public political or cultural leadership to speak of, nobody with the authority and no institution with the profile to identify and champion radical new talent in a national and international context. Eardley's debut exhibition in a cinema foyer in Aberdeen (the Gaumont Gallery, in 1950) was also the occasion of her first visit to Catterline, so her double life, her career as a Glasgow, and also as an east coast painter, was simultaneous almost from the beginning.

By the mid-1950s it was obvious to anyone who encountered her work that she was a major talent, yet there was no chance of the Edinburgh Festival showing the work of a Scottish artist. There was no chance of a book being published to introduce or discuss its qualities and originality. If ever proof were needed about what happens in a country without its own politics, here it is: Scotland in the 1950s. With a culturally self-conscious and educationally enlightened independent government, what might have been done in that decade to promote the best things?

So the question arises, why didn't Eardley set off for London like so many others at the time?

Instead, she went north to Catterline. The exhibition catalogue gives us this description of what she was headed into: 'Catterline was predominantly a fishing village, although villagers also took agricultural work when need be. There were about 30 cottages, the oldest ones numbered from 1 to 24 Catterline, plus the Coastguard Buildings and the Station Officer's House. Many of the buildings and the pier were built by Viscount Arbuthnott, who originally owned the village. [...] By the time Eardley first visited the village, the fishing industry was in steep decline: a report produced in 1928 recorded that only 30 people lived there, while about 100 had been resident 20 years earlier. By 1928, only 11 fishermen remained, and almost all of them were over 50 years of age. The

report added that the future of fishing in the "quaint" village was under threat partly because of the cost of getting the fish to market, since the village was off the main road and had no train station. [...] Many of the little cottages had been abandoned and used for storage; some had bare earth floors. There was no mains electricity, gas or water in the village until about 1954–55, when the council built three cottages and a new school.'

In other words, the desolation and deprivation, the distance from a strong, working economy and a healthy social community was almost as great in Catterline as it was in Townhead, in Glasgow. No slums, but no shortage of hardship. But Eardley's response in her paintings was not primarily to the people or children of the place, but to the elemental realities it presented. Her early paintings of Catterline are relatively straightforward. She's painting what she sees and coming to terms with the space, curvatures, heights and depths. *Catterline Coastguard Cottages* (1951) and *Cornfield at Nightfall* (1952) are of this nature.

Eardley's friend Audrey Walker was a gifted violinist and Joan's favourite composers were Bach, Britten and Bartok. After art, music was her principal love. So is it fanciful to suggest that in the paintings you can 'hear' something of the epic exactnesses and energies of Bach, the modernism, common humanity, puzzlement and anguish in Britten and the jagged, challenging, yet deeply earthed and ultimately romantic spirit of Bartok? Britten's 'Sea Interludes' from the opera *Peter Grimes* look out on the same sea, a bit further south, deliver a similar chill and foreboding and energy in storm. All these composers are intellectually fierce but humanly immediately accessible and emotionally charged. Nothing arid there. It seems that the London critics thought that, because Eardley hadn't moved into abstraction like some of her more fashionable contemporaries, she was behind the curve. But if you keep the musical affinities in mind, you can see how irrelevant fashion, London critics and all such pontifications were – and are.

There are a trio of field paintings, *Seeded Grasses and Daisies* (1960), *Harvest* (1960–61) and *Summer Fields* (1961), which look back or take us back into the hinterland above the sea, behind the village. As with the late landscapes of Van Gogh, these paintings emit a fierce energy via the thickly painted surfaces, mixed with sand and earth, occasionally with flowers and grasses embedded in the paint. The artist's sense of struggle is vividly conveyed. Apart from the impact and immediacy of these landscapes, Eardley's response to nature is essentially a lyrical one, imbuing the paintings with a warm-hearted radiance. She is gauging the depths and distances, measuring the scope and resources of the earth itself.

In literary terms, maybe the closest analogy is Lewis Grassic Gibbon's essay 'The Land': '*That* is The Land out there, under the sleet, churned and pelted here in the dark, the long rigs upturning their clayey faces to the spear-onset of the sleet. That is The Land, a dim vision this night of laggard fences and long stretching rigs. And the voice of it – the true and unforgettable voice – you can hear even such a night as this as the dark comes down, the immemorial plaint of the peewit, flying lost. *That* is The Land – though not quite all. Those folk in the byre whose lantern light is a glimmer through the sleet as they muck and bed and tend the kye, and milk the milk into tin pails, in curling froth – they are The Land in as great a measure…'

Grassic Gibbon, as a novelist, engages with the people of this land, who, as he says, are the land itself as much as the earth and the weather upon it; Eardley, as an artist, doesn't engage with human character and narrative but turns and looks the other way, to paint the great seascapes: *The Wave* (1961), *January Flow Tide* (1960) and *Summer Sea* (1962).

These are the works that leave you breathless. It's difficult to say why without becoming pedantic, talking about technique, the clutch of the paint at grasses, blown straw, scraps of living things, or melodramatic, talking about the scale and overwhelming authority she is acknowledging here. Eardley, like Turner and McTaggart, both confirms and defies the authority of nature. This is maybe most apparent in the sequence of five small pastels, *Approaching Storm* (1963), tiny sketches on paper, each 20.1 x 25.3 cm, so not dependent upon the scale of the great seascapes, but equally urgent and dramatic in their rapidly executed depictions of cloud and sea. Once seen, these are permanently lodged in the visual imagination. They are works which remind you of an absolute imperative, as Wallace Stevens puts it in 'The Snow Man':

> One must have a mind of winter
> To regard the frost and the boughs
> Of the pine-trees crusted with snow
>
> And have been cold a long time
> To behold the junipers shagged with ice,
> The spruces rough in the distant glitter
>
> Of the January sun…

And this 'snow man', winter-minded, a listener, listening in the snow, 'beholds / Nothing that is not there and the nothing that is.' Stevens gets it right in another poem too, where he says, 'As part of nature he is part of us.' Who is 'he' here?

Call him – or her – the artist. Call the whole greatness of her or his work a recognition rare at any time, very rare today.

In his book, *Dear Sibelius*, Marshall Walker refers to the lines the great composer noted as the 'programme' of his tone poem Tapiola: 'Wide-spread they stand, the Northland's dusky forests, / Ancient, mysterious, brooding savage dreams...' and comments: 'But this is too picturesque; it domesticates their "magic secrets", diminishing the chill and the apprehension of colossal emptiness. Your wood-sprites are no kin to a mini-anthropoid Puck or go-between Ariel, they're spears of wind and shards of light glittering from icicles, reflected by snow-caked branches along interminable corridors of quintessential cold.'

Stevens and Sibelius evoke winter forests but Eardley turned to an even greater austerity, the sea. Yet Walker could as easily be talking of her work here: 'The music's an apotheosis of unpeopled nature. The sub-zero dynamism of Finnish Northland may terrify us – we may try to personify it down to the scale of human malignity by using words like "hostile", "savage" or "brutal" – but you understand that it's purely and impersonally itself, as far from considerations of human reason as the iceberg that sank the Titanic, the tsunami that devastated Aceh, the earthquake that killed 50,000 in Pakistan a few months later...'

That's what Eardley saw, looking at the North Sea off Catterline.

Part Three: Scotland's Music and Composers

National Music

Alan Riach (Friday 27 May 2016)

WHEN HUGH MACDIARMID wrote his series of articles *Contemporary Scottish Studies* for the *Scottish Educational Journal* in the 1920s, he addressed seven specific subjects: literature, language, literary and cultural criticism, music, art, historiography, and education. In this series of articles for *The National*, I've been concerned so far principally with literature and painting, so there's still plenty to talk about. But I should emphasise that for me, the core of it is three-fold: (1) poetry and literature, (2) paintings, sculpture and architecture and (3) music. Maybe music is the most important thing of all, encompassing every-thing, but thankfully we're talking here about a world where there is no need for competition, only an unencompassable and ever-changing treasury, a true currency. The question is how to use it well. So, following from that, I'd keep in mind three other areas of vital concern: (4) performance, which includes concerts, plays, dance, ballet, song (and sport), (5) newspapers, radio, TV, film and other media, all forms of public communication, and (6) institutions of education, including libraries, galleries and museums. Fundamental to all these is (7) methodology: how to, rather than what to. These seven areas of activity in the nation are always in need of review, investment and revitalisation. All health depends upon them. Which reminds me of Ezra Pound's essay, 'How to Read' (1929) and his little book, *ABC of Reading* (1934), both of which are essential, and for all that you'd want to disagree with, stay packed with good advice.

So far, so 'universal' but things do change and can be changed, which is why *The National* exists. Other examples help. After 1945, the artistic capital of the western world moved, or was moved, from Paris to New York. There were com-mercial and political interests in that as well as aesthetic ones. Concentrated effort by artists, museum directors and government to promote and disseminate Ameri-can art and culture began seriously at that time, taking on an extra urgency because of the Cold War. For composer/conductor Leonard Bernstein, a left-leaning liberal, the first native-born principal conductor of the New York Philharmonic, the issue was about American music and not primarily the defeat of communism.

As well as placing a large portrait of George Washington in the foyer of Lincoln Centre, Bernstein programmed a work by an American composer in every concert during his first season. 'My job is an educational mission' he told the *New York Times* a few weeks after his appointment. The coming season was to be 'a general survey of American music from the earliest generation of American composers to the present.' That opening season, 1958–59, was a turning point in the musical and cultural life of America.

In the 1970s, at concerts by the NY Phil, you would see an American Flag on the stage beside the orchestra. Its very presence was saying: 'We're an American orchestra! This is the best of America!' There are some who would recoil in horror at such chauvinism, but it's a far cry from Mr Trump, and there are times when it's right and proper to make such a point confirming cultural identity and self-confidence. And times when it's wrong. It happens regularly in London on the last night of the proms. The Elgar hijack.

So what if the flag were the Saltire?

James MacMillan may be hostile towards Scottish independence, but he is committed to a project in his native town of Cumnock in Ayrshire, the 'Cumnock Tryst'. Essentially, this involves school children having fun and getting involved in performing and learning about classical orchestral music. That's terrific. Recently, educationalists have emphasised that for children, music education and playing should be paramount in early learning. Playing is of far greater value than league tables and tests. The letters in *The National* of May 16 ('A step change in education needs a radical rethink') say so, and why. But in Scotland, this needs complementary work in concert programmes and adult exposure to classical music by Scottish composers of a wide range across centuries, because a lot of great Scottish music simply isn't in the repertoire.

A Culture Minister might take the initiative here. Think of a Scottish conductor/composer, a Scottish professional orchestra, getting together to do what Bernstein did in America: a general survey of Scottish classical music, embedded in the repertoire and explored sensitively, thoughtfully, over time: Robert Carver, John Clerk, Thomas Erskine, Alexander Campbell Mackenzie, Hamish MacCunn, John Blackwood McEwen, Frederic Lamond, Cecil Coles, F.G. Scott, Erik Chisholm, Ronald Center. There is much more than MacCunn's 'Land of the Mountain and the Flood' (excellent as it is). And there is an evident want for it. In 1992, the Edinburgh International Festival put on a series of concerts of Scottish music, covering a very wide range and ending with Mackenzie's *Scottish Concerto* which was received with wild applause. Something similar could be done every five years, at least.

In Scotland, there is a great champion of Scotland's music in John Purser. He broke open new ground, whole territories of enquiry and enjoyment, for the widest possible range of people, with his radio programmes, books, and his encouragement of new recordings of Scotland's music – from Bronze Age horns to full-scale major orchestral works from the 19th and 20th centuries, particularly. The first radio series in 1992 comprised thirty 90-minute programmes broadcast every Sunday afternoon, with a double CD selection from it and an illustrated book with an extensive discography. There was a revised series of fifty 30-minute programmes and a revised edition of the book with an extended discography in 2007. The books are currently out of print and the radio programmes difficult to find outside of the Scottish Music Centre, Candleriggs, Glasgow. They should be in every school in the country, and in use.

So much of the material has still to be brought into practice. Much of it, I imagine, is simply written off as negligible because it's Scottish. Yet literature and music and all the arts arise from the nation in which they are imagined and created. This is certainly the case with English music, especially at the start of the 20th century. Elgar was an inspiration from whom Vaughan Williams would learn, but do different things; Vaughan Williams himself had that role for Benjamin Britten. But the depth and character of their music, and its practice, is English. I love it. And maybe Vaughan Williams most.

It may seem paradoxical to introduce Scottish composers with reference to the writings of a pre-eminently English composer but it's salutary to consider how national history and aspects of character apply in other countries, and England is our neighbour, and English art and music has a significant bearing here. Vaughan Williams more than any of the three great modern English composers talks about this in his book, *National Music and Other Essays* (1963), where he says that 'the musical style of a nation' arises from the vernacular in poetry and the character of its speech. Therefore, he warns, 'English musical history is full of the tragedy of genius withering on barren soil... Many young British composers have been ruined by abdicating their birthright in their most impressionable years. Before they knew what they wanted to achieve, before they had learned, so to speak, their own language, they went to Paris or Berlin or Vienna and came back having forgotten their own musical tongue and with only a superficial smattering of any other.'

Now, Vaughan Williams himself went to Paris and studied under Ravel, but that was where he discovered his essential English character – in the same way, a little earlier, that J.D. Fergusson went to Paris and discovered his essential Scottish character (previously discussed in a former article in *The National*). After

travelling to France, they both returned to see anew and deeply the national languages each wanted to reaffirm and regenerate in their different arts.

The status of the arts is connected with the status of the nation in which they arise. An independent nation has its own independent arts, and this is seen clearly internationally. Ireland is a good example. Irish literature has an international status quite different from that of Scottish literature, although that has been changing because of the enormous range and the quality of critical and scholarly work that has been done and continues to be done on Scottish literature.

And it's just as true of England. Vaughan Williams again: 'When Stravinsky writes for the chorus his mind must surely turn homeward to his native Russia with its choral songs and dances and the great liturgies of its church.' He suggests that Stravinsky's *Les Noces* and the *Symphony of Psalms* will remain fresh and alive because of that Russian depth of attachment. He also notes this: 'Smetana, the recognized pioneer of Czech musical nationalism, received his first impulse from 1848, the year of revolution, when he wrote his choruses for the revolutionary National Guards.'

Vaughan Williams is scathing about the 'misguided thinker' who described music as 'the universal language' when even the most 'universal musician', Johann Sebastian Bach, built up all his work 'on two great foundations, the organ music of his Teutonic predecessors and the popular hymn-tunes of his own people': 'I am quite prepared for the objection that nationalism limits the scope of art, that what we want is the best, from wherever it comes. My objectors will probably quote Tennyson and tell me that "We needs must love the highest when we see it" or Rossini, "that they know only two kinds of music, good and bad."'

No, Vaughan Williams insists: 'It is because Palestrina and Verdi are essentially Italian and because Bach, Beethoven, and Wagner are essentially German that their message transcends their frontiers.' He quotes Dr H.C. Colles: 'A people's music grows in contact with the people's mother tongue, from the emergence of the vernacular in poetry and prose literature speech stamps its character with increasing decisiveness in the name of the music of that people.' Vaughan Williams comments: 'The roots of our language and therefore of our musical culture are the same, but the tree that has grown from those roots is not the same.'

It's just as true of writing. It's certainly true of all the major Scottish writers, from Dunbar to Duncan Ban MacIntyre, from Elizabeth Melville to Fergusson and Burns, from Violet Jacob and Hugh MacDiarmid and William Soutar to Liz Lochhead and Jackie Kay.

Democracy educates and education democratises. Otherwise, both fail. Anyone who has been deeply engaged in the works of great artists is changed by that experience, because great art has things that matter to give us. All great art is on the side of humanity. The ideals of democracy in the social structures that give access to the arts must be effected for the arts to realise that gift, and for people to receive it.

And this is keyed to national identity, in two respects. One is what rises from people, like water in the well; the other is what the state can do to help that nourishment circulate freely, in educational egalitarianism. This is why James MacMillan's work in Cumnock has to be supported, and needs to be extended, nationwide.

Vaughan Williams again: 'Mozart and Beethoven [were] nationalists just as much as Dvorak and Greig.' He speaks of himself as benefiting from Cecil Sharp's 'epoch-making discovery of English folk-song' thus aligning his own music with a rediscovered and regenerated English nationalism. Within this nationalist flourishing of rediscovered traditions, Vaughan Williams says, when you are talking of difficult work, the democratic purpose of your address to all people may be enhanced, if you talk to people with respect for their full human-ity: 'The people must not be written down to, they must be written up to. The triviality which is so fashionable among the intelligentsia of our modern musical polity is the worst of precious affectations. But the ordinary man expects from a serious composer serious music and will not be at all frightened even at a little "uplift".'

This was at the heart of the development of an American idiom in poetry in the 20th century, from Walt Whitman to William Carlos Williams and Allen Ginsberg. Williams shared Whitman's belief, as written in the last sentence of the preface to *Leaves of Grass* (1855): 'the proof of a poet is that his country absorbs him as affectionately as he has absorbed it.'

You could test that the other way, though: the proof of a country is that it absorbs its great poets as deeply as they have absorbed it. And by 'poets' we mean artists, composers, sculptors, writers and 'makars' of all kinds.

So the proof of Scotland as an independent nation will be its ability to hon-our by practice and knowledge all its arts and artists, and be open to, and learn from, all the best art and artists in the world, throughout history. And by 'Scot-land' here we mean the people of Scotland, the people who live here, the citizens of the nation, including all the people in government. We take our bearings from this place, opening out to the world.

So with that purpose in mind, the next three essays in this series will be written by John Purser, and focus on the triumvirate of great 19th to 20th

century composers, Alexander Campbell Mackenzie, Hamish MacCunn and John Blackwood McEwen.

We are apt to look on art and music as a commodity and a luxury commodity at that; but music is something more – it is a spiritual necessity. [It] cannot be treated like cigars or wine, as a mere commodity. It has its spiritual value as well. It shares in preserving the identity of soul of the individual and of the nation.

Ralph Vaughan Williams, *National Music and Other Essays* (1963)

Scotland's Music: Alexander Campbell Mackenzie

John Purser (Friday 3 June 2016)

IT IS NOT usual for a 10-year-old lad to be taken by his father to study music in Germany and, on being left there in the ducal town of Sondershausen, told that he will never see his father again.

That was what happened to one of Scotland's greatest composers and one of Edinburgh's most distinguished and unacknowledged citizens, for his father was ill and knew he was dying. Was it cruel of him to leave the lad alone on the edge of the Harz mountains, apprenticed to Kapellmeister Stein? No, it was not. It was a selfless gift of a future for a talented boy who rose to eminence in European music, admired by Liszt, Busoni, Hans von Bülow, Pablo Sarasate and Edward Elgar; was knighted by Queen Victoria in 1895 and made Knight Commander of the Victorian Order by King Edward VII in 1922 and, to this day, shamefully neglected by his own nation. We may have a less enthusiastic opinion about these honours nowadays, but for a composer, and a Scottish one at that, they represented a level of recognition which, in his case, could not have been more thoroughly deserved. In fact I'm virtually certain that Mackenzie is the only Scottish composer ever to have made it onto a cigarette card – Wills's cigarettes to be precise, and the older readers amongst us will remember driving past the factory on the A8 east of Glasgow. But tobacco, just like the KCVO, has lost its cachet.

So when I write about the Scottish composer Mackenzie and you ask 'Who he?' I have to start pleading for your attention and listing all the famous people who thought well of him, down to a tobacco company. Sad.

I've been following Alan Riach's articles over the last weeks, with their focus, naturally enough, on the great and often neglected heritage of Scottish literature – and Alan has mentioned music now and again: but if you want to study neglect, then Scottish classical music is a classic example and, were it not for some (note this) London-based CD companies, the bulk of their major works would be unknown.

Don't get me wrong. This is not a piece of unionist propaganda. On the contrary: it is a call to arms for us to recognise and promote our own heritage;

but it is a sad reality that when I ask even the most aware of Scottish artists, in any medium other than music, to name a few Scottish composers, they can only name a very few, and some cannot name any. The same applies to the bulk of our historians.

It does not help one's street cred as a composer to be knighted, and it does one even less good to be Principal of a great musical institution such as the Royal Academy of Music in London. Mackenzie was its Principal for 36 years, and if you have ever sat an Associated Board exam in music, you may thank or curse Mackenzie for having made it possible, for it was he who overcame the rivalries between the principle music institutions of the time to establish an international standard still sustained today. As a result, Mackenzie is regarded as academic and old-fashioned when he was anything but.

As a student, he turned up unprepared for a piano exam and improvised a piece. The then Principal, Walter MacFarren, asked him what it was and Mackenzie declared it to be a Schubert Impromptu. It was no such thing, but he got away with it. His cantata *The Rose of Sharon* is based upon the only truly sexy book in the Bible – The Song of Solomon. Its presence in the Bible is usually explained as a kind of parable for the love of the Church for Christ and Christ for the Church: but Mackenzie got rid of that part of the libretto so that, in his own words 'any suggestion of a religious basis disappeared.'

Few have heard more than a few examples of this incredibly alluring and sensuous piece, and then only in specially commissioned broadcasts. It is a tragedy, for this is an expression of the most accomplished love. It doesn't suffer from the usual desperate strivings and endless struggles to reach a brief ecstasy: rather it is a consummate and relaxed engagement full of physical assurance and sweetness. No wonder the chorus masters of those days shied away from it. It offended their religious and puritan sensibilities. So if you have heard that Mackenzie was a musical conservative, think again.

Mackenzie was not a nationalist. He was born in 1847 and died in 1935, spending most of his life in England. His was not a fertile environment for thoughts of national independence. But in his music he was as proud as any Scot of his own country and her traditions. He knew those traditions intimately and frequently exploited them with sensitive intelligence in his music, often drawing inspiration from Robert Burns whose work as a collector and arranger Mackenzie himself continued, after his own fashion.

Mackenzie's dad was a violinist, both classical and traditional, who led and conducted the Theatre Royal orchestra in Edinburgh, where the young Henry Irving was building his acting career. The older Mackenzie was also the

composer of the tune *The Nameless Lassie* for his friend James Ballantyne's lyrics – a beautiful song recorded memorably by Kenneth MacKellar.

When Mackenzie's father died in 1857, James Ballantyne published a memorial poem:

> While Scotland mourns her minstrel gone,
> And all our breasts with sorrow thrill,
> Let's pray that his young orphan son
> In time his father's place may fill:
> And thus our country still shall be
> The home of simple melody.

Ballantyne added a note: 'Mr. Mackenzie's eldest son, a boy of ten years of age, inherits his father's musical talent, and is being educated in Germany.'

There, he was one of the first to become familiar with the music of Wagner and Liszt, then in the avant-garde of European classical music. Virtually orphaned, there was no money to support Mackenzie in Sondershausen, but such were his talents that he was supporting himself from the age of 11 as a second violinist in the ducal orchestra. When he eventually left Germany for Edinburgh and then on to study in London, he had to re-learn English – or perhaps one should say Scots, for he never lost his Scottish accent and was affectionately referred to as 'Mac'.

Mackenzie knew more than most about Scottish music and was well aware of the meanings of accompanying lyrics and their historical background. Here he sets us a still relevant musicological challenge:

> In 1847 many staunch Jacobites could still express themselves strongly . . . Poets and composers (such as Lady Nairne) had kept a fascinating tradition alive and the glamour of Scott was over it all.

> Incidentally be it said that the purely Jacobite melodies of that period have an unmistakable essence of their own and differ considerably from the rest of our national tunes. How this came to pass has always been an interesting puzzle to me.

J.S. Blackie dedicated his book *Scottish Song* of 1888 to the much younger Mackenzie, who was delighted to accept:

> I appreciate to the full the honour in being associated with one whose life has been devoted to his country's literature and music. I am eager and anxious

that Scotland should take her place among the musical nations, and within the last few years I have been led to believe that this hope will be realised.

> I do hope from time to time to add a little contribution to Scotch Music, I mean in this popular way and apart from the more elaborate work to which, of course, I am devoted.

By 'the more elaborate work' he means compositions such as the *Pibroch Suite*, *Scottish Concerto* and the *Scottish Rhapsodies*, works of astonishing beauty, power and humour in which he blends the traditional and classical with consummate skill, but equally proud to claim that

> A tune of my own, evidently so racy of the soil as to have been accepted as a genuine antique of long forgotten parentage, was innocently reproduced as such, and for some years I have enjoyed the pleasure of hearing myself played and whistled 'incog'.

In 1900 John Glenn dedicated his *Ancient Scottish Melodies* 'With Permission' to Mackenzie. But Mackenzie's interest in his native music was not exclusively home-grown. In his *The Life of Liszt*, Mackenzie notes:

> A firm belief in nationalism in music urged him to give an initial start or an additional impetus to it in every country. With prophetic finger he pointed to Russia's great future, and all the composers of that country, from Glinka to Tschaikowsky, enjoyed his help. But Grieg, Smetana, Saint-Saëns, besides many smaller men, had his personal aid and encouragement.

So Mackenzie was part of a Europe-wide movement which included the increasing use of 'vernacular' languages. Beethoven had studied the setting of Italian, but *Fidelio*'s libretto is in German, Brahms broke away from the convention of Latin for his *Ein deutsches Requiem*, and our own Hamish MacCunn pioneered opera in English. National musical characteristics were encouraged but composers were under no obligation to pursue them, though their works often betray a geographical and even national identity. This was Mackenzie's comment on the matter:

> Whether with exactness or not, it has been said that all through my efforts at composition the Scot keeps peeping out. If that be so, he obtrudes his presence either unwittingly or beyond control. When I did write in the Doric I meant it; and must have contributed more than nineteen works to its native list.

Nationalism does not mean chauvinism and, with the First World War, Macken-zie was far from being the only Scottish composer to be distressed by the cultur-al ironies of the situation. Helen Hopekirk, the virtuoso pianist and composer from Portobello, had studied in Germany: Fredrick Lamond (another virtuoso pianist and composer and son of a Glasgow weaver) also studied in Sondershau-sen, and was a favoured pupil of Liszt's and had been a champion of Brahms's piano music in Germany and Vienna: and Cecil Coles had studied in Germany alongside Richard Strauss, but died as a stretcher-bearer in northern France.

But all of that is a story for another day. Meanwhile, there is a simple per-sonal commemoration due to this great composer, so rich in lyricism, so skilled in orchestration, so giving in spirit; that he be accorded the fame and perfor-mance time that his music merits, for he represents for our nation, one of our highest musical achievements.

Mackenzie is sometimes described as being influenced by Elgar. If anything it was the other way round, as this kindly letter reveals. Mackenzie was a widower by then and Elgar used to send him fruit from his garden. Spacious days indeed.

Marl Bank,
Rainbow Hill,
Worcester.
22nd of April 1930
My Dear Mackenzie,
... I am seldom in London now as I have – for the last lap in the race – taken up my rest in my old town.

Here in 1881 'we' (!) produced *The Bride,* you as composer and myself a fiddler therein: I often pass the old hall where the performance took place & think over those spacious days & my pride & delight at being presented to you by Geo: d'Egville. And what a lovely work it was (& is) & how you startled & dominated us all & how proud we were (and are) of you & none more than your old friend

Edward Elgar

You can get several of Mackenzie's major works on the Hyperion label, including *The Scottish Concerto,* the *Violin Concerto* and *Pibroch Suite,* the overture *The Cricket on the Hearth,* the *Benedictus,* the music for *Twelfth Night,* the music for *Coriolanus,* the *Burns Rhapsody,* and the overture *Britannia,*

either as CDs or as downloads of complete works. www.hyperion-records. co.uk/ci.asp?c=C379

The *Pibroch Suite* was also wonderfully recorded by Rachel Barton Pine and the Scottish Chamber Orchestra on Cedille Records CDR 90000 083: the *Prelude to Colomba* (a major opera by Mackenzie) is on *Heritage & Legacy* RLPOLIVE RLCD301: *The Little Minister* overture is on *Overtures from the British Isles*, Chandos CHAN 10797: the glorious *Piano Quartet* was recorded by the Ames Piano Quartet on the Albany label, TROY910/11: the *String Quartet in G*, played by the Edinburgh Quartet, is on *Scottish String Quartets* Meridian CDE 84445: and *Scenes in the Scottish Highlands*, played lovingly by Ronald Brautigam, is on *Essentially Scottish*, Koch Schwann 3–1590–2 H1.

Scotland's Music: Hamish MacCunn

John Purser (Friday 10 June 2016)

IN MY PREVIOUS article, I protested that few Scots, even educated ones, could name more than one or two Scottish composers of so-called 'classical' music.

Hamish MacCunn would be one of those, and some might even be able to name his most famous work 'Land of the Mountain and the Flood'.

It's a powerfully evocative concert overture, very Scottish, and composed when MacCunn was just 18. Older readers might recognise the music as it was used for the BBC television series *Sutherland's Law* in the 1970s. Perhaps that explains why there are two full-length studies of MacCunn in print and none of Alexander Campbell Mackenzie or any of his other contemporaries.

But it does not explain why, on the centenary of MacCunn's death, that, as far as I know, nothing major is planned by any of our state-subsidised bodies to mark it.

The title Land of the Mountain and the Flood is a quotation from Sir Walter Scott's *Lay of the Last Minstrel* which MacCunn also set to music with decisively patriotic fervour.

> Breathes there the man, with soul so dead,
> Who never to himself hath said,
> This is my own, my native land!
> Whose heart hath ne'er within him burn'd,
> As home his footsteps he hath turn'd,
> From wandering on a foreign strand!
> If such there breathe, go, mark him well;
> For him no Minstrel raptures swell;
>
> O Caledonia! stern and wild,
> Meet nurse for a poetic child!
> Land of brown heath and shaggy wood,
> Land of the mountain and the flood . . .'

As far as MacCunn was concerned, there was going to be no last minstrel while he was around to do something about it. But MacCunn's greatest tribute to Scott was his opera *Jeanie Deans*, based upon *The Heart of Midlothian*. More of that anon. Meanwhile, here is how MacCunn started his brief autobiography, written for Janey Drysdale in 1913. Janey's brother, the composer Learmont Drysdale, had recently died and his sister worked hard to promote his and other Scots' music.

'I arrived at Greenock on the 22nd March 1868, at 15 Forsyth Street, accompanied by a twin brother, who was afterward christened William – I being labelled James at the same matinée . . . When we were six months old, the aforesaid William left me to complete the duet as a solo, there being apparently nothing but "tacet" for him after his piping little prelude.'

In this delicately laconic manner, was MacCunn covering up a sense of loss; a loneliness present throughout his life at the death of a twin brother? As a teenage music student in London he had felt his isolation deeply, hurt by the snobbery of many of the staff, and seeking from Hubert Parry – the only one whom he truly admired as a man and musician – a level of friendship and hospitality which Parry was quite unable to give, his wife being a bed-ridden hypochondriac. Drysdale, like MacCunn, was sensitive and even touchy. Drysdale fell out with MacKenzie and the Royal Academy of Music, and MacCunn fell out with the Royal College of Music, both in London. The two composers were of a younger generation, perhaps more socially radical, but also emboldened by the success of Mackenzie, Parry and Stanford – a Scot, Welshman and Irishman – who had worked their way into the heart of the British establishment.

Drysdale died too young to make his name but MacCunn's success was considerable. He had many commissions and his operas had extended seasons and toured the country. With the noble exception of Opera West and a revival in New Zealand, his outstanding contribution to the genre has not just been neglected, but ignored. *Jeanie Deans* has been described as a masterpiece and 'the finest serious opera of the late Victorian period'. Scottish Opera has yet to stage it.

MacCunn was the son of a Greenock shipowner. Greenock seems to have been a fertile breeding ground for composers – McGibbon, MacCunn and Wallace. Both MacCunn's parents were musical and their son wrote his first piece of music at the age of five. At 12, he was composing an oratorio, but it was left incomplete as he got more fun out of fishing and sailing. At 15, he won a scholarship to the Royal College of Music in London and there he stayed. He was a dashing young man who married the daughter of a Scottish painter, Pettie, who has immortalised him both as Bonnie Prince Charlie and as the victorious suitor

for a young lady who was the Petties' governess. The painting is called *Two Strings To Her Bow* and is held in Glasgow's Kelvingrove Art Gallery.

MacCunn was handsome and debonair, but if you're looking for a composer who can shoot straight from the hip, he is your man. Here he is in interview with George Bernard Shaw, who started off by asking who was MacCunn's favourite composer:

'You might as well ask me which I like best, my arms or my legs.'

Or did he (as was Wagner's practice) write his own words for setting to music?

'I have not the vocabulary. I can find music but not words. Besides, if I write the book, you will be expecting me to paint the scenery too, on the same principle.'

Finally, Shaw – aware he was meeting his match – wrote: 'I at last had the hardihood to ask Mr MacCunn for his notions of press criticism.'

'"I think," said the composer, fixing his eye on me to indicate that he felt confident of my approval, "that criticism, above all things, should not be flippant, because if it is, nobody respects it".'

What of MacCunn's musical style? Well, he could pull large tufts from Wagner's mane (for which he was criticised by an appalled Royal College of Music teacher). But alongside that is the rugged grandeur and heart-warming lyricism that speak most clearly through the broad Scottish inflections of his music, as broadly Scottish as are Wagner's inflections Germanic. In *Jeanie Deans*, MacCunn was able to blend the two. The plot is anything but Victorian. Scott's *The Heart of Midlothian* tells of Jeanie Deans' successful pleading for a pardon for her sister, mistakenly accused of murdering her bastard child. The love which led to that pregnancy and, ultimately to the reuniting of the lovers, is expressed with compassion and compelling intensity. When it was revived in Ayr, it moved Michael Tumelty, *The Herald*'s music critic to write that 'the music is frankly astonishing ... The act one duet between Effie and Staunton is not far short in its style and effect of the great Siegmunde and Sieglinde duet from *Valkyrie*.'

Jeanie Deans is not MacCunn's only opera suffering from inexcusable neglect: 'About 1895, the then Marquis of Lorne (now the Duke of Argyll) suggested to me that the old Celtic legend of "Diarmid and Grania" would make a good subject for an opera. I wrote this work, to the Duke's libretto, and it was produced, with much interest and excitement and success, at Covent Garden Opera House, by the Carl Rosa Company, on the 23rd October 1897 [...]. "Diarmid" had afterwards an extended tour in the provinces, remaining in the company's repertoire for some years. In 1898, Queen Victoria commanded a performance of selections from the opera at Balmoral.'

This is what the leading musicologist, Nicholas Temperley, wrote about it: 'It is a staggering piece of work for a British composer of only 29 writing in 1897. It shows that MacCunn was completely aware of all that was going on around him: the influence of Richard Strauss is considerable, and in several places the score anticipates Debussy's *Pelleas et Mélisande*.'

I can add to that, thanks to the fact that I was able to secure a recording of a substantial section of the work, specially made by BBC Scotland for my 2007 radio series *Scotland's Music*. But be aware that this required financing the scanning of the manuscript full score, the production and checking of parts – and the recording has only ever been heard on Radio Scotland. What the score reveals is not only music of great beauty, but of dramatic power, built into substantial structures with that directness of expression so characteristic of the man and his music. I have done what I can, but in the presence of such outstanding music, I remain ashamed that I have not been able to do more. For example, MacCunn composed well over 100 songs, including many of great beauty with settings of Burns and other Scottish writers, alongside many arrangements of Scots song. Like Mackenzie, MacCunn was steeped in the tradition, and the following opinion of 'The Broom O' The Cowdenknowes' is typical of the man: 'This is undoubtedly an air of one strain only. The editions containing the second strain, (simply a slight melodic variation of the first) and the interpolated bars at the end are certainly spurious and bad at that.'

MacCunn died of throat cancer in London in 1916, far from Greenock and Arran where he had met his wife and where he loved to holiday and to fish, and past which the clippers of the MacCunn shipping line had sailed. What he gave us was a triumph of musical self-confidence: an assurance that we can be who we are without apology. He was far from flawless, but he is glorious. Whisky and temperament, gold and mercury, they are there in the music as they were in the man.

Discography

Here is a list of MacCunn's music on CD or download. A special BBC Radio Scotland recording of excerpts from his opera Diarmid can be accessed at the Scottish Music Centre.

Songs: O Would That I Could See Again, I Will Think Of Thee My Love, Piano solo: In The Glen. *Scotland's Music*, Linn CKD 008

Orchestral Overtures: Land of the Mountain and the Flood, The Ship o' The Fiend, The Dowie Dens o' Yarrow, Opera: Jeanie Deans (excerpts), Oratorio: The Lay of the Last Minstrel (excerpt). *Hamish MacCunn*, Hyperion CDA 66815

Land of the Mountain and the Flood. *Encores You Love*, Halléhandord CD – CFP 4543

Six Scotch dances, Valse. *The Scottish Romantics* Divine Art CD 2–5003

There Is A Garden, It Was A Lass, O Where are Thou Dreaming, Soldier Rest, Madrigal, O Mistress Mine. Sae Fresh and Fair *Scottish Romantic Choral Songs*, REL Records RECD550

Highland Memories. *Scottish Orchestral Music* ASV WHL 2123

The two studies on MacCunn are *The Music of Hamish MacCunn*, by Alasdair Jamieson, from authorhouse, 2013; and *Hamish MacCunn (1868–1916) A Musical Life*, by Jennifer L. Oates from Ashgate, 2013.

MacCunn in his own words...

Just in case you're thinking that MacCunn's Scottishness was simplistic, here is what he wrote to Janey Drysdale in 1911 on the dangers of cultural narrow-mindedness:

They 'never seem to get much further than an enthusiasm for the too familiar "Scots wha' hae" order. Or else they incline the other direction of a rather useless and irrelevant insistence . . . on "snippets" of legendary particulars as to fairies, fairy beans, rowan trees, "bogles" & such-like, common to all nations whose commerce with Scotland & Ireland has fired the Celtic imagination. It is, perhaps, little wonder that, betwixt the heroic & melancholy splendour of "the Gaelic" as presented in Macpherson's "Ossian" and the domestic humans & incidents of Burns, the general public is quite in a "smirr" as to Scottish poetry & music generally.'

Scotland's Music: John Blackwood McEwen

John Purser (Friday 17 June 2016)

WHERE DO SCOTTISH composers come from? The answer is 'all over'. I could list them from Orkney to Sprouston, Skye to Glasgow, but of the three composers in this series, McEwen (1868–1948) was the one most clearly responsive to his birthplace. Mackenzie was Edinburgh born, MacCunn a son of Greenock, but McEwen was not just a Borderer; his music breathes the Borders as does no other, except of course the Border ballads themselves. McEwen's *Three Border Ballads* are orchestral – *Grey Galloway*, *The Demon Lover*, and *Coronach* – but he spent only a short period of his life actually in the Borders: perhaps that explains his longing for that country, so very much itself, and which he expressed movingly in work after work; including the *Solway Symphony*, and the string quartet *Threnody* which sets that ancient Borders melody 'The Flowers of the Forest' with such deep feeling and simplicity.

The Battle of Flodden, which 'The Flowers of the Forest' commemorates, was on the 9th of September 1513, 400 years before the outbreak of World War I. By April 1916 when McEwen composed his *Threnody*, 'The Flowers of the Forest' was being played over and over in memory of the many thousands of Scottish dead, and indeed, the dead of all nations. It is the tune that is played at the end of Grassic Gibbon's novel *Sunset Song*, the music printed in the book at his insistence. As for McEwen, at the end of his personal copy of the published score of *Threnody*, he wrote out the whole of Jane Elliot's poem by hand. The poem ends:

> *We'll hae nae mair lilting at the ewe-milking:*
> *Women and bairns are hameless and wae,*
> *Sighing and moaning on ilka green loaning –*
> *The Flowers of the Forest are a' wede away.*

The melody of 'The Flowers of the Forest' has a wide range typical of Scots song. McEwen's setting is marked *con espressione ma semplice* and it is accompanied by the simplest of pentatonic chords with heart-breaking dignity and infinite tenderness. Traditional musicians will only play this tune at funerals

and memorial services, which, in essence, is what the *Threnody* quartet is. It was dedicated to Dora D'Arcy whose husband was killed at Ypres in 1916.

What was happening in France must have had peculiar relevance for McEwen, who was deeply influenced by French music and literature and who had spent months in the Côte d'Argent recuperating from insomnia. There he composed his *Vignettes from La Côte d'Argent*, and his 'Biscay' Quartet – of which more below. What these works demonstrate is McEwen's vivid musical response to French Impressionism, and the connections between his music and visual art in general should be widely heard and exhibited. They were once – but not in this country.

When in 1993 the Van Gogh Museum in Amsterdam put on an exhibition of Scottish artists contemporary with Van Gogh, they also put on, in the museum, concerts of Scottish music, one of which was devoted to McEwen, Drysdale and Lamond, for which they invited me over, and another given over to songs by F.G. Scott, William Wallace (like McGibbon and MacCunn a son of Greenock) and McEwen. What could be more natural? So forgive me if memory has failed me and I am unable to point to anything remotely equivalent in Scotland. How well would not Kellie (6th Earl of) go with Allan Ramsay? Or Thomson with Wilkie and Lauder? Or Mackenzie with McTaggart? Or...but the list is a long one so I'll close it for now with McEwen alongside Peploe and Cadell, never mind the French Impressionists.

Here is what McEwen had to say about being Scottish:

'I assume that the word "Scottish" applied to a composer has a significance which is more than merely geographical and that the musicians who are banded together under this designation have something individual to say and are able to say it in a way ... peculiar to their race, associations, and outlook.'

But how Scottish was McEwen himself? He was born in the Borders to a Calvinist minister but mostly reared in Glasgow and largely employed in London. Did he miss Scotland? Oh yes. None more than he. You can hear it as an ache in the heart in *Hills o' Heather*, for cello and orchestra, beautifully played by our own Moray Welsh, or in his last orchestral work, *Where the Wild Thyme Blows*, composed in Cannes in 1936, but totally and utterly in the Borders. This last realises such a sense of distance and nostalgia that it is almost impersonal: but McEwen had a strong notion of Scottish individuality, as he writes to Henry George Farmer in 1947:

'I think that there is something in the Northern attitude to life and its work and problems, that prevents the promotion and growth of any kind of "school" in which the works of one member are practically indistinguishable from those of his fellow nationals ...'

Individualistic and private McEwen may have been, but his music reveals a very great deal.

The underlying meaning of the last movement of the 'Biscay' Quartet is a delightful example, for which McEwen himself offered the clue. The work was composed at Cap Ferret near Arcachon, where McEwen was on compassionate or medical leave from the Royal Academy of Music where he taught under its Principal Mackenzie. The reason given was insomnia, but for insomnia I suspect one should read depression, for Arcachon in those days provided support for people with depression and other mental illnesses. In the case of 'La Racleuse', however, McEwen had most likely found a better source of recovery.

The racleurs were women who raked up cockles from the mud of the Arcachon basin, so they might not strike one as obvious subjects for musical portraiture; but McEwen's music is such a jaunty, affectionate and delightful portrait that I always suspected there was more to it than met the eye – for it surely meets the ear, with its swagger, cheek and tenderness. My suspicions were justified when I came across a note by McEwen about the three movements of the 'Biscay' Quartet, which reads:

'The titles [Le Phare, Les Dunes] attached to these are self-explanatory, although that of the last movement, "La Racleuse", bears a significance which is clear only to those who have personal knowledge of the region.'

Intrigued, I contacted the Alliance Française in Glasgow and got a reply from a native of the Côte d'Azur that in 1913 the term implied that La Racleuse's income was supplemented by an even older profession. The movement is stylishly French and beautifully textured; full of the melodic and harmonic wit which Poulenc (then a teenager) was later to pursue with such verve. What role La Racleuse might have played in McEwen's recovery is delightfully implied in the music and we need say no more about it.

Over the years I have had the chance to revive many wonderful forgotten works – sometimes even the composers themselves, also forgotten; but in the case of McEwen, the man we have all to thank is Alasdair Mitchell, supported by the Ralph Vaughan Williams Trust and the Chandos label. Alasdair not only wrote his thesis on McEwen; he brought out editions of major orchestral works and conducted and recorded them with the London Philharmonic Orchestra.

We have practically nothing recorded of major choral works by Scottish composers. No Mackenzie *Rose of Sharon*, no MacCunn beyond excerpts: but we do have McEwen's *Hymn on the Morning of Christ's Nativity*. It is a wonderful work which well deserves a chance to vary the Christmas diet of Bach or Berlioz or Corelli. The libretto is by John Milton, and McEwen has matched the mystery and dignity of this great religious poem with sensitivity and joy.

Religious joy? Yes, even we Scots can do it; even the son of a Calvinist minister. There are so many prejudices to wipe away. Alasdair wiped them away by rescuing this work (and others) from oblivion, reconciling differences between the full and vocal scores, creating parts and – wait for it – thereby directing its world première almost 100 years after its composition. McEwen never heard it.

I can't express to you on paper just how beautiful and subtle is McEwen's music – and also immensely entertaining. I often find myself thinking of him in relation to Robert Louis Stevenson. Drama, wit, and that subtle, gentle and yet probing irony of *The Child's Garden of Verses*, for McEwen too is capable of a deceptively light touch. His Piano Sonatina was composed for the Final Grade of the Associated Board piano exams; so it's for talented children, but it's as full of poetry, delicacy and humour as any of his larger works. He doesn't speak down to learners, he speaks up to them.

McEwen was to succeed his boss, Sir Alexander Campbell Mackenzie, as Principal of the Royal Academy of Music in London, and McEwen too was knighted. Please don't hold it against him!

His was a voice full of life but also full of thought and, above all, full of beauty.

McEwen's works on CD or available for download

Grey Galloway, The Demon Lover, Coronach. *McEwen Three Border Ballads*, Chandos CHAN 9241

Solway Symphony, Hills O' Heather, Where the Wild Thyme Blows. Chandos CHAN 9345

Hymn on the Morning of Christ's Nativity. Chandos CHAN 9669

Scottish Rhapsody 'Prince Charlie', (violin and orchestra version) Cedille Records CDR 90000 083

Violin Sonatas 2, 5 (Sonata-Fantasia) and 6, and Prince Charlie, a Scottish Rhapsody (violin and piano version). Chandos, CHAN 9880

Sonata in E minor, On Southern Hills, Vignettes from La Côte d'Argent, Three Preludes, Four Sketches *McEwen Piano Works* Chandos CHAN 9933

Four Sketches, Sonatina, Three 'Keats' Preludes, On Southern Hills, Five Vignettes, *The Scottish Romantics*, Divine Art CD 2–5003

Biscay String Quartet (1913). *Scottish String Quartets*, Meridian CDE 84445. Also recorded by the London String Quartet, Music & Arts CD1253.

Quartet No. 16 'Quartette provençal' in G ma, 1936; Quartet for Strings No. 7 'Threnody' in Efl ma, 1916; Quartet No. 4 in Cmi, 1905; 'Fantasia' for String Quartet, No.17 in Csh mi, 1947 *String Quartets volume 1* Chandos CHAN 9926

Quartet No. 13 in C mi, 1928; Quartet No. 3 in E mi, 1901; Quartet No. 6 Biscay, in A ma, 1913 *String Quartets volume 2* Chandos CHAN 10084

Quartet No. 8 in Efl ma, 1918; Quartet No. 2 in A mi, 1898; Quartet No. 15 A Little Quartet 'in modo scotico' 1936 *String Quartets volume 3* Chandos CHAN 10182

The Links O' Love, Weep No More. *Sae Fresh and Fair Scottish Romantic Choral Songs*, REL Records RECD55

Built for speed...

PERHAPS the most unusual musical portrait ever penned is that of McEwen's La Rosière of 1913. This was the name of a boat – but not just any boat. Forget the Franco-Scottish composer Erik Satie calmly sailing in *Sur un Vaisseau* which he composed for piano in the same year.

McEwen's portrait is of one of the new motor speed-boats, and in 1913 that was new indeed. The piece is for solo piano and it starts off on just one stave of music – but don't be fooled! It's fast and fiendish – very fast and very fiendish, and it clearly tickled McEwen's own fancy to the extent that he even published a photograph of La Rosière at the end of the piece.

I remember asking Kathron Sturrock to learn it up at the last minute for a BBC Radio Scotland broadcast, which she did with great panache. You can hear it splendidly recorded by the, alas, late Geoffrey Tozer on the Chandos label CD of McEwen *Piano Works*.

Frederic Lamond: A Soaring Talent that Wretched Poverty Could not Keep Down

John Purser (Friday 12 August 2016)

WHEN 10-YEAR-OLD Frederic Archibald Lamond was appointed as official organist at Newhall Parish Church in the east end of Glasgow, the organ stool had to be sawn down so his feet could reach the pedal board. The following year (1879) he became the organist at Lauriston Parish Church where the pay was better. That was important. His father was the choirmaster but his day job was that of a weaver and the Lamonds (Archibald and Elizabeth and their children Barbara, Archibald, David, Archibald, Elizabeth, Isabella, Margaret, Frederic and Charles) were living in dire poverty. But Frederic had the better of it compared with his older brother, Archibald, who when he was aged 10 had to take on work in the cotton mills.

Frederic's father had taught himself how to read music and how to play a clarinet, and then founded an 'orchestra' of flute, clarinet, trombone, two fiddles, cello and double bass. After the minister's initial scandalised response, the orchestra was allowed to accompany the singing in divine services. Needless to say, weaving took second place, and Frederic was ready to admit in his memoirs that 'years of bitter poverty followed' and that the family was 'wretchedly poor'.

As Lamond wrote: 'Trials and tribulations never come alone.' His eldest brother died from tuberculosis in 1870 and when his mother gave birth prematurely to Charles, she died shortly afterwards; so from the age of two, little Frederic Lamond had no mother.

Young Frederic was born in 1868 and as early as 1882 it was clear to everyone that he was already no mean oboist and violinist, but something of a child prodigy as a pianist. A committee was formed to raise the funds to send him to London for study, but that fell through and somehow the Lamonds scraped together enough for David, Elizabeth and Isabella to take Frederic to Frankfurt where they opened up a guest house to support him and themselves.

The selflessness of this action gives one some idea of just how highly musical talent and music itself was valued by them all – and we are talking here about

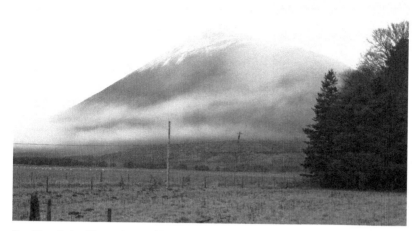

Ben Dorain by Alexander Moffat

The Birlinn by Alexander Moffat

The Scottish Chapbook (Photograph by David Riach)

The Modern Scot (Photograph by David Riach)

MacDiarmid and George Davie in Shetland (courtesy of Dorian Grieve and the MacDiarmid Estate)

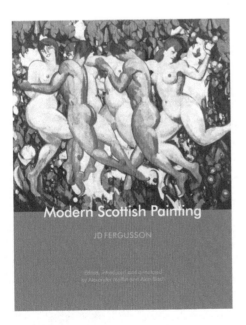

Cover of *Modern Scottish Painting* by J.D. Fergusson (Luath Press)

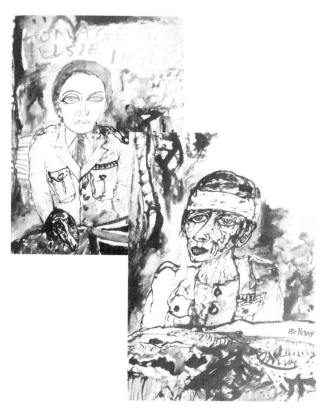

'Homage to Elsie Inglis' by
John Bellany and 'Wounded
Soldier' by John Bellany
(Courtesy of the
Bellany estate)

Alice Neel, 'The Subject and Me' (Instal-
lation, Talbot Rice Gallery, photograph by
Chris Park)

Catterline from the harbour
(Photograph: Ingrid A. Fraser)

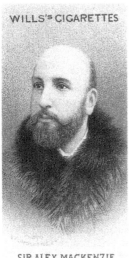

SIR ALEX.MACKENZIE

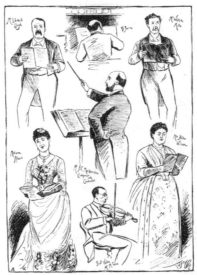

Wills cigarette card of Mackenzie (Collection of John Purser) and Mackenzie conducting in Glasgow by Twym (Collection of John Purser)

Hamish MacCunn by John Pettie

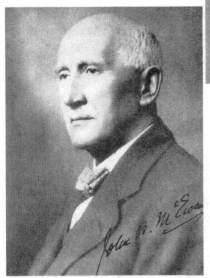

John Blackwood McEwen

Frederic Lamond by Twym, c.1905 (Collection of John Purser)

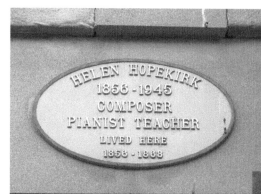

Memorial Plaque to Helen Hopekirk at 148 High Street, Portobello and Helen Hopekirk wearing a Celtic medallion, c.1910 (With thanks to Dana Muller and Gary Steigerwalt)

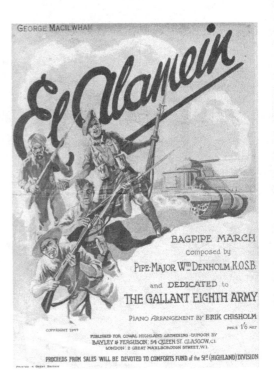

Cover of Chisholm's setting of El Alamein (Courtesy of the late George MacIlwham)

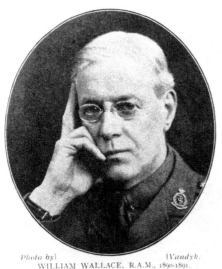

William Wallace c.1916 (Photo by Van Dyck)

Photo by *Vandyk.*
WILLIAM WALLACE, R.A.M., 1890-1891.

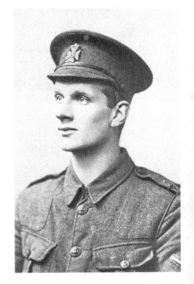

Cecil Coles in 1917, the year before he was killed near the Somme (Courtesy of the late Penny Coles)

A Drunk Man Looks at the Thistle and
Sangschaw (first editions) and *Northern
Numbers Third Series* (Photographs by
David Riach)

Standing Stones of Callan-
ish by Sandy Moffat

In front of Bankura University

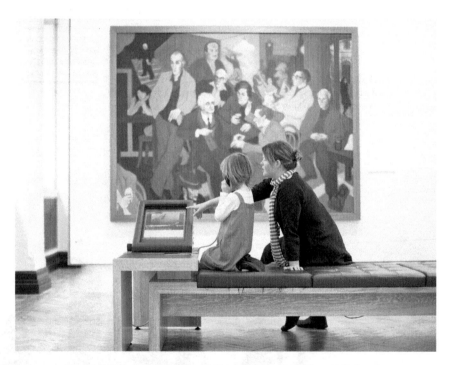

Poets' Pub and visitors at the National Portrait Gallery, Edinburgh

the works of Haydn, Mozart, Beethoven, Schumann and, soon also Liszt and Brahms. The Lamonds were not privileged Glasgow west-enders brought up in the expectation of learning to play the piano, going to public concerts and holding private ones: they had none of that. They made it for themselves and his brother David subsequently organised Frederic's debut in Glasgow.

In Frankfurt, Lamond was given an introduction to Hans von Bülow – one of the greatest musicians of the day both as pianist and conductor. Von Bülow already knew Lamond's compatriot Alexander Mackenzie and had performed in Mackenzie's piano quartet and conducted his music, so fine Scottish musicians were well known to him.

But young Lamond loved Beethoven's music and, in particular the famous *Opus 106*, the 'Hammerklavier' Sonata. When he told Von Bülow that this was the work he had prepared, Von Bülow scolded him for his impudence and told him to wait years before attempting such a piece, stamping his foot in indignation at the mere thought of it.

Three times Lamond insisted and the third time Von Bülow relented, and after he'd heard Lamond play the Scherzo, he didn't tell the 17-year-old never to darken his door again: he didn't tell him to go away and learn something better suited to his abilities: he told him to come back next time and play the opening Allegro, a movement of volcanic drama and power.

That says it all. If piano sonatas were mountains, *Opus 106* is in the Everest range, if not Everest itself, and one of the greatest musicians in Europe was telling this Glasgow lad that he was worthy of climbing it. A year later, in 1885, Franz Liszt asked Lamond to play the fugue from *Opus 106*. It is the final, magnificent, terrifying ascent. A year later again, when Liszt heard him perform the *Three Transcendental Studies, Liebesträum*, and the ninth *Hungarian Rhapsody* in London, he 'stood up and bowed to his young protégé'.

By the time he was 21, Lamond was so readily accepted into the inner circles of the greatest of German musicians that he was one of an audience of three for a first run-through by the Meiningen Orchestra under Von Bülow, of the third and fourth movements of Brahms' *Fourth Symphony*. The other two persons permitted to attend were the Landgraf of Hesse and Richard Strauss. Strauss and Lamond were often together thereafter. He was wonderfully pictured in those days by 'Twym' – the artist A.S. Boyd – Lamond by now a young man about town in evening dress with casually held cigarette.

Like Strauss, Lamond was also composing in his early days – but sadly only his early days. He started work on a Symphony in A around 1885 when he was 21. It went through at least two revisions before its publication in Frankfurt in 1893, and was performed at the famous Court Theatre at Meiningen where Lamond was greeted by the orchestra with a 'tushe' or flourish of trumpets and drums.

August Manns conducted it in Glasgow on December 23, 1889, and again at the Crystal Palace, London, in 1890. Lamond also started work on an opera, and there is an exciting orchestral overture, *Aus Dem Schottischen Hochlände*, and a *Sword Dance* as Scottish as they come and bursting with controlled energy. Both pieces are in Scottish-Germanic vein, dramatic, and composed with immense skill and confidence. They should be in the repertoire of many orchestras, never mind our own.

Smaller scale works include a Cello Sonata in D Major premiered by Lamond and Piatti in St James's Hall, London in 1889, and a B Minor Piano Trio (performed in Vienna in 1890 by the Quartett Rose) which has tremendous energy and command of texture. The eight *Clavierstücke Opus 1*, published in Leipzig in two volumes, are subtle and fluid studies in keyboard writing without a hint of the showmanship that Lamond could readily have employed. But that seems to be the sum total of his output, for Lamond devoted himself with the deepest artistic humility to the realisation of the works of others. He was one of the first to introduce Brahms to those parts of Austria and Germany still reluctant to accept Brahms' more classical approach as opposed to Wagner's greater radicalism. He created a sensation in Vienna by devoting one of his three solo recitals entirely to Brahms and when he met the great man himself, Lamond launched into a description of Scottish scenery as he remembered it from the Isle of Arran.

He had also met Tschaikovsky in Frankfurt and heard him perform, and it was at Tschaikovsky's request that he gave a performance of the *B Flat Minor Concerto* in Moscow at what turned out to be a memorial concert. It was in such circles that Lamond constantly moved, and his own great contribution was acknowledged by his appointment to a professorship in the Hague Conservatory in 1917. He gave master classes in Sondershausen, where his compatriot Alexander Mackenzie had studied some 50 years before and, in the 1920s, he regularly toured the United States, directing classes at the Eastman School of Music.

The University of Glasgow awarded him an Honorary Doctor of Laws in 1937, which made up for the hostility of the London press who resented his artistic preference for Germany. On that occasion, he gave the university the beautiful baton, originally given by Glasgow Choral Union in tribute to Von Bülow's conducting in Glasgow, and then given to Lamond by Von Bülow's widow.

The hostility of the London press was ill-placed. During the First World War, Lamond had briefly been imprisoned as an alien, but released because he was so highly respected. He did indeed live in Berlin with his Jewish actress wife, Irene Triesch, and gave a 70th birthday recital there in January 1938; but when fleeing the Nazis, he was stopped at the border by a Gestapo officer demanding to see his

passport. 'You can see it, but I will not allow you to take it into your hands' was the answer: and when asked was he an Aryan, he replied 'No, I am a monkey!'

On his return, Lamond was the first to give a public wartime recital in London on October 7, 1939. Later, having returned to Glasgow, he and his audience all had to run to an air-raid shelter just as he was about to start a Liszt recital. In 1942, the artist William Crosbie captured the spirit of the old man, his back to us and his leonine head bent over the keyboard, in a performance with the Scottish National Orchestra of one of the Beethoven piano concertos. Many commented that Lamond looked like Beethoven, but many more that he was unsurpassed in his interpretations of Beethoven. But no matter how good you are, there are always mean detractors. When Bantock told Lamond 'nobody in London is interested in you' and not to put on a recital again, 'your day is past and you would only lose money', Lamond was profoundly depressed. Fortunately for London, the manager of the Wigmore Hall told him not to listen to Bantock, and John Ireland said 'Schnabel cannot hold a candle to you in Beethoven'. Lamond went on to give 10 highly successful recitals.

Lamond died in 1948 at the age of 80. He was still teaching and was a strict teacher, 'very German in his outlook but he spoke with a broad Glasgow accent', as Mai Edmond told me. He was still fascinated by languages and immersed in learning Gaelic, but as with so many Scots of international standing, he was quite certain that had he stayed in Scotland he would have remained a church organist. How, I wonder, would he have fared today?

There is only one publicly available recording of Lamond's own compositions. It features the Symphony in A Major, the Concert Overture 'From the Scottish Highlands', and the Sword Dance, on *Lamond Symphony in A Major*, Hyperion CDA 67387.

The first book of Clavierstücke and the Sonata for Cello and Piano were broadcast by William Wright (piano) with Mark Bailey (cello). The Scottish Music Centre holds recordings of these performances.

The Memoirs of Frederic Lamond, was published by MacLellan in Glasgow in 1949. An excellent paper 'Frederic Lamond in Scotland (1940–1948)' by William Wright was published in French in *Quaderni 10 dell'Istituto Liszt* in 2011.

There are recordings of Lamond's playing readily available on the web, and listed in the Welte-Mignon Catalogue, and on piano rolls in the Animatic Catalogue, and you can hear him speaking, intelligently and movingly, about Liszt on YouTube.

Helen Hopekirk: Romantic, Poetic and Tinged with Gaelic Folk Music

John Purser (19 August 2016)

ABOVE THE DOOR of 148 Portobello High Street is a small commemorative plaque to Helen Hopekirk, placed there in 2006, the 150th anniversary of her birth on the 20th of May 1856. Who she? Just another forgotten Scottish musician?

Well, yes and no. Portobello remembered her with a mini festival: but it is thanks to two Americans, Dana Muller and Gary Steigerwalt, that something has been done to remind us of a truly remarkable woman both as pianist and composer. To both of them I am much indebted.

'Up-town' in Edinburgh, at 20 years old she played Beethoven's *5th Piano Concerto*, the 'Emperor', and was performing with her teacher Sir Alexander Campbell Mackenzie, whose piano music she was one of the very first to perform. That was 1876.

Her father was a printer, bookseller and piano retailer, and following his wishes shortly before his death, she travelled to Leipzig to study in the Conservatoire under Maase, Reinecke, Jadassohn and Richter, making her debut in the Gewandhaus in 1878, playing the Chopin 'F minor' Concerto. While there she also met Liszt.

'A meeting with Liszt, which took place in Leipzig while I was studying there, is one of the things that I remember with the greatest pleasure, as it showed his kindness of heart and sympathy with young enthusiasm ... I was then at the height of my Liszt fever, and hoped that I might some time study with him. One evening, as I was descending the stairs, I met him face to face – this man of whom all Europe was talking, and whose compositions I admired with a frantic admiration. The suddenness of the encounter surprised me, and I stopped short, breathless.

'Presently, however, I found my voice, and on my mentioning the name of Lichtenstein, who was an old friend of Liszt, he (Liszt) showed the utmost cordiality, invited me to come and talk with him, setting off at once, and evidently taking it for granted that I would follow. But my embarrassment had not entirely disappeared, and I continued to stand, stock still.

He turned, offered me his hand, and a little later, to my own vast astonishment, I found myself talking freely and confidently as to an old friend.'

Hopekirk made her London debut at the Crystal Palace under Manns in 1879, playing the second Saint-Saëns Concerto. In London she met Clara Schumann, Grieg and Rubinstein, whose playing she particularly admired and whom she recalled replacing the artificial roses in her hat with real ones from his table. While in London she also met the famous poet Robert Browning.

'I had always, myself, conceived there to be a close relationship between the poetry of Robert Browning and the music of Robert Schumann. One afternoon in London, I was playing at the house of Lady Mary Hamilton. I had just finished Schumann's *Kreisleriana*, that magic set of tone pictures, when a rather little man stepped up, and leaning over the piano commenced speaking in a most enthusiastic manner about the music. He evidenced an insight which, though he was evidently an amateur, astonished and delighted me. With all the ardor of youth I replied, and a rapturous discussion, a la Davidsbündler, was in progress, when up stepped our hostess, who said: "Mr Browning, won't you have a cup of tea?" You may imagine my astonishment, and, at first, consternation. But that is now one of my most treasured memories.'

In 1883 she performed under Henschel in Boston, again with the Saint-Saëns, and stayed in the US for three seasons, appearing in over 60 recitals and concerts. You might think that by now Hopekirk was well enough established not to require any further lessons, but she thought otherwise and in 1887 went to Vienna to study piano with the legendary Theodor Leschetizky who described her as 'the finest woman musician I have ever known'. In Vienna she also studied composition with Nawratil and played with the renowned Belgian violinist, Eugène Ysaÿe.

On the reverse of a cabinet card photograph, Leschetizky wishes Hopekirk 'a successful journey that will result in many, many dollars.' Hopekirk's description of her revered teacher is wonderfully revealing:

'Leschetizski is a small, very nervous, but kind-hearted man. It is true that he had fits of irritation. I recollect one occasion in the class when he became impatient and broke one of the strings of his instrument. He was sometimes very sarcastic, and always impatient of halfway work. But you would go far to find a more innately kind, considerate, generous man. From the majority of his artist pupils, he would accept no payment whatever.

As a teacher he laid especial stress upon artistic consciousness. He insisted upon the student knowing the why and wherefore of every technical combination, and how to apply such knowledge to esthetic interpretation. Technique was a means to an end. My first lesson was spent entirely in the demonstration of the various kinds of touch; my second in employing them in a Beethoven sonata.

He was a most illuminating commentator upon the music we studied. A passage in a Chopin nocturne was like the unfurling of a beautiful piece of exquisite silk. The slow movement of Beethoven's trio in D suggested thoughts of an old, stern castle in the midst of a battleground filled with grim reminiscences...Those were wonderful days.'

Hopekirk became an influential teacher in the USA, notably in the New England Conservatory from 1897 until 1901, when commitments to private teaching took over. She took US citizenship along with her husband in 1918, but in 1919 they returned to live in Scotland, expecting a musical renaissance which never took place. Like Lamond, she was better appreciated in other countries and continents, so a year later Helen and William were back in the US, living in Brookline, and she resumed her teaching and performing, though later affected by her husband's illness and death. For her last public appearance in 1939, she gave a recital of her own works in Steinert Hall, Boston.

As a composer, Hopekirk deserves much more attention. Her *Concertstück* was premiered by her in Edinburgh in 1894 and 1904 in Boston, and she premiered her *Piano Concerto in D major* in Boston in 1900. But the score and parts are missing, so her biggest work is lost to us. What we do have makes that loss all the more tragic. There are many lovely piano pieces, a fine early Violin Sonata and her songs were deservedly popular. They include outstanding settings of Heine's *Der Nordsee*, deeply thoughtful lieder with a quiet beauty and assurance which can stand comparison with the best in the genre. A little masterpiece of a song cycle – but few have heard it.

Hopekirk's music is romantic, poetic and graceful to play, and shows influences of Scottish folk music. She regarded folk music as an important element in musical education, and much admired the work of Marjorie Kennedy-Fraser.

In 1905 Hopekirk published her collection of Scottish Folk-Songs in her own arrangements. She also wrote a remarkable introduction, describing her memories of Gaelic singing.

'... As the song goes on, one is strangely moved by a subtle something - a wild irregularity of rhythm, something ancient, remote, more easily felt than expressed. The quaint Gaelic language, the old-world melodies, the quiet and pathos of the way of singing, are haunting...' Hopekirk's words may seem condescending: but hers was a very real respect.

'There are also queer little grace notes introduced between the notes of the melody. As a child I remember hearing a beautiful old Highland lady over 80 years of age sing Jacobite songs to her own accompaniment on an old spinet-like piano, with such a little, sweet, pathetic voice, and with so many of these little grace notes, that it has ever since been one of the outstanding memories of

my childhood. My maternal grandmother also had that quaint way of singing, and it used to be the pleasure of the church service to me to hear "Granny's graces" added to the decorous performances of the others.'

But now comes Hopekirk's sharp-edged criticism of the state of cultural affairs in Scotland at the time – this written over 100 years ago:

'Two influences have been powerful in stifling that impulse towards expression in music which has been for years the inheritance of both Gael and Low-lander. The first was the introduction of a hard, merciless Calvinism at the time of the Reformation. The aim of that seemed to be, not to "glorify God and enjoy Him" and His gifts of the beautiful "forever," but to glorify Him by despising these gifts as a sacred duty. Scotland is only now recovering from that blight.'

And if that were not enough, the following asserts a reality which is with us to this day.

'Another influence was the Anglicizing of everything Scottish since the Union – "girdling the world with Brixton," as George Moore expresses it. England brings material prosperity when she sets her foot on a lesser nation, but it is generally accompanied by a waning of interest in the real things, which are the inward things ...'

Enough said.

Where can I hear Hopekirk's music you may ask? Well, there are no commercial recordings available. However, here is a link to Gary Steigerwalt's performance of the *Concertstuck*:

http://www.unsungcomposers.com/forum/index.php?topic=6207.0

And also for the *Nordsee Lieder*:

https://www.youtube.com/playlist?list=PLp5_1nni9b7tl3_A5Xl-Bi2bk253bpYzN1

Two short pieces played by Philip Sear are also available on Youtube. A lecture recital, 'The Audacity of Hopekirk', including a performance of Hopekirk's song settings of poems by William Sharp ('Fiona MacLeod'), is available from the Library of Congress, Washington, at:

https://www.loc.gov/today/cyberlc/feature_wdesc.php?rec=6602

Hopekirk's papers are kept at the Library of Congress, Washington.

The woman's perspective

What was it like to be a female musician in 19th-century Edinburgh? Here is Catherine Jameson, writing in 1833, aged ten: 'I am fonder of music than ever. Oh! Had I a pair of ten league boots to carry me to Berlin to see yourself and hear the delightful music . . . Professor gave a grand concert on Thursday last

. . . I played two pieces on the Piano Forte, the first was a Concertstück by Weber with orchestral accompaniments . .'

The Weber is a decidedly difficult piece and to be able to even think of playing it in public at the age of ten is remarkable.

Then there was Robena Laidlaw (1819–1901). In her 'teens she performed in Berlin and Leipzig, and, in 1832, at Paganini's farewell concert in London; of which performance he wrote 'I shall never forget the prodigious effect she produced at my concert, and confess never to have heard that instrument [the piano] treated so magnificently'.

In June and July of 1837 she became intimate with Schumann. She was the dedicatee of his Fantasiestücke Opus 12: 'It is true I have not asked for permission to make this dedication, but they belong to you, and the whole "Rosenthal," with its romantic surroundings, is in the music.' The reference is to a walk in the Rose Valley when Schumann selected a flawless rose to present to her. Of her personality, he wrote: 'This artiste in whose culture are united English solidity and natural amiability, will remain a treasured memory to all who have made her closer acquaintance' and said of her playing that it was 'thoroughly good and individual'.

Following a tour in Prussia, Russia and Austria, Laidlaw was appointed pianist to the Queen of Hanover, but settled in London in 1840. In 1852 she married a George Thomson – a fellow Scot – and this put an end to her career.

Helen Hopekirk, on the other hand was lucky in her husband, who devoted his energies to furthering her career. She had married William A Wilson on 4 August 1882 but sadly he was injured in a traffic accident in 1896 and in the end Hopekirk's career changed from that of performer to teacher. Wilson is shown in a photo likely taken during Hopekirk's series of recitals in Chicago in 1886. Theirs was a happy marriage without issue, ended only by her husband's death in 1926. For her last public appearance in 1939, she gave a recital of her own works in Steinert Hall, Boston. She died in Massachusetts, in November 1945.

Erik Chisholm: The Pacifist who Made Music in the Thick of War

John Purser (Friday 28 October 2016)

THE THREE COMPOSERS I am going to write about now experienced war in very different ways. Erik Chisholm was a conscientious objector who, in any case, failed his fitness test and ended up working for ENSA – the Entertainments National Service Association.

William Wallace trained as an eye surgeon but alienated his father by abandoning medicine for composing. War saw him back as a medic, ending up in charge of all eye cases in Eastern Command during the First World War and, to the best of my knowledge, scarcely wrote a note of music after it.

Cecil Coles studied composition in Germany on a Reid scholarship, heard his music premiered in Stuttgart, and ended up as a band-master and voluntary stretcher bearer in France where he died of his wounds in 1916. His music only came to light in the 1990s through the efforts of his daughter, Penny, who had never known him.

But I am starting with Erik Chisholm because just this month a CD has come out of his opera *Simoon*. It is about war and it is all too relevant. Set in the 1890s in North Africa during the aggressive French colonisation of Algeria, the plot is focused on conflict between Muslim and Christian. It describes, with horrifying intensity, the use of psychological torture to drive a man to suicide. The libretto is a word-for-word translation of Strindberg's play Simoon. Neither Strindberg nor Chisholm takes sides.

Chisholm's eyesight was poor, so he started the Second World War painting white lines on pavements to guide people during the black-out. He made the best of it.

'When painting lines on steps and along the edge of pavements I lay on the paint as a musical stave – in five lines with four spaces between – and this gives me an advantage over the man who lives as it were only from line to line, doing what must be one of the most monotonous jobs in the world. Looked at in this way, our gang must have ruled enough five lines and four spaces to write the

complete works of Bach and Beethoven! . . . Nor can I complain that my life lacks variety – this morning, for instance, I was helping in blacking-out 1,200 large windows in a large building and now I am going off to rehearse my piano concerto with the Scottish Orchestra.'

You can hear his *Piobaireachd Concerto* on the Hyperion CD listed below. It usually takes governments a few months to realise that the arts are vital for morale in wartime, but they nearly all do in the end, so not only was Chisholm as soloist premiering his concerto in Glasgow, he was also commissioned by the BBC to write a work for children. The result was *The Adventures of Babar* for narrator and orchestra – a kind of parallel to Prokofiev's *Peter and the Wolf*. It was first performed by the BBC London Symphony Orchestra under Adrian Boult. It is great fun, and starts off with an amazing orchestral imitation of air raid sirens. Chisholm dedicated the piece to his middle daughter, Sheila, whose personal copy of Babar he dismembered in order to decorate the score. She never forgave him.

Then came a remarkable statement in the form of the ballet *The Earth Shapers*, in four scenes. In the Prelude 'Tir-na-Moe, The Land of the Living Heart', the Earth Spirit pleads successfully for help from The Shining Ones – Brigit, Midyir the Mighty, Ogma the Wise and Angus the Ever-young – to rid the world of the Fomors under their King, Balor of the evil eye. In the end the Gods refashion the Earth, with the Spear of Victory, the Stone of Destiny and the sound of Angus' magic harp promising peace and plenty in Eire.

This was potentially highly provocative. In the dark days of the Second World War, we have a ballet company in one of the combatant nations suggesting that regeneration will start in a country which was neutral, and much criticised for being so.

That it is the Republic of Ireland that is necessarily implied is indicated by the fact that at the end Brigit calls it 'the White Island, the Island of Destiny – Eire'. It seems clear, then, that something approaching a neutral, if not pacifist agenda, can be detected in this work, although the Fomorian enemy would naturally be associated with Hitler and the Germans.

But the ballet invokes Celtic, not Christian, Roman, Greek or British gods, to see off the evil with which the world is confronted. *The Earth Shapers* was premiered in Glasgow's Lyric Theatre in 1941. Much of its music migrated from Chisholm's Second Symphony (see below), and some of William Crosbie's designs for sets and costumes survive, including one which Crosbie entitled 'illness'. He was himself ill at the time, but so was the world.

Chisholm was also arranging a bagpipe march El Alamein, and going round army camps giving lecture recitals. Later he took charge of the Anglo-Polish ballet, touring with a piece called *Pan Twardowski*.

Chisholm hated it, and made it plain he did, condemning it thus: 'This horrible abortion, this balletic monstrosity, this unspeakable concoction of bits and pieces (set to the most blatantly plagiaristic and dully pretentious music it has ever been my misfortune to hear – by one Vladimir Launitz) has been dragging its slimy trail across England and Scotland for three interminable years, purporting, if you please, to be an example of Polish artistic endeavour at its finest.'

The Anglo-Polish Ballet was then posted to Italy, following the Allies' push north. Chisholm narrowly escaping being killed, the two lorries in front of his being blown up by land mines. When he got to Rome, he took the opportunity of visiting Alfredo Casella, whom he had invited to Glasgow in the 1930s and with whom he had shared a piano, performing Casella's Pupazetti.

Casella was a Fascist and a great Mussolini supporter, facts which did not prevent left-wing Chisholm from arranging for food-parcels to be sent to the Casellas from ENSA stores.

'Towards the end of World War II, when British and American forces occupied Italy as far north as Ravenna, I called on Casella . . . His wife opened the door and told me she was doubtful if her husband could see me as he had been ill, on and off, for the past two years.

'While waiting in the music room which was all but filled by two concert grand pianos, I noticed on one of them a large photograph of Mussolini signed by the Duce with the inscription "To my dear, devoted and loyal friend, Alfredo Casella." On the other piano was an equally large photograph of Roosevelt (signed by the President) and inscribed in words to the same effect, "To my dear, devoted and loyal friend, Alfredo Casella."'

At the end of the war, after a period in India and Singapore, Chisholm was appointed Dean and Professor of the Cape Town University Music Faculty, and Principal of the College of Music. He was also in charge of the Opera School and was able to compose operas knowing they had a good chance of performance.

It is one of these, *Simoon*, that deals with the effects of war upon humans at the most personal levels of hatred and mental suffering and which was released on CD this month. It is a stunning work: one which demonstrates why Chisholm is beyond doubt Scotland's leading modernist composer.

Creating an orchestra...

In November 1945 Chisholm was posted to Singapore where he founded the Symphony Orchestra: 'The authorities really wanted an orchestra there and were prepared to give me carte-blanche to get it. The Japs had just vacated Singapore and the Allied Authorities moving in had little enough transport for their

own official business, so in rickshaws and tongas I started to search the entire neighbourhood for orchestral musicians; within a week we had our first rehearsal and within a fortnight of my arrival in the country our first concert. I doubt if any such cosmopolitan orchestra has ever been assembled before or since.'

Amongst the soloists to perform with them was the great Jewish violinist, Szymon Goldberg, who had only recently been released from Japanese internment in Java. Fortunately he had been able to save his precious Stradivarius violin by hiding it up a chimney. Goldberg gave the world premiere of Chisholm's Violin Concerto recently recorded for the Hyperion label, with Matthew Trusler and the BBCSSO conducted by Martyn Brabbins. It is due out later in 2017.

The wind of conflict

Strindberg's one-act play dates from 1890 and is set in Algeria 'at the present time', a period of continuing brutal colonisation by the French. There are three characters; Biskra, an Arabian girl utterly consumed by a desire for revenge for the murder of a former lover; Yusuf, her present lover; and the Frank, Guimard, a lieutenant in the Zouaves. The Zouaves were a regiment, originally of native soldiers, fighting for the French. Guimard (who is French) is therefore an enemy.

Biskra knows that Guimard is approaching a sacred sepulchral chamber in the desert and will already be exhausted and disorientated by the Simoon, the strong, sand-laden, suffocating desert wind. She intends to use her magical skills to reduce him to such a state that he dies of despair and wretchedness. She persuades Guimard that his senses are totally confused and that he has rabies and cannot drink water though he is dying of thirst. She taunts him with false visions of his wife's affair with his best friend; then that his son is dead. She makes him lose faith in his religion, and believe that he has deserted his own troops. Finally, she shows him a skull, and Guimard, now utterly distraught, is persuaded that it is his own. Dead in his own heart and imagination, he dies in truth, and Biskra and Yusuf celebrate their triumph in music of compelling and awful power.

It is now half a century since the opera was composed, and well over a century since the text was written, but the opera belongs to the here and now. An invading power and religion are confronted by a fundamental resistance, merciless in its sense of justice. From Afghanistan to the Middle East, to North Africa and to Guantanamo Bay, and no doubt to places of which we have not even heard, such things continue with much the same motivation, much the same 'justification'. But neither Strindberg nor Chisholm takes sides.

Simoon does not come up with easy answers. Indeed, it does not take a stance. It simply gives powerful expression to powerful emotions and beliefs. What is achieved is a deeply disturbing insight into the kind of human motivation

that leads to torture (both psychological and physical), and murder in the name of religion and under the cloak of 'warfare'. There is horror in its beauty. It is a brave work, but it leaves judgement to others.

The list of recordings of Chisholm's music is a long one and best consulted at www.erikchisholm.com. Here is a selection. Erik Chisholm, Simoon, Opera, Delphian DCD 34139. *Chisholm, Piobaireachd and Hindustani Piano Concertos, Hyperion* CDA 67880. *Erik Chisholm, Symphony No.2. 'Ossian', Dutton* CDLX 7196. *Chisholm Pictures from Dante, Dutton* CDLX 7239. *Erik Chisholm, Music for Piano in 7 CDs, diversions* DRD 0222, 0223, 0224, 0225: *Dunelm ddv 24140, 24149, 24155. Songs for a Year and a Day, Claremont* GSE 1572.

There is a full-length critical biography of Chisholm – Erik Chisholm, Scottish Modernist 1904–1965 – Chasing a Restless Muse by John Purser, published by Boydell & Brewer in 2009. This is available in hard copy from the Erik Chisholm website and also as a download from the publishers.

The Tragic Silence of Composer William Wallace

John Purser (Friday 4 November 2016)

IN THE PREVIOUS article, I gave an account of Erik Chisholm's Second World War experiences and his disturbingly apposite opera, *Simoon*. This week it is the story of a composer whom war effectively silenced, though he survived it physically unscathed. His silence is tragic, for his music is profound and inspiring. The composer was William Wallace, born in Greenock in 1860, the son of a surgeon in Glasgow's Western General, and who studied there himself to become an eye surgeon. He designed the cover of his song 'Carmen Glasguense', showing a student with mortarboard, and the Hebrew letter Shin which became a secret symbol between himself and his fiancée – of which more later.

Of course with such a name, when it came to the 600th anniversary of the execution of William Wallace on the 23rd of August 1305, Wallace had to be the composer to commemorate that horrific event in our history. He did so with a quite wonderful dignity and a depth of understanding of its national significance. The music took the form of a symphonic poem, opening in dark brooding tragedy but bursting into defiance and ultimately revealing Scots Wha Hae Wi' Wallace Bled without any of the all-too-frequent vulgarity, not to mention insincerity, with which it is sung by people who would not give their nation so much as a nose-bleed. Back in 1305 William Wallace had been betrayed by his own people into the hands of the English who executed and dismembered him, displaying his mutilated parts and making up in thoroughness what they lacked in chivalry. But the symphonic poem is a rousing piece, contrasting thoughtful poetry with military energy, bold and defiant: and if it leaves something unsaid, that is because in 1305 the leader did not live to enter his promised land, and in 1905 his namesake's music carries with it the sense of a destiny yet to be fulfilled.

Wallace's *William Wallace* was first performed under the baton of Sir Henry Wood on the 19th of September 1905 at the Queen's Hall Promenade Concerts. An earlier symphonic poem is a wonderful evocation of Dante's Beatrice in *The Passing of Beatrice* – a vision of beauty and purity. It was followed by a portrait of François Villon and this too was a symphonic poem entitled simply *Villon*. A

French critic described it as 'étonnante de justesse', which is saying something as Villon is an iconic figure in French culture, and for anyone who was not French to get truly under the skin of such a compelling character as Villon and do it in music is indeed astonishing.

If my subject is the effects of War, with Wallace we have to start with Love, otherwise you will not understand what the war took from him and therefore from us. It did not kill either him or his beloved Ottilie, but it seems to have killed his muse and what that meant to them both is hard to say, for the true love story of William Wallace and Ottilie MacLaren is one of the finest examples of a beautiful and high-minded relationship – and we know this not only from their own works, he as composer, she as sculptor, but from their love letters, bound in calf-skin by William himself, and now in the National Library in Edinburgh.

Wallace was a complex character to whom composers and musicians in general owe a particular debt of gratitude, for it was he who, almost single-handedly, represented their interests in Parliament during the drafting of the Copyright Bill of 1911. He virtually lived in the House of Commons for months and was severely cross-examined by the Board of Trade Committee. The fact that composers' copyright interests with respect to the new media of recordings and transmission were respected is largely owing to his efforts.

He was also a painter, playwright, music critic, wonderful letter-writer and, of course, a surgeon, in which capacity he must have exercised the utmost art and subtlety, for he rose to be in command of all ophthalmic cases in Southern Command in the First World War. But far more than that, he was one of our finest creative artists whose own *Creation Symphony* has, as far as I can tell, yet to be heard in public in Scotland. It is a highly ambitious work, and nowhere more so than in the opening of the last movement, celebrating the creation of humankind and also his own love, triumphant and absolutely thrilling.

Wallace was a highly literate man in several languages, but France – Paris in particular – had a special meaning for him, for it was in Paris that his beloved Ottilie was studying sculpture with none other than Rodin. Ottilie MacLaren became Rodin's assistant, and is reliably reported to be one of the few who resisted his seductions. Rodin admired her greatly.

No such support existed for Wallace as a composer. In changing course from medicine to music, despite having already qualified, he alienated his surgeon father to such an extent that, when he left after a particularly bad row, his mother wrote to him: 'My dear Willie, It wrung my heart to see you go last night in such a state & with such cruel words ringing in your ears & mine – the only thing I can say is, try to forget them – bitter though they be – & unjust though they are. Ever my dear son, your truly grieved mother.'

His father discontinued payment for William's composition lessons with Mackenzie and Corder in London; and William's enforced separation from Ottilie – it was nine years before they were able to marry – must have added to his sense of isolation. Meanwhile, Ottilie's father continued to oppose the relationship:

'I have a very good opinion of Mr Wallace's talent and industry, and it is only the fact of his having taken up a rather unremunerative profession that makes the difficulty.'

It was not easy. Ottilie admitted that Wiliam had given her a lift 'out of a pretty deep hole', and William at one time thought he was in a Hell he could never get out of. But 'Music, the Heavenly Maid, my intangible goddess hasn't left me after all.'

He referred to Ottilie as 'diamond eyes', an image that was to take on a cosmic light in the second movement of the *Creation Symphony* with the creation of the stars, the moon and the sun, stately and ethereal. He again used the letter Shin as a signature at the end of each movement. The name of the letter means 'song' and it looks like a letter 'W', but for Wallace it stood for the personal name 'Shelomith' meaning 'peacefulness', a Biblical name he used in his play *The Divine Surrender*. He also gave it to Ottilie because the character in the play represents the spirit of the Law, but looking for 'a more human interpretation'. The letter also represents the eye and has symbolic associations with the number six – the number of days of the Creation and particularly associated with the creation of Man.

The *Creation Symphony* starts with a depiction of Chaos – not the noisy idea, but in Wallace's own words, 'deep very mysterious and weird – sullen . . . when I think of it I seem to see your patient fingers making Kosmos out of the Chaos clay.'

Chaos was to come soon enough in the form of the First World War. Ottilie joined the Wrens and William returned to eye surgery and took only three weeks of leave throughout the entire war. He personally processed 19,025 cases, making a detailed statistical analysis which contains some revealing moments: 'There is little to note in the first three groups of the above table. Only one case of gonorrhoeal infection of the conjunctiva was seen, contracted innocently by an NCO who was splashed in the face with urine from a soldier whom he was attempting to restrain from making water in a hut.'

He published *The Vision of the Soldier with Special Reference to Malingering* – a fascinating study of human psychology – and *Opthalmic Cases seen during a period of four years in the RAMC*. He also made many watercolours of the cases he dealt with and left them to the Royal Army Medical War

Museum – but despite my best efforts, no trace of them has been found. Ottilie wrote 'He is so busy that we only see each other in the evenings when we're both worn out.'

When it all came to an end in 1918, William aged 58 and no doubt utterly exhausted, had ceased to compose.

He was a painter, had published *The Divine Surrender* and books on Wagner and Liszt, had composed a number of masterpieces with scant encouragement and no family support, had married against the wishes of his father-in-law, had pursued the wrong career in the eyes of his father, and had given himself utterly to everything he did. I love his music and admire him beyond measure.

As for Ottilie, her fine bust of her father is in the Faculty of Advocates and another fine bust by her of John Scott Oliver was recently exhibited in Edinburgh. Other examples of her work are in private hands, and she also designed war memorials, but I have yet to trace them.

William and Ottilie's love endured through it all. It is enshrined in their letters and Wallace enshrined it in the symphony, putting Ottilie's secret sign at the end of each movement and using number symbolism which equates them with Adam and Eve in the Creation of their own making.

Let Ottilie have the final word: 'Wallace, if ever I can cut myself a path up to that loftier place which your imagination has prepared for me it will be you who will have put me there.'

There are two CDs of Wallace's music. *William Wallace* Hyperion CDA66848 has four of his symphonic tone poems: Sir William Wallace, Villon, The Passing of Beatrice and Sister Helen. *William Wallace* Hyperion CDA66987 has the Prelude to the Eumenides, three movements from the Pelléas and Mélisande Suite, and the *Creation Symphony*. Valerie Carson wrote a thesis '*A Protean Spirit*' *William Wallace: Artist, Composer and Catalyst* for the University of Durham in 1998. I am indebted to her work for many insights.

An Enduring Love

Ottilie MacLaren was born in Edinburgh in 1875 and her father, John MacLaren, was Scotland's Lord Advocate. Ottilie was a sculptor – perhaps led in that direction by the help moulding clay would give to her hands which were rheumatic from an early age.

It seems she and William met and fell in love on holiday in Switzerland in 1895 when she was 20 and he 36. Her father's disapproval meant that they had to carry on their relationship in secret for many years.

We can get some idea of what William must have felt for this beautiful young woman, from his music for Maeterlinck's love-story of Pelléas et Mélisande.

They sustained their love through their long-enforced separation by writing lengthy letters, sometimes two a day. Here is just a taste of their correspondence:

Ottilie: 'You have hitherto seemed to read the unspoken – sometimes unformed, thoughts which lay in my heart and which my lips could not utter. Read there now the passionate gratitude which I can find no words for.'

William: 'Here and there I see thy sweet sign as a little prayer to the dear one who rules all my thoughts and thou art so much with me, I am so much part of thee that I can't conceive of the most ordinary event taking place without the thought in my mind of thee somehow concerned in it.'

Cecil Coles: A Genius and a Hero

John Purser (Friday 11 November 2016)

THIS BEING THE 11th day of the 11th month, those who love the arts in Scotland should particularly remember Cecil Frederick Gottlieb Coles. He was born at The Hermitage, Tongland, Kirkcudbright on October 7, 1888, and died of his wounds near the Somme on April 16, 1918. He is buried at Crouy, north-west of Amiens. On his tombstone are the words: 'He was a genius before anything else and a hero of the first water.' These words were written of him by his great 'chum' in the Battalion, as his friend, the composer Gustav Holst recalled. Coles' father was a landscape painter and archaeologist, later becoming keeper of Queen Street Museum in Edinburgh. His drawings of stone circles are an important record, some including members of his family.

How young Cecil came to study music composition is one of those near fairytale stories. He had matriculated as a music student at Edinburgh University and was carrying home repaired shoes from the cobbler's, wrapped in newspaper. He started to read the newspaper and saw an advertisement for a scholarship in composition at the London College of Music for which he duly applied, winning the Cherubini Scholarship in 1906, aged 18. The piece which won him this life-changing opportunity was probably *From the Scottish Highlands*, a three-movement orchestral suite which he had started in 1905.

By 1907, Cecil Coles had moved to London where he had to learn to fend for himself. It was not easy and, for his midday lunch, he made do with the smell of the pickles from the local pickle factories. Fortunately, he was taken under the wing of a Miss Nancy Brooke. She ensured that he had an adequate diet and also introduced him to Morley College where she taught woodcarving and kept the orchestral library. There he met Gustav Holst, newly appointed as director in 1907, and Coles also joined the Morley College orchestra in that year.

His work was not yet ready for public appearances, but Holst wrote of Coles that his 'genuine love of and talent for music, combined with his never failing geniality, enthusiasm and energy, worked wonders at a time when wonders, of that sort, were badly needed'.

In 1908, Coles won the Bucher Scholarship – administered by Edinburgh's Reid School of Music – and went to study in Stuttgart. Théophile Bucher had

been a friend of the Mackenzie family, and it is likely that Sir Alexander Campbell Mackenzie (principal of the Royal Academy of Music and who had himself studied in Germany) suggested that Coles apply for it.

In any event, it must have been a major stimulus for Coles who was only 20 years of age. Miss Brooke went out with him to make a home, acting as a mother to him. The friendship with Holst continued on a walking tour in Switzerland and Holst wrote that he was 'having the biggest rest I've had in my life ... and Cecil Coles ist ein ausgezeichnet prachtvoll Führer! The only drawback is that I'm not as young and vigorous as I was ...'

In 1911, Coles' scholarship was given an unprecedented extension for six months, perhaps in acknowledgement of his *Ouverture Die Komödie der Irrungen* (The Comedy of Errors), which was composed in Stuttgart that year and performed in Cologne Conservatoire on June 25, 1913.

At the same time, Coles was appointed assistant conductor at the Stuttgart Royal Opera House, giving him the opportunity to rub shoulders with musicians such as Richard Strauss. Some of his works were even performed at the Liederhalle in Stuttgart, which was a considerable honour for such a young foreign composer, and it was there that he set Alfred de Musset's Les Moissons for voice and piano. Brief and exquisite, it epitomises the concluding lines 'A plant bowed low by rain/But radiant with flowers!'

It was presumably at this time also that he wrote the *Fünf Skizzen für Klavier* published in Magdeburg. They are perfect miniatures: *Zum Anfang* gently persuasive; *Ihr Bild* like an innocent song without words; and, after a busy *Kleine Etude* and ghostly *Phantome*, concluding with the longing and lonely backward look of *Rückblick*.

In 1912, Coles married Phoebe Renton in St Saviour's Church, Brockley Rise, London and brought her back to Germany. However, in 1913, with the approach of the First World War, Cecil and his wife returned to England.

Holst wrote that 'he never joined in the ordinary hatred of Germany; he was utterly incapable of hatred under any provocation whatsoever. But he told me that in spite of all the courtesy and kindness he was receiving he found life there impossible'.

In England, Coles toured with the Beecham Opera Company as chorus master and taught elementary harmony and sight-singing at Morley College, also taking over choral and orchestral classes when Holst was on holiday, Holst describing him as 'our good friend ... who has so often helped me in the past'. In 1913 Coles' first child was born and named Brooke after Miss Nancy Brooke, who became his godmother.

It was at this time that he composed his most important surviving work, *Fra Giacomo*, a powerful dramatic monologue for voice and orchestra, the revision

of which was completed on May 23, 1914. A wronged husband poisons his wife's priestly confessor who is also her lover. The text is by Robert Buchanan. Nobody comes out of it well, but the drama and psychology of the situation are masterfully realised, with a frightening insight into the darkest aspects of humanity. Did Coles feel some kind of parallel between this and the breakdown of trust between Britain and Germany? The First World War saw an end to those cultural links which had done so much for British musicians – Mackenzie, Lamond, Hopekirk, Coles himself.

For all the xenophobia of those times, there must also have been a sense of deep cultural loss, almost bereavement.

The contesting monarchs were themselves first cousins. Mackenzie had dedicated his greatest work, *The Rose of Sharon*, to Queen Victoria's eldest daughter, Victoria – Kaiser Wilhelm II's mother. And Mackenzie's *Scottish Concerto*, published in Leipzig, was itself a casualty of war: 'I see that the Germans are melting down all music plates for bullets ... no doubt by this time the concerto has been re-cast in another form, less musical, but more effective perhaps. You see how this ghastly business touches us all in many queer forms.'

It was to touch Coles only too deeply. In 1915 he signed up for overseas service in the 9th London regiment – Queen Victoria Rifles. Stationed in France, he corresponded regularly with Holst: 'I could fill a whole number of the magazine with extracts from his splendid letters. They were always full of bravery and music, of details of impromptu concerts, of his band (he was sergeant bandmaster), of rejoicings over the Morley programmes.'

Alas, the correspondence does not survive. On his last leave from France, Coles spent an evening carol singing at Morley College. In January 1917 he set Robert Browning's Benediction 'Grow old along with me' and in February of that year he wrote the *Sorrowful Dance* for small orchestra, dedicated: 'To my dear wife.'

It was composed at 'Southampton Rest Camp 1.2.17.' and rewritten in France May 19, 1917, so he probably missed the birth of his daughter Penny in March 1917. It would not be surprising if these moving works were written with a sense of foreboding: the casualties were horrific and Coles was ready to take his share of risk although he would, 'under ordinary circumstances, have remained at the transport lines' as the regimental doctor wrote.

On one occasion, Coles was saved from straying into enemy lines when Cassiopeia appeared from behind a cloud to show him he was going the wrong way – but his luck was not to hold. Throughout what must have been harrowing experiences, Coles was a regular and prized attendant at gramophone record sessions behind the lines, listening to Beethoven, Brahms and Schubert symphonies. These sessions were run by the medical officer, Captain Gourlay,

who wrote that he 'was never quite happy unless Sergeant Coles was there, as he was the most appreciative of my audience.'

And despite it all, Coles kept composing, including *Behind The Lines*, at the end of which Coles has written 'Feb 4th, 1918 In the Field'. Two months later, aged only 29, he was dead. He had volunteered to help bring in some casualties from a wood, and on their return, two of the stretcher-bearers were killed and Coles was mortally wounded.

Fortunately, Coles appears to have been unaware of the seriousness of his injuries, humming a little Beethoven and asking whether his piano playing would be affected.

The MO wrote to his widow: 'I think there can be little doubt that your husband died of shock, in which case he would not suffer any pain.'

One of his regimental mates wrote of him: 'Cecil was a genius before anything else, and a hero of the first water. I admired him more than anyone, highly strung and sensitive, but with a fine, firm, noble will, and able to bring it into force at the critical moment.'

They shall grow not old, as we that are left grow old:

Age shall not weary them, nor the years condemn.

At the going down of the sun and in the morning

We will remember them.

So wrote Robert Laurence Binyon in 'For the Fallen' – but though Coles was one of the most talented of the composers who lost their lives in the First World War, few know his music and, unusually, it is only his orchestral music that is available on CD.

There is no published biography of Cecil Coles, but quite a lot of information in the liner notes for the one commercial CD of his music. This is *Cecil Coles Music from Behind the Lines*, Hyperion CDA67293. This includes his Overture *The Comedy of Errors*, the dramatic monologue with orchestra, *Fra Giacomo*, the *Scherzo in A minor*, *From the Scottish Highlands* and *Behind the Lines*.

The radio programme *The Score* (BBC Radio Scotland), broadcast on Remembrance Sunday, 1995, was devoted entirely to Coles and included specially commissioned performances of his songs and piano music, and an interview with the composer's daughter, Penny Catherine Coles. The programme can be accessed at the Scottish Music Centre.

The National Library of Scotland holds all of Coles' original manuscripts.

Part Four: Mass Media

Scotland: The Promised Land (Part 1)

Alan Riach (Friday 29 July 2016)

READERS OF *The National* will be familiar with the political bias of mass media news reporting in Scotland. John Robertson has written extensively online providing scholarly examinations of how this has worked over recent years, his conclusions a result of his own meticulous research. He has also written appropriately scathing exposés of the suspect credentials of certain TV 'presenters' to comment upon matters of history and the arts. (Check out: http://newsnet.scot/archive/flawed-fake-history-boys-bbc/) Here, I want to consider another kind of television.

Over the course of three weeks in March and April 2016, BBC 2 Scotland broadcast a series of programmes entitled *Scotland: The Promised Land*, produced and directed by Colin Murray, with research by Nadine Lee, Amy Cameron and Joanna Taylor. The commissioning executive producer was David Harron and the executive producer Rachel Bell. They're available to purchase from BBC Store and for a while since transmission, were in the public domain on the BBC iplayer. Technology has its uses. I think these three programmes were that rarest of things: excellent television. I'd like to explain why.

The programmes themselves are history now. I want to look back and think about them as a single, coherent 'literary' text, a multi-faceted, carefully-researched construction of meaning, where implications, suggestions, questions without answers, linger and stay. Three very different programmes, each was focused on Scotland in the 1920s, in the immediate aftermath of the First World War. Each was themed in a different way, each of them complementary, each rising from, reflecting on, and nourishing the others, in ways I can't remember any series like this doing before now.

First, cards on the table: I was invited to take part in the third episode and became 'Programme Consultant'. Normally, modesty would insist I say nothing in the wake of the shows and let them do their job for themselves. But since the series ended, they've stayed in my mind as a single, coherent enquiry, and when I asked myself what was so impressive about them, I began to make notes that I think are worth pausing on for a bit longer than most TV reviews allow.

Unanswered questions and unfulfilled potential are what the series was about, far more than predictable securities and propaganda-biased definitions. That's the essential thing. These were TV programmes in which this strange message was coming across: a lot more is going on under the surface than what you ever see on the screen. Unlike most news reporting, these programmes were offering an interpretation, in which selectivity was clearly shown to be an essential part of their construction.

There was not a 'celebrity' in sight. No 'personality' taking us through the locations, tossing hair or cracking jokes, no kowtowing to 'celebrity culture'. The voice-over narration by the actor Ken Stott was restrained, sometimes sounding tough in recognition of what was being shown, sometimes permitting itself a little ironic humour at things – but never a trace of condescension, never an insinuated implication of superiority. Always an understated sense that the narrator's voice was as human and mortal as any of the people we would meet in the programmes, and as each of us watching them is. What was consistently in focus was the exposition of the historical data, what happened to real people in real places, what the events of their lives arose from, and what they led to: the consequences for us, nearly a century later.

Three programmes: (1) 'The Birth of Modern Scotland'; (2) 'Homes for Highland Heroes'; (3) 'The Cultural Revolution'. Each one was determined by the question, 'What happened in the immediate aftermath of the First World War?' Each was constructed from documentary news footage of film, photographs and records from the era; each also incorporated on-location film of people in our own time; each had contributions by a range of contemporary scholars in different fields of expertise, and by teachers, curators of archives, librarians, offering comment, introducing books, newspapers, preserved artefacts, objects, memorabilia, communicating their knowledge to others, younger generations, curious citizens. The value of these educational workers, their beneficiaries and the benefits that might be bestowed by such knowledge and understanding, sustained the series. But the focus was not on them but on what they were addressing: the people, the economy, the forces moving in this axial period of Scotland's history.

Take them in turn:

The series began with 'The Birth of Modern Scotland' (broadcast 23 March): 'In late November 1918, in towns across Scotland, crowds of well-wishers gathered to welcome their troops as they began to arrive home from the horrors of war. The "war to end all wars" had left 100,000 of their comrades dead. No town, village or home was untouched. These soldiers came from all classes, all walks of life.' As Dr Catriona MacDonald of Glasgow University put it, 'These

were not professional soldiers, these were citizens in uniform' and so, if this had been a 'people's war' it had to be 'a people's peace'. As we hear these words, we see contemporary film of returning soldiers, marching one-legged on crutches in their hundreds, eye-patched, bandaged, in hospital beds, and then film of working people in industrial cityscapes, looking around, at us and at each other. One month after the war ended, in December 1918, all men over 21 and women over 30 were allowed to vote for the first time. Meanwhile 'in Ireland, a nationalist rising developed into a full-blown war of independence and in Russia the revolution was threatening to spread west.' When a political demonstration in Glasgow turned into a riot, tanks were sent onto the streets. Order was reinstated. But 'under the surface' things were building.

The war had cost money. There were to be public expenditure cuts. Overcrowding, malnutrition and high infant mortality were rife. Professor Richard Finlay of Strathclyde University (Programme Consultant) commented that by 1922, it was increasingly realised that this was not 'a land for heroes'. Rhona Rodger of Dundee's McManus Gallery and Museum showed the register photographs of inebriates and down-and-outs: portrait pictures of hard, damaged, brutalised working-class women and men. The visual impact was shocking. In the 1922 Dundee election, working-class and ex-service men and war widows all were ready to vote. Dr Billy Kenefick of Dundee University remarked upon the candidates: Winston Churchill of the ruling Liberal Party, in post, but disdaining women's rights and opposed by the working-class and Irish constituents; Dundee-born Edwin Scrymgeour, independent Christian, socialist, pacifist and prohibitionist; Willie Gallacher, revolutionary communist, recently returned from meeting Lenin; Edmond Morrel for the Labour Party. Scrymgeour won overwhelmingly.

But Labour were on the up, because they were talking class, and now class mattered. The Red Clydesiders, James Maxton and John Wheatley among them, went to London as parliamentary representatives. We see film and photos of them. The leader of the Labour Party, Ramsay Macdonald, illegitimate son of Lossiemouth farm workers, had the problem of reconciling the seemingly-wild behaviour of the Labour members with the respectability of the parliament in which he wanted to preside. Cut to the present: Macdonald's grand-daughter takes us around her house, reminiscing. Scenes of contemporary Lossiemouth. In 1924, the Conservative government fell and Macdonald was PM. Labour was in power for the first time. The question is now pressing: how to deliver a better society? And the other question: how to demonstrate parliamentary credibility? 'But the forces of conservatism were mustering and strange conspiracies were forming.' Dr Gill Bennet of the Foreign & Commonwealth Office

gives details of the 'Zinoviev letter', a forged secret document passed by British Intelligence to the *Daily Mail*, published just days before the election. The effect was to incite distrust of Labour and bring down the Labour government. The Conservatives, class warriors, traditionalists, were back in.

If there was a red Clydeside there was obviously a blue Clydeside too. Rebecca Quinton of the Burrell Collection, Glasgow Museums, shows us some of the most fashionable and expensive dresses (each one-of-a-kind, the bill to be sent to the husband) that would have been worn by fashionable wealthy women of Glasgow, perhaps to be glimpsed by people in the street as such a woman stepped from taxi to venue. Film from the era shows just this. The Conservatives, known as the Scottish Unionist Party, are returned in the wealthy South Side of Glasgow, commented on by journalist David Torrance. John Gilmour, landed gentry, Orangeman, scourge of the socialist, definitive imperialist is appointed Scottish secretary. His descendants look at his campaign medals and reminisce. Monuments to the war dead are unveiled all over the country, confirming a vision of a conservative, patriotic, unionist Scotland. Faith (Protestantism), monarchy and empire were essential to this form of Scottishness. But, as the decade wore on, Catholics were increasingly a significant component in Scottish industrial life, and anti-Catholic sectarianism was growing too. Professor Enda Delaney of Edinburgh University looks at the poisonous tract held in the Scottish Records Office called 'The Menace of the Irish Race to Our Scottish Nation', written by 'bigot-in-chief' Reverend John White, emphasising the power of the Kirk in 1920s Scotland. Scotland's economy collapsed, wages were cut, the General Strike approached because of the decline of 19th-century industries, coal, steel, ships, locomotives. London drew Scotland closer. Gilmour became Secretary of State for Scotland. We see film of him visiting St Andrews to play golf, but not welcomed by the working people of Fife, unemployed miners confronting the aristocrat on the fairway.

In 1928, equal franchise for women at the age of 21 was established. This was called 'The Flapper Vote' but most women were not of the bright-young-things 'flapper' class. Conditions of deprivation and physical debility were common. Dr Lesley Hall of the Wellcome Library shows various books and pamphlets providing information about contraception from the era. The underlying sense is that the lives of women – motherhood, working and social life – were as vulnerable, dangerous and threatened as those of men in mines or any hard industries. We see film of Jenny Lee, a miner's daughter from Lochgelly in Fife, who stood up for women's rights and class justice, was voted into power at the age of 24 in the mining constituency of Shotts in central Lanarkshire, and went to Westminster. Her biographer, Baroness Patricia Hollis, explains her

story, her choosing her side, beautiful, argumentative, sexually uninhibited, a brilliant orator, for a while she combined film-star glamour with working-class solidarity. In 1929, the equal representation act ensured votes for all women over the age of 21. In the election, Labour and Jenny Lee were voted back into power. But the outcome is salutary: Jenny seduced, and was seduced by, Westminster. Abandoning her ties with Shotts, she settled in England. Labour parliamentarians representing Scotland were compromised in London.

But in the 1929 election, something new happened. Two candidates stood for a fringe party that would set itself against Westminster, the National Party of Scotland (established 1928), and they won between them just 3,000 votes; five years later, it would become the SNP. 'Not only was a new kind of nationalism stirring, but the once all-powerful Liberals were eclipsed, never to be a dominant force in Scotland again; the Labour Party had become electable, but a deep Conservatism had also been revealed. Crucially, though, the future of the country was in the hands of its people, regardless of their sex or class...'

And 'these inter-war years also saw the birth of a new story for Scotland as seeds of change were sown that would take root deep in British political thinking.'

The first programme, then, set the scene with hard data and historical reference, documentary film and photographs from the era. The focus was industrial Scotland and political representation. The visual impact was powerful, indeed. But if the main centres of Scotland's population were the industrial cities depicted, especially Glasgow and Dundee, there is more to Scotland than its people and their economic conditions. There are vast stretches of depopulated wilderness, territories where even the small towns and villages had been disproportionately affected by the 'Great War'. This brings us to the second programme, which will be explored in the following article.

Scotland: The Promised Land (Part 2)

Alan Riach (Friday 5 August 2016)

WE PREVIOUSLY LOOKED at the first programme in the three-part BBC2 Scotland series, *The Promised Land* (series producer Richard Downes, broadcast in March and April earlier this year, available to purchase from BBC Store, and accessible elsewhere online if you search). This week, we're looking at programmes two and three and asking what all three amount to, taken together. The series as a whole focused on the formation of Scottish identity – or identities – in the aftermath of the First World War, through the 1920s. The first programme looked at the industrial cities of Glasgow and Dundee, centres of population where deprivation, poverty and squalor were rife. Socialist priorities, conservative investments, the weight and momentum of political interests gathering and growing, pulling back in reactionary force, or taking new forms and directions, were all indications of movements happening under the surfaces of what could be seen on the screen. The most important quality of the programme was this sense of vital things taking shape beyond the visible, quantifiable world.

The second and third programmes went further, in quite unexpected ways.

'Homes for Highland Heroes' directed by Andy Twaddle (broadcast 30 March) considered how veterans and their families in the Highlands and Islands were promised land for enlisting to fight in the First World War, and how the promise was broken. The land wasn't theirs when they returned from the war, prompting the mass emigration of one tenth of the population of the area to Canada and elsewhere. Disappointed and betrayed at home, further betrayals were in waiting. We heard testimonies from emigrants and their descendants who felt that those in authority had not kept their word about the life the exiled Scots would find after they'd crossed the Atlantic.

The programme began with the proposition that the Highlands and Islands of Scotland proportionately lost more of their men in the war than any other part of Britain. After the war, big estates were going bankrupt while crofters were being starved of land. Following one family in Lewis, we heard of a sailor who returned to find the promise of better conditions no more than a cruel deception. When English soap millionaire William Hesketh Lever, Lord

Leverhulme, bought the Isle of Lewis and proposed to industrialise the whole crofting community, what might have seemed like progress was quickly understood as attempted dictatorship. The key thing was understood by the residents to be, not a 'growing economy' but a relationship with the land. The islanders chose crofting as a way of life over that of capitalism. When, early on January 1 1919, 181 returning ex-servicemen died in the wreck of the 'Iolaire' within sight of their home, Leverhulme donated £1,000 in an act of benevolence some would describe as severely limited. Later that year, when the Land Settlement Act ensured the Scottish Board of Agriculture should legislate for new crofts, Leverhulme was not obliged to observe this law. Landraids followed. About 1,000 crofters confronted the landowner on the bridge over the river Gress, but to no avail. In 1920, Leverhulme pulled out of Lewis, his profits diminished by a trade embargo in the east, following the Russian revolution, and prohibition in America, cutting the profit from sales of salt fish bar snacks intended to encourage a thirst for alcohol. The Soap Lord offered land free but the crofters refused that responsibility, already strained with poverty as they were.

Working men moved south but the economy was collapsing there too and many left Scotland from the industrial cities. The Forestry Commission was established in 1919 but gave limited employment. For the people of the Highlands and Islands, the 1920s was above all a decade of mass departures.

In 1922, the Empire Settlement Act began subsidising one-way tickets to the British 'dominions' to the tune of 3 million pounds per annum for 15 years to come. In the programme, insightful comments were provided by Professors Ewen Cameron (Edinburgh University) and James Hunter (University of the Highlands and Islands). Professor Marjory Harper of Aberdeen University (Programme Consultant) pointed out that when the British government began paying Scots to leave there were two major effects: (1) it would bolster the Empire abroad and (2) it would rid home territories of those working men most likely to stir up revolt. In the 1920s, more people (488,000) left Scotland by this means than in any other European country, and the deepest, most widespread, most lasting effect this had was on the Highlands and Islands.

In 1923, whole families left from Barra and Benbecula and South Uist, joining others from Glasgow heading for their 'promised land' in Canada. With film from the era, still photographs, quotations from contemporary accounts and maps, the programme tracked two ships and two sets of individuals across generations, from the Outer Hebrides to the North American wilderness. One émigré eventually set up a charter flight operation from Vancouver to Prestwick, knowing that many Scots would want to return home. In 1926, the Clandonald 'colony' was established by another. Many of the descendants of the emigrants,

still living in Canada, talked movingly of their own memories of their parents' and grandparents' conditions, and their own relative prosperity.

But questions and anger remain. Almost every family in Scotland probably has some relative abroad, but whether they prospered or not, might the money spent on sending people away from Scotland have not been better invested in hydroelectric schemes, commercial forestry, industrialisation, repopulating the homeland itself? Why was it not used thus?

The programme concluded that the 1920s were 'a time of missed opportunities when the question of who owns Scotland's land and to what purpose were left to another generation' while 'a lack of investment and a lack of imagination had paralysed post-war Scotland'.

That 'lack of imagination' is the key phrase here.

Now, in the 21st century, among the present generations of residents, some communities have purchased the land upon which they live and work, in community buy-outs, ending the dominance of the big landowners. Not everywhere, by any means. But it can be done. The programme ended by trailing the final episode of the series, in which 'a band of revolutionary writers and artists would mount an explosive rear-guard action to portray their country in a language free from sentimentality, free from tired music-hall parody, a battle for a noble cause to find the voice of Scotland's people.' This was a regeneration of 'imagination' returning at full capacity.

This concluding episode, 'The Cultural Revolution' directed by Laura Mitchell (broadcast 6 April), followed the emerging writers and artists such as novelist Lewis Grassic Gibbon, poet Hugh MacDiarmid and sculptor William Lamb. Many served in the war, and all of them campaigned to revive Scotland's voices and culture at a time when screen media, particularly film, was becoming overwhelmingly popular as a political means of distributing persuasive images of Scottish identity as oddly colourful and politically inept. Where Charlie Chaplin could be subversive and progressive, Harry Lauder confirmed establishment authority and reactionary views of Scottish life. Music hall, comedy, film and later television, persuasively and successfully promoted 'Scottishness' as entertainment, while writers, artists, sculptors and composers were thinking more profoundly about the human cost and value involved in a regeneration of national culture. The intention was emphatically 'revolutionary': a real battle was to be fought, not with bombs and guns but with words and ideas. The legacy of these things is still our condition today.

MacDiarmid, as a newspaper reporter in the north-east seaside town of Montrose, covered the unveiling of the local war memorial. Some saw it as 'a tribute to those who had fallen for King, Country and Empire' but to

MacDiarmid it was 'a reminder of wholesale industrialised slaughter in the trenches of the friends and comrades needlessly ordered to their deaths by the British ruling class'.

The programme centred on the activities of people in Montrose, not only MacDiarmid and Lamb but Violet Jacob, Marion Angus, Helen Cruickshank, Compton Mackenzie, Fionn Mac Colla (Tom MacDonald), Willa and Edwin Muir, the composer F.G. Scott and artist Edward Baird.

Readers of *The National* will be familiar with most of these characters from my article, 'Modernist Montrose' (February 26 2016 [reproduced earlier in the present book]): there is no need to repeat material from that. Still, crucial to the TV programme were the contributions of a range of scholars, critics and teachers: Dr Paul Maloney (Glasgow University) on the burgeoning popularity of music hall entertainment, pantomime and variety theatre; Dr David Goldie (Strathclyde University) on the conflicts and contradictions in MacDiarmid's vision and strategies and the example set by Ireland; Professor Douglas Gifford (Glasgow University) on Scottish 'popular literature' of the time, persuasive in its bogus instructions about 'how to be a good Christian – and know your place' and 'establishing social order...within the Empire'; Raymond Vettese, presenting some of MacDiarmid's sources in Montrose Library; Dorian Grieve, MacDiarmid's grandson, offering personal reminiscences and shrewd analysis; Maura Currie, Head of Presentation, BBC Scotland, on John Reith's new radio stations promoting an imperial vision of Britishness through standardised English Received Pronunciation, 'the accent of the upper class, the ruling class, the privileged class...a vocal status symbol' with direct access into millions of Scottish homes; Sheila Mann (National Trust for Scotland) on Violet Jacob's Scots poetry; Dr Fern Insh of the William Lamb Studio, showing how Lamb's Rodin-like sculptures developed in style and intensity of purpose after the war; Andy Shanks, teacher, Montrose Academy, who serendipitously discovered the cottage of 'Avondale' where MacDiarmid assembled 'A Drunk Man Looks at the Thistle' (1926) in St Cyrus (surely this demands a blue plaque!); Dr Trevor Griffiths (Edinburgh University) on the mass attractiveness of contemporary cinema culture; Les and Cathie Smith, owners of Helen Cruickshank's house in Edinburgh, the hub of the Scottish Renaissance writers and artists in the 1930s; Dr William K Malcolm of the Lewis Grassic Gibbon Centre, discussing *Sunset Song*. As with the first two programmes, the experts introduced a variety of voices and interpretations that emphasised the plurality of the history represented, intrinsically opposed to the interpretive monopoly 'celebrity' presenters often seem to hold. Each one offered insight and provocation.

I mentioned last week that I was 'Programme Consultant' on this third episode. When I did that work, the series was provisionally entitled 'Wounded Nation'. I don't know whose decision it was to rename it *The Promised Land* but it was a good one. Not all the wounds have healed but the promise is still with us. The 1920s saw the lines of demarcation between reactionary forces and progressive aspirations drawn more firmly than at any time in Scotland's history since the 14th century. Those lines are being etched out even more deeply today, in 2016.

These three complementary approaches to 1920s Scotland, moving from the industrial centres of population, to the depopulated Highlands and Islands, and then to the cultural revolution, reflected and illuminated each other in startling ways. The result was an understanding of Scotland in its entirety – not a comprehensive understanding, nor one divided into closed categories but rather one that remained suggestive and open, inviting further explorations. The series delivered the sense that Scotland is created, regenerated, variously, essentially and pre-eminently through these three areas of life: people, geography and cultural practice. And that all three areas draw upon history and experience in ways that often cannot be easily seen, that lead to new and contemporary conditions in ways we might learn more from if we understand them coherently, both intuitively and self-consciously. The series presented Scotland in the 1920s in relation to British and international identities. Contexts and questions were at the core of the whole enterprise, and ran through each episode consistently, and with purpose.

What might TV do if we applied this to every decade since then? A series of three programmes for each of the following eight decades, and into the 2010s? What if we had a series on Scottish painters, sculptors and composers in their full political, geographical and linguistic contexts? Or on the relations between specific locations and writers, over centuries? Imagine a programme on Edinburgh in the works of Dunbar, Scott, Stevenson, Spark and Sydney Goodsir Smith. Or one on Meg Bateman's Skye and Liz Lochhead's Glasgow? There's ample material in the archives and no shortage of knowledgeable and personable educationists and artists ready and willing to contribute. How much more good TV could BBC Scotland make? Things change and can be changed. So when we say 'Scotland' think what that cultural revolution really brought about.

In his autobiography, *Theme and Variations* (1947), the great conductor Bruno Walter said this: 'History! Can we learn a people's character through its history, a history formerly made by princes and statesmen with an utter disregard, frequently opposition to its interests? Is not its nature disclosed rather by its poetry, by its general habits of life, by its landscape, and by its idiom? Are we

not able more deeply to penetrate into a nation's soul through its music, provided that it has actually grown on its soil? Is anyone entitled to speak with authority of the Russians who has not become familiar with Pushkin, Lermontov, Gogol, Dostoevsky, Tolstoy, and Gorky, and has not listened to the music of Mussorgsky, Borodin, and Tchaikovsky?

'I have preserved the unshakable conviction that man's spiritual accomplishments are vastly more important than his political and historical achievements. For the works of the creative spirit last, they are essentially imperishable, while the world-stirring historical activities of even the most eminent men are circumscribed by time. Napoleon is dead – but Beethoven lives.'

Scotland: The Promised Land seems to have started from this premise, without ever neglecting the lives of all the people, and the resources of the non-human geography our infinitely various country offers to us all. Let's never lose sight of it. There's more to be done.

The Most Deadly Weapon in the World: The Power of Mass Persuasion

Alan Riach (Friday 18 November 2016)

JOHN PURSER'S ESSAYS on the composers Erik Chisholm, William Wallace and Cecil Coles, the award of the Nobel Prize for literature to Bob Dylan, and the death of Leonard Cohen, prompt reflection on the ways different forms of verbal, narrative, visual or musical expression articulate themselves across the spectrum and the interconnectedness of all the arts. I guess this is what the politicos call 'soft diplomacy' as opposed to the crude rhetoric which is pretty much all we get from mass media. The trouble is, when politicos undervalue it, which is pretty constantly, they imperil us all.

Literature takes many shapes. It comes in different genres. The doyenne of crime fiction Val McDermid countered the argument that genre fiction was not 'literature' recently by pointing out that literature was essentially something that made you care, something that sensitised you. In the aftermath of Armistice Day, the US presidential election, the post-EU referendum chaos of Westminster ineptitudes, and how all this is reported, it feels like an increasingly desensitized world. Maybe it's simply that the driving force of politics and war is deeply and ultimately rooted in the desire for power. The rallying commands are for absolute authority, 'reclaiming' your 'rights', while the energies and aptitudes that produce works of art are essentially concerned with the enablement and clear exercise of differences, variations, multiplicities, more than one story, many ways of understanding.

Any good society balances standards of justice and egalitarian social practice with an encouragement of difference and diversity of practice. Any bad society tries to enforce the former by killing off the latter and policing forms of 'justice' that serve only the rulers.

Sounds familiar? Let's go elsewhere, then.

Let's pause on diversity, a range of different forms and genres, and consider their literary or artistic effect. How will history speak of what has happened in 2016 through the arts? How will the thoughtful minds of those who consider

different ways of understanding come to an account? Sometimes you have to act fast, but thinking things through takes time and work, so perhaps we have to trust that the minds that help keep other minds alive are working unobtrusively, even now.

Philosophical aphorisms or extended enquiries, essays, multi-volume studies of history are in themselves a kind of storytelling. They are literature just as much as poems, fiction and plays. Good history well-written is as much a *literary* achievement as anything. If it's usually written by winners, it's often better understood by losers. The writing that allows film narratives or television programmes, either stand-alone drama or long-running series, to develop character, relationships, social contexts, tension and ultimately meaning, is also literature. So is song. The ballads are generally understood this way, and despite the commercial imperative, so are many songs caught up in the music industry, like those by some of the most famous names in Scotland since the 1960s: Frankie Miller (b.1949), Michael Marra (1952–2012), Annie Lennox (b.1954) and Eddi Reader (b.1959). One of the most popular songs of the 1980s and 1990s, 'I'm Gonna Be (500 miles)' by The Proclaimers, Craig and Charlie Reid (both b.1962), a comic, joyful declaration of love and commitment, has its own distinctly literary subtleties and ironies. The singer promises to be the man who will wake up next to, walk out alongside, and work hard to provide for, his beloved; but he also admits he's probably going to get drunk ('next to you'), and will be 'havering' (a good Scots word, 'talking nonsense') 'to you' and when the money comes in, he'll 'pass almost every penny on to you'. The certainty of hesitation in 'almost' is delightful: the commitments are qualified, but still the singer swears that he would walk a thousand miles to 'fall down at your door' – though whether his beloved would welcome the sight of him at that stage might be a moot point.

Reading against the grain, analysing what you're meant to take on trust, is what good literary critics do, what literature itself encourages us all to do. Popularity is no guide. Some of the best of it, in its day, was not well-received. The poetry of William Blake, Melville's *Moby-Dick*, were not considered 'classics' in their time. Almost exactly 100 years ago, on November 22 1926, Hugh MacDiarmid's 'A Drunk Man Looks at the Thistle' was published in an edition of 500 copies. Only 99 had been sold by the end of the year.

Yet one of the phenomena of modern literature has been the rise of established popular genre fiction, successful both in commercial terms and as literary forms in which a balance must be struck between the fulfilment of genre expectations and the renewal of novelty, books which are both reliable and unpredictable. There is a long tradition of popular genre work, from espionage novels

by John Buchan, Ian Fleming and Alistair MacLean, science fiction by Naomi Mitchison, David Lindsay, Iain Banks, Ken MacLeod and Paul Johnston, in the western genre, Alan Sharp's film script for *Ulzana's Raid* (1972), and in Romantic fiction, from Annie S. Swan (1859–1943) to Dorothy Dunnett (1923–2001) and Jessica Stirling (another name for Hugh C. Rae, 1935–2014).

Crime fiction has a long pedigree in Scottish writing, arguably beginning in major authors such as Hogg and Stevenson but centrally occupying the golden period of the genre in work by Michael Innes (J.I.M. Stewart, 1906–94) such as *Lament for a Maker* (1938), with its recurring motif from William Dunbar, 'Timor Mortis Conturbat Me', and Josephine Tey (Elizabeth Mackintosh, 1896–1952), who set her novel *The Singing Sands* (1952) in Scotland, where the terrain itself is a significant component of the story. The excellent new biography by Jennifer Morag Henderson brings out the depth of Tey's interrogations of the assumptions working against truth. Tey's novel *The Daughter of Time* (1951) is a salutary reminder of how quickly and deeply a lie can become established as fact in the public imagination.

Blending expectations familiar from the crime fiction genre with exotic locations, Alexander McCall Smith (b. 1948), in his novels featuring Mma Precious Ramotswe, *The No. 1 Ladies' Detective Agency* series, and in other books often set in Edinburgh, brings a poised, cleverly balanced style to bear on humorous, sometimes whimsical, situations, often spiced with serious implication. The sheer unexpectedness of the early novels sustains their charm. As genre fiction, after the scene is established, they trade on expectation, but the variety of his series novels (such as *The Sunday Philosophy Club* and *44 Scotland Street*) and the non-series novels such as *La's Orchestra Saves the World* suggests something of McCall Smith's range and calibre.

The early novels of Hugh C. Rae (the great-grandfather of Tartan noir), particularly *Skinner* (1965) and *A Few Small Bones* (1968), combine tight plotting and tense stylistic understatement. William McIlvanney (1936–2015), in mainstream novels, including *Docherty* (1975), delivers complex character-portraits and a depiction of community (Graithnock, based on Kilmarnock) at a particular historical moment, but he also occupies the crime genre with *Laidlaw* (1977) and its sequels *The Papers of Tony Veitch* (1983) and *Strange Loyalties* (1991). These are highly literate, politically engaged novels in which the genre opens the door to social exploration and moral judgement in bravura style. Frederic Lindsay (1933–2013) produced one of the most sinister, enigmatic crime novels in *Brond* (1984) and each of his subsequent books, some with the recurring main character Inspector Jim Meldrum, is cleverly paced and convincing. Christopher Brookmyre (b.1968) is a more effervescent writer whose writings bristle and

fizz with irreverent humour and political bite, but they also make serious points about contemporary issues, including terrorism and international finance. Louise Welsh's *The Cutting Room* (2002), *The Bullet Trick* (2006) and *Naming the Bones* (2010) move through dark criminal underworlds but are more than strictly genre fiction. The same might be said for the unflinchingly determined feminist self-possession of Denise Mina. Of course, the Inspector Rebus series of the most famous of modern Scottish crime novelists, Ian Rankin (b.1960), while satisfying 'police procedural' conventions, give a running commentary on the shifting ethos of late 20th-century Scotland, especially Edinburgh, over more than 20 years, as the Parliament was resumed and the political dynamics and criminal aspects of the economy changed.

Different priorities occupy writers in science fiction. Attention to the modern international scene informs fictional explorations of political ideas in the 'What if?' scenario proposed by the genre. Naomi Mitchison (1897–1999) was a pioneer in this field, as in others, with *Memoirs of a Spacewoman* (1962). The novels of Ken MacLeod (b.1954) clearly connect with contemporary issues, explicitly addressing religious, communist or anarchist political ideas, while Paul Johnston (b.1957) has a quintet of novels (1997–2001) set in a futuristic Edinburgh. Matthew Fitt (b.1968) in *But n Ben A-Go-Go* (2005) produced the first science fiction novel in Scots. Scotland after global warming is 300 feet under water and a virulent strain of sexually-transmitted disease is rife, but the novel is compelling not only because of its social vision and its suspenseful quest narrative, but in the strangeness of the Scots language itself, used in this way. Many readers, after initial difficulty, report being swept into it eagerly.

There are major literary genres which might take entire book-length studies to themselves. Children's literature is one of them. The Association for Scottish Literary Studies publishes an annotated bibliography of children's fiction, *Treasure Islands: A Guide to Scottish Fiction for Young Readers aged 10–14* (2003, with supplements available online at the ASLS website).

Walter Scott and Robert Louis Stevenson wrote some works specifically for children introducing the history and ethos of Scotland to new generations. Edinburgh-born R.M. Ballantyne (1835–94) was one of the quintessential literary figures of British imperialism addressing an international readership of children and by that token, very much an historical figure. But in the last quarter of the 20th century and into the 21st, writing for children has become a major commercial industry in literary production. Certain novels are deliberately intended to address difficult issues like religious sectarianism and bigotry, and notwithstanding their planned didactic intention, some are terrific, like Theresa Breslin's *Divided City* (2005). The phenomenal success of J.K. Rowling (b.1965) and the

Harry Potter series of novels and films testifies to an appetite for new fiction that addresses tried-and-tested themes: childhood and adulthood, loneliness and company, independence and loyalty, courage in adversity, the qualities of friendship and caring for others, are central to both novels and films. Yet their political implications are perhaps not as innocent as they seem. An immense popularity for stories set in an exotic fantasy-world clearly related to the public school ethos of *Tom Brown's Schooldays* in which magic is an antidote for reality has its ideological liabilities, no doubt. And what of their ancestry?

As Yeats put it in 1922, 'We had fed the heart on fantasies, / The heart's grown brutal from the fare'. The perennial classic by Kenneth Grahame (1859–1932), *The Wind in the Willows* (1908), has had many manifestations in film, television and theatre. Writing about John Buchan (1875–1940), Marshall Walker once commented that his heroes Richard Hannay, Sandy Arbuthnot and Sir Edward Leithen 'seem now like humanoid editions of Mole, Ratty, Badger and Toad at play on a Boy's Own Paper riverbank' and yet 'Buchan writes as committedly as William Golding about the fragility of civilization.' Sandy Arbuthnot's speech about propaganda in *The Three Hostages* is to be taken seriously: 'He said that the great offensives of the future would be psychological, and he thought the Governments should get busy about it and prepare their defence...

He considered that the most deadly weapon in the world was the power of mass persuasion.'

Buchan wrote that in 1924. Not a bad prediction of where we are.

William Butler Yeats (1865–1939) wrote this during the Irish Civil War, in 1922. A 'stare' is a west of Ireland term for a starling. For an excellent reading of the poem alongside Derek Mahon's 'A Disused Shed in Co. Wexford' by Patrick J Keane, go to: http://numerocinqmagazine.com/2012/09/26/a-poetry-of-petition-w-b-yeatss-the-stares-nest-by-my-window-and-derek-mahons-a-disused-shed-in-co-wexford-patrick-j-keane/

W.B. Yeats

The Stare's Nest by My Window

> The bees build in the crevices
> Of loosening masonry, and there
> The mother birds bring grubs and flies.
> My wall is loosening; honey-bees,
> Come build in the empty house of the stare.

We are closed in, and the key is turned
On our uncertainty; somewhere
A man is killed, or a house burned.
Yet no clear fact to be discerned:
Come build in the empty house of the stare.

A barricade of stone or of wood;
Some fourteen days of civil war:
Last night they trundled down the road
That dead young soldier in his blood:
Come build in the empty house of the stare.

We had fed the heart on fantasies,
The heart's grown brutal from the fare,
More substance in our enmities
Than in our love; O honey-bees,
Come build in the empty house of the stare.

Scottish Literature, Mass Media and Politics

Alan Riach (Friday 2 December 2017)

ONE OF THE most important cultural figures of modern Scotland, and probably one of the least familiar names, is Stuart Hood (1915–2011), novelist, translator and former Controller of BBC Television. If we're talking about radio, film and TV, I'd want to keep him in mind. His work is centred on the inter-relatedness of literature, media and politics. Walking out of an Italian POW camp into the countryside in 1943, he spent 11 months in an ancient peasant world of ploughing, planting, harvest and communal hospitality, but also working with the partisans, engaging in guerrilla warfare against the German troops. The most direct opposition to fascism gave him a lasting sense of human priorities. The sensitivity of his writing – particularly in his greatest novel, *A Storm from Paradise* (1985) – is measured against the absolutism of the fascism he fought against. He once said, 'I was always interested in how politics is lived.' That's the key to understanding his work as a novelist, a broadcasting professional and a politically aware and committed individual.

When Hood wrote his later books, *Fascism for Beginners* (1993), *On Television* (1994) and edited *Behind the Screens: The Structure of British Television* (1994), he was acutely aware of the relations between fiction, mass media, persuasion, and the truths that must be told. Since his death, the power of social control, the selective dissemination of information, and the relation between online, screen and print media has become the essential ethos of our time. Some of the dangers are discussed by Iain MacWhirter in his book, *Democracy in the Dark: The Decline of the Scottish Press and How to Keep the Lights On* (Saltire Society, 2014). The analyses provided in *The Media in Scotland*, ed. Neil Blane and David Hutchison (EUP, 2008) are very much in the spirit of Hood. The argument is brought up to date in Christopher Silver's brilliant *Demanding Democracy: The Case for a Scottish Media* (2015).

For Lord Reith (1889–1971) the BBC's job was to inform, educate, and entertain. But consider Sir Alan Peacock (1922–2014), from 1984–86 Chairman of the Committee on the Financing of the BBC, rejecting Margaret Thatcher's proposal to fund the BBC by advertising and proposing a long-term strategy in

which subscription would replace the licence fee. Essentially, he advised abandoning Reith's priorities and changing the BBC and all associated 'Heritage' industries away from educational priorities towards money-making. He has a special place in the story. Alongside him we might note the significance of Director General John Birt. In his 2002 autobiography he admitted how fiercely he aligned the corporation with the unionist agenda in the late 1990s and opposed devolution in broadcasting, insisting that BBC news 'bound Britain together'. When he put the case to Tony Blair, the then PM grasped the argument immediately and agreed: 'Let's fight'.

Hood concludes *On Television* by noting: 'The future shape of the television industry will be determined by political decisions taken at government level. These decisions will be determined by how that government perceives television – as an industry in which the market decides or as a medium which can provide a public service, supplying the Reithian trinity of information, education and entertainment. These are political issues that deserve to be addressed and discussed by viewers, trade unions, by political party branches. A society – to coin a phrase – gets the kind of television it deserves.'

Well, we deserve a lot better than what we have now. Looking back over the last 50 years, say, what could we single out as exemplary engagements with Scottish literature in radio and screen media?

Many fine writers produced original radio plays or adaptations of classics, and there were, once, countless literary discussions and arts reviews. The medium is perfect for audio work focused on poetry as sound, literature and music, endorsing the literary validity of regional voices, forms of speech and the acoustics of locations. Literature means different things in soundscapes of different geographies, movements on land, river and sea. Think of what the external acoustics of Orkney are like, and what the indoor acoustics of Iona Cathedral are like. All poetry is about movement, one way or another. If Wordsworth's poems are mainly at a walking pace, 'The Birlinn of Clanranald' moves continually upon water, first by rowing, then by sailing, through storm, then finally rowing again. And after its opening episode in the pub, 'Tam o' Shanter' is mainly about riding – first slowly and unsteadily, then at full gallop. Radio is the perfect medium for evoking the sounds of such movements. It doesn't have to be hindered by visual literalism.

Radio plays by writers such as Jessie Kesson, Iain Crichton Smith and Stewart Conn and adaptations by Catherine Lucy Czerkawska and especially Chris Dolan's adaptation of Stevenson's *Kidnapped* and Gerda Stevenson's radio version of Scott's *The Heart of Midlothian*, exemplify a vast and massively under-researched archive, not to mention the biographical and critical value of recorded

interviews and accounts of the lives of major writers. One work of lasting value is the radio play *Carver* (1991) by John Purser (b. 1942), about the life of the great composer of polyphonic church music, Robert Carver (c.1485–c.1570). It was published by Methuen in *Best Radio Plays of 1991: The Giles Cooper BBC Award Winners* (1992).

In film, entire national iconographies have been fashioned and refashioned, most often by people who have neither lived in Scotland nor studied our history. If narrative fiction is the convention of what used to be called quaintly 'feature films' what about poem-films? And where are the film biographies of such great Scots as John Maclean, or Tobias Hume? If they're made for cinema, they can be broadcast on TV.

There's a long history of representations of Scotland, from Laurel and Hardy's *Bonnie Scotland* (1935) to *Brigadoon* (1954) and on, but the list of films whose foundations in vision and writing might be accounted Scottish literature is a lot shorter. Examples might include *Red Road* (2006), co-written and directed by Andrea Arnold or the films of Bill Forsyth (b.1946), such as *Gregory's Girl* (1981) or *Local Hero* (1983), with its extensive location filming in Pennan on Scotland's east coast and Morar and Arisaig on the west coast. Ostensibly a comedy affirming old Scottish priorities over the exploitative materialism and power of American international finance, it opens ambiguities and asks questions about motivation and purpose that permit no easy answers, poised between seriousness and whimsy, dark adult themes and happy optimism. Forsyth's TV film *Andrina* (1981) was an impeccable adaptation of a short story by George Mackay Brown. Jonathan Murray's *Discomfort and Joy: The Cinema of Bill Forsyth* (2011) provides a thorough overview.

Another 'literary' scriptwriter is Alan Sharp (1934–2013), raised in Greenock. After writing two novels of a projected trilogy, *A Green Tree in Gedde* (1965) and *The Wind Shifts* (1967), he went to work in Hollywood. The film *Night Moves* (1975) relocated noir conventions to the post-Watergate era of disillusionment and cynicism, yet Sharp's novel of the film reads like the strange third in the trilogy, as if some of the characters from the earlier books had been transposed to a different ethos. In *Rob Roy* (1995), Sharp returned to Scotland with an epic adventure story, but *Dean Spanley* (2008) came as a complete surprise. Based on a novella by the Irish writer Lord Dunsany, the film, set in Edwardian England, begins as a whimsical, poignant comedy about a Dean of the Church who seems to have been reincarnated from a previous life as a spaniel, yet this startling proposition gives way subtly and gently to an exploration of ageing, the changing relation between a father and his son, and a meditation

on and ultimately an affirmation of the vitality of life, despite the inevitability of mortality.

And so to TV. Given its pitiful current condition it's worth noting as a yard-stick some of the best work of the past. Troy Kennedy Martin (1932–2009) was of the same vintage as John McGrath. Born in Scotland, his early work included the police series *Z-Cars* (1962–78), *The Sweeney* (1975–78) and the serial *Reilly, Ace of Spies* (1980). Like Sharp, he also wrote for Hollywood, but his six-part television serial *Edge of Darkness* (1985) is his masterwork. The story takes the theme of power and corruption in the nuclear industry as it applies within and well beyond national boundaries and Westminster state pol-itics. In a sense, it's a cross-medium sequel to McGrath's play, *The Cheviot, the Stag and the Black, Black Oil* (1973), taking the subject of international com-mercial exploitation to a further stage of history. Scotland, England, Ireland and America are represented in the national identities of the main characters: each has different priorities. In the tensions and unfolding development, the relations between state-centred political authority and the brokers of international power are explored in the form of a thriller. In Stuart Hood's words, it is about 'how politics is lived'. The text of the scripts was published by Faber & Faber and the programmes made available on DVD, while an analysis of the work by John Caughie was published in the British Film Institute's 'Television Classics' series (2008). I'd call *Edge of Darkness* a classic of Scottish literature.

The playscripts and screenplays for television and film by John Byrne (b.1940) cross conventions of literary, visual and screen art forms, beginning with *The Slab Boys* (1978), followed by *Cuttin' a Rug* and *Still Life*, and then a fourth play, *Nova Scotia*. His two TV series, *Tutti Frutti* (1987) and *Your Cheatin' Heart* (1990) are full of wild humour, generous sympathies and tender-ness. Like Hood, Forsyth, Sharp and Kennedy Martin, Byrne is a literary artist whose storytelling and depiction of characters and relationships are equal to those of our finest novelists.

The same might be said of Peter McDougall (b.1947). Glasgow-born, he worked in the shipyards before moving to London, where he began writing. His first television scripts were broadcast in the 1970s to critical acclaim and a shock of recognition. *Just Another Saturday* (1976) focused on a young man's experiences through the day and evening of an Orange Walk in his native city, while *Just a Boy's Game* (1979) recounted another single day experienced by two friends, a construction worker (played by Ken Hutchison) and a gang leader (played by the singer Frankie Miller) trying to move away from his violent past. The American director Martin Scorsese noted that the atmospheric filming was the Scottish equivalent of his own film *Mean Streets*. *Down Where the Buffalo*

Go (1988), starring Harvey Keitel, documented an American officer's experience in the nuclear submarine base near Glasgow and remains an overwhelmingly downbeat account of the social dysfunction brought about in that awful era.

In more recent years, we've had almost nothing to compare with these works, let alone the TV adaptations of great works of Scottish literature from the 1960s and 1970s: *The Master of Ballantrae* (1962), *Sunset Song* (1972), *Weir of Hermiston* (1973), *Willie Rough* (1976), *Clay, Smeddum and Green-den* (1976), *Rob Roy* (1977), *Huntingtower* (1978), *The House with the Green Shutters* (1980), many of these made possible by another heroic figure too easily missed in Scottish literary histories: the producer, Pharic Maclaren (1923–80). We wrote earlier this year about the three-part series *Scotland: The Promised Land* and emphasised how good TV could be, at its best – but this only emphasises how much remains to be done, and thinking of Maclaren, how much has been lost.

In Ireland in Dublin in 1916 it was the Post Office, in Nigeria in the 1960s it was the radio, in Hood's time it was television, and today it's all these plus more: information control of the most far-reaching kind. Not revelation but distraction. Entrapment is the law.

Joseph Goebbels once said, 'The essence of propaganda consists in winning people over to an idea so sincerely, so vitally, that in the end they succumb to it utterly and can never again escape from it.' Richard Strauss went to see Goebbels in Berlin in 1941, to be told, 'Franz Lehar has the masses – and you don't! The art of tomorrow is different from the art of yesterday. And you, Herr Strauss, are from yesterday!'

But maybe that's where resistance always comes from.

From Stuart Hood, 'The Backwardness of Scottish Television', in Karl Miller, ed., *Memoirs of a Modern Scotland* (London: Faber & Faber, 1970):

By what criteria can we judge the quality of a country's television? One is the range and variety of programmes offered to the viewer. Another is the degree of freedom it enjoys to show and speak the truth. A third is its success in reveal-ing a society to itself: on a primitive level by showing its citizens how they speak, behave, live, and on another higher level by revealing to them the mechanics of their society, how it functions politically, economically and culturally. All three criteria are linked. For it is not possible to deal in the truth unless there is a suf-ficiently wide spectrum of programmes to include those which honestly explore the nature of society. No society can be explored unless its broadcasters are free to ask honest questions and answer them. Unless broadcasters are allowed this minimum of freedom, self-revelation is impossible. All over the world there are

societies, ranging from great modern capitalist or socialist states to small, emer-
gent, underdeveloped ones, which have not achieved self-awareness because the
dominant instruments of mass culture do not provide a mirror in which their
citizens can see themselves truthfully. In most countries television is now the
main disseminator of mass culture. In many of them it has either failed in its
duties or been prevented from performing them.

Scottish Literature and New Media

Alan Riach (Friday 9 December 2017)

FIRST OF ALL, there's old media: newspapers and magazines. The American poet Ed Dorn used to run a paper of political-intellectual journalism called *Rolling Stock* in Reagan's America which, he said, was just about the only place where Marxist ideas could be published for a wider readership than specialists. Every issue's first page ran a banner title headline with an Old West locomotive coming straight at the reader with the strapline: 'If it moves – print it!'

Magazines, journals, periodicals of different kinds in different historical epochs, have been an essential part of literary and political culture internationally. Scotland's literature has been vitally nourished by such publications and by literary journalism in newspapers. The early 19th-century rivals, the Tory *Blackwood's Magazine* and the Whig *Edinburgh Review* are famous examples, and in the 20th century, *The Scottish Chapbook*, *The Scottish Nation*, *The Scottish Educational Journal*, *The Modern Scot*, *The Voice of Scotland*, *Lines Review*, *Chapman* and many others were constantly engaged in literary and cultural debates, where contemporary events and new publications were analysed and discussed, new poems and fiction were published, and writers could set out their wares.

In 21st-century Scotland, new technology brings different possibilities yet the key questions remain: whose interests are being served? How does the technology help? What are its liabilities?

Let me offer three different examples of valuable Scottish literary practice in new media, and then a fourth value.

Three e-publications suggest three very different forms of practice. The online journal *Glasgow Review of Books*: https://glasgowreviewofbooks.com/about/ effectively does what a published, paper-dependent magazine would do. Its technology isn't tree-based but computer-reliant. Its 'Home Page' tells us: '*The Glasgow Review of Books* is a review journal publishing short and long reviews, review essays and interviews, as well as translations, fiction, poetry, and visual art. We are interested in all forms of cultural practice and seek to

incorporate more marginal, peripheral or neglected forms into our debates and discussions.'

The emphases are on an international approach, the importance of translation, and the Glasgow base. Currently, the magazine is structured around 'threads': every fortnight new poetry is published; there's 'Translation Thursday' with reviews of translated work or new translations; and short fiction is also published regularly. There are reviews of books and literary festivals. Other 'threads' include ecology (using visual images as well as poetry and criticism). Since the Review is unfunded, the online format makes the material both widely accessible and cost-effective.

I contributed in 2015, when there was a retrospective reassessment of 'Informationism', 21 years after the 'Informationist Primer' anthology *Contraflow on the Superhighway*. The poet who gave the group its name, Richard Price, wrote: 'One of the features of Informationist poetry is its engagement with and deliberate mixing of different linguistic registers, and the interrogation of language's power-bearing qualities in the process.'

That question of power, the interconnectedness and limitations of the 'information society' we inhabit today, was what concerned us, I think, most intuitively, back in the 1980s and especially the 1990s. The most famous recent manifestation of our concerns is in Paul Mason's book, *Postcapitalism* (2015): 'Information is different from every previous technology. Its spontaneous tendency is to dissolve markets, destroy ownership and break down the relationship between work and wages. And that is the deep background to the crisis we are living through.'

Online resources are essential to that crisis, and maybe, its resolution. Our Scottish literary precedents were pre-eminently the late, epic, quotation-filled poems of Hugh MacDiarmid and the referentially wide-ranging poems of Edwin Morgan.

If the *GRB* is an online equivalent of a print-based periodical, even as it makes use of new technology to help with dissemination and cost, a different enterprise is evident with Andy Jackson and Brian Johnstone's *Scotia Extremis* website: https://scotiaextremis.wordpress.com/

Johnstone explains: 'It's a long time since I was last called an extremist – not since my student days, in fact – but from Burns Day this year I've been happy to consider myself as such, though entirely in the cause of poetry. For on that date the Perthshire-based poet Andy Jackson and myself launched a new poetry project, the online anthology *Scotia Extremis*.' The idea was to publish 'writing by a wide range of Scottish poets – from the well-known to almost the yet-to-be discovered': 'poems from the polarities of Scotland's psyche'.

Taking their cue from Hugh MacDiarmid ('I'll ha'e nae hauf-way hoose, but aye be whaur extremes meet') the aim was to explore 'the soul of Scotland' through specially commissioned poems. In Johnstone's words: 'Each week the editors publish a brace of themed poems with a particular Scottish focus: people (past and present), places (real and imagined), culture (high and low), customs (ancient and modern) and more.' While the list represents the editors' interests they're also addressing what they see as objectively intrinsic to Scotland's identity: 'Each theme is designed to represent what might be called an 'icon of Scotland', often of the sort that would be found in museums or arts centres, but equally often such as would not be out of place in the tartan gift shop, on the sports field, the national radio station or the local newsstand.'

Pairings published so far include Burns Night and Up-Helly-Aa, Jenners and The Barras, Charles Rennie Mackintosh and Robert Adam, the Forth Bridge and the 'Bridge Over the Atlantic', Billy Bremner and Archie Gemmill, Celtic Connections and the White Heather Club, black bun and Black Bob. Many more unexpected, bizarre but mutually illuminating pairings are still to come. The invited poets remain ignorant of their partners, so that what gathers is an anthology which examines in poems, from a range of different angles, 'the interplay between extremes of the nation's culture'.

One virtue of the project is that it sets its own limitation: it's intended to last one year, from Burns Day 2016 to spring 2017. There are over 1500 online followers and the number is growing. Online technology is arguably what has made this project possible, though one might imagine a published book coming from it. The excitement and curiosity is most immediate while it's being enacted, and the book would be a resource to return to later, to dwell upon.

The third example is Peter McCarey's *The Syllabary*: http://www.thesyllabary.com/: poetry as new technology arising uniquely in the computer era. In 2006, on his website, 'The Hyperliterary Exchange': http://hyperex.co.uk/reviewsyllabary.php, Edward Picot defined 'hyperliterature' as 'literature which makes use of the computerised/digital medium in such a way that it cannot be reproduced in print'. There are animations, sound-effects, nonlinear structures, interactivities, or combinations of these. Picot's own website: http://www.edwardpicot.com/ links to other hyperliterature sites.

McCarey described the origins of *The Syllabary* as a list of monosyllabic words which formed the basis of his elaborations into short, dense and complex lyrical poems. The priority of syllables as opposed to metrical structures, sonnet or ballad forms for example, abandons rhyme and regulated rhythm for apparently random associations of sound. When you open the site, McCarey says, 'The simplest way to visualize what happens when you're in the programme is

to imagine a set of concentric dials on the door of a safe. The outer dial is the initial, the second is the vowel, and the third is the terminal.' The dial turns, the letters form a sound, sometimes a recognisable word, and if there's a poem behind it, the screen pauses to display it. When there's a fix on a poem, what looks like an old portable typewriter's script takes form as you hear the poet's voice reading it. Then the dials shift again. Visually, the screen is layered with the dials, and then seemingly hand-written words or letter-clusters containing the syllables come and go, horizontally, and fade up into focus or back down to invisibility.

Edward Picot's conclusion is worth noting: 'Igor Stravinsky once wrote that "The more constraints one imposes, the more one frees oneself of the chains that shackle the spirit...the arbitrariness of the constraint only serves to obtain precision of execution." There are other ways of working, of course: but constraint and process certainly seem to suit McCarey. They have enabled him to produce a work of literature which is experimental, elaborate, simple, mathematically precise and deeply personal all at the same time.'

And perfectly suited to online technology in a way no printed poem, or poem from the oral tradition, has ever been.

Paradoxically, the greatest 'futurist' of modern Scottish letters, Edwin Morgan, author of computer poems and hi-tech poem-jinks you'd think online technology was made for, never used a computer: his old typewriter stayed with him pretty much to the end and is now held in the Morgan archive at the Scottish Poetry Library. Yet Morgan knew well enough what the future might portend and in this context, it's also curious to reflect on the fact that he never published a major scholarly work, neither of literary history nor of close analysis of his favoured authors. He did, however, excel as a literary scholar in another form: the essay. With all the technological resources for information and the movement of data, the purpose of the essay remains an essential method of enquiry, whether in print or online.

Morgan's *Essays* (1972) and *Crossing the Border: Essays on Scottish Literature* (1990) prompt a final consideration of the essential need for prose criticism, literary, social, historical accounts, from the Enlightenment to contemporary political and literary analysis. Of many valuable works in this area from the 20th and 21st centuries, among the best are the collection *Scottish Scene: or, the Intelligent Man's Guide to Albyn* (1934) by Hugh MacDiarmid and Lewis Grassic Gibbon and 'The Voice of Scotland' series of books they commissioned early in that decade, including Victor McClure's *Scotland's Inner Man*, Compton Mackenzie's *Catholicism and Scotland*, Eric Linklater's *The Lion and the*

Unicorn, William Power's *Literature and Oatmeal*, Willa Muir's *Mrs Grundy in Scotland* and Edwin Muir's *Scott and Scotland*.

More recently, Neal Ascherson (b. 1932), in *Stone Voices: The Search for Scotland* (2002), continued a tradition of considering literature, the arts, all forms of cultural production in Scotland, in the context of changing social, economic and political conditions. Cairns Craig, general editor of the 'determinations' series from Edinburgh University Press from 1987–97, is similarly committed to deep cultural engagement. This series included titles such as Craig Beveridge and Ronald Turnbull's *The Eclipse of Scottish Culture* (1987), *A Claim of Right for Scotland* (1989), edited by Owen Dudley Edwards, and Alexander Broadie's *The Tradition of Scottish Philosophy* (1990). More recently the series of 'Companions' to Scottish literature published by Edinburgh University and now the Association for Scottish Literary Studies take the spirit of critical enquiry further.

Angus Calder (1942–2008), historian and poet, was the author of major studies of the Second World War, *The People's War* (1969) and *The Myth of the Blitz* (1990), but his major work was *Revolutionary Empire: The Rise of the English-Speaking Empires from the Fifteenth Century to the 1780s* (1981). This is among the best Scottish books of the 20th century. In it, the responsibilities of the professional historian, an assiduous attention to recovered information about the conditions in which people of all kinds lived their lives, and the priorities of a cultural critic, who knows intimately the value of all the arts in the work of human imagination, are perfectly matched. Many literary critics are committed to the latter, many historians to the former, but few writers have brought them together with such lucidity and power. At over 900 pages, *Revolutionary Empire* is monumental, but never flags. It's one of the very few works to take a comprehensive account of the history of the English-speaking world in an international context which gives as much weight to considering the people of Scotland as it does to the people of more imperial centres of gravity. Calder's books of essays and literary appraisal dealing more closely with Scotland's culture and society bring unique insight and contagious engagement: *Revolving Culture: Notes from the Scottish Republic* (1994) and *Scotlands of the Mind* (2002).

To these names I'd add the less familiar one of Thomas Docherty, author of *Aesthetic Democracy* (2006), *Universities at War* (2014) and *Complicity* (2016) which engage fiercely with questions of philosophy, social purpose and morality. The first of these opens with the proposition: 'democracy is impossible in a polity that degrades the arts.' The second applies the argument to tertiary educational priorities in a world where financial wealth is the determining force, 'that

has co-opted its countervailing authority, that of civilization or, tragically, of the university.' The third is a devastating analysis of the relation between ethics and contemporary politics, with brilliant analyses of Shakespeare alongside a close reading of Edwin Morgan's poem for the opening of the Scottish parliament in 2004.

The work of Ascherson, Craig, Calder, Docherty and others is another example of a distinctive characteristic of Scotland: the priority, not only of perception, but of participation. Their examples show how the virtues of Scottish literature, like all other literatures and all the arts, are always with the open, never with things fixed, finally formed and closed. If new media excels in immediacy, essayists, historians and critics like these emphasise the necessity for its complement: incisive, reflective, serious thinking.

The online examples of Scottish literature in new media I began with are necessary practice, but they require the complement of the work that essays do. In her seminal book *Artful* (2012), Ali Smith asks: 'What is a screen?' And answers: 'A thing which divides.' But then she asks: 'Does an image on a screen form the same kind of surface as words on a page?' The answer to that is more complex.

Part Five: Scotland International

What Can We Learn from Edward Dorn?

Alan Riach (Friday 1 April 2016)

WHEN ED DORN died on 10 December 1999, *The Guardian* obituary by James Campbell described him as a poet 'rooted in the imagery of the dispossessed, of working-class America and the mythology of the wild west'. Dorn's practice in his later poetry was to interrogate and satirise excesses of power in darting, elliptical, explosive little poems, often responsive to particular events. Effectively, this was a poetics of critical journalism. As he puts it elsewhere: 'The curtain might rise / anywhere on a single speaker'. The English poet, Tom Raworth, ended his obituary of Dorn in *The Independent* with the sorrow: 'Fools can sleep easier.'

Among Dorn's most lasting attacks on fools are the epigrammatic observations from the 1990 volume *Abhorrences: A Chronicle of the Eighties*. This remains a contemporary guidebook to what Dorn called 'the Rawhide era': Reagan in the White House and Thatcher in Downing Street. The two of them were famously depicted in a poster popular in student flats throughout the decade, based on the cinema hoarding for *Gone with the Wind*, with the leaders of the free world superimposed over the Hollywood icons Clark Gable and Vivien Leigh and instead of a background depicting the burning of Atlanta, a nuclear mushroom blossoming behind them, with the caption, 'She promised she'd follow him to the end of the world – He promised he'd arrange it.'

Dorn's 'chronicle' is even more pungently redolent of the period. Here are the references to AIDS, to the Chernobyl disaster with its nuclear fallout, to popular culture with the *Star Wars* films and the 'Star Wars' nuclear rhetoric, pop songs and TV, Central America, the Lebanon, Algeria, the pieties of local politics and the hypocrisies of the international arena. Black humour is characteristic, elliptical yet unrestrained. The position Dorn takes is that of the solitary individual, not turning his back on society but squaring up to it, face to face, in a confrontational poetry of unhesitating judgement. 'The Protestant View' tells us:

> that eternal dissent
> and the ravages of

faction are preferable
to the voluntary
servitude of blind
obedience.

The temporal nature of popular culture was captured in 'Every example tells a story': 'Like everything else / rock & roll / is here to go away.' Yet the ephemerality of all culture gives Dorn authority in *Abhorrences*. There's a story that at a public reading of his tragic sequence of poems about the native Americans of the south-west, *Recollections of Gran Apacheria*, a questioner drew attention to the fact that the sequence had been published (in 1974) in an A4 comic-book format, with a lurid coloured cover (brazen reds and yellows), poor quality paper, pre-aged, browned and fragile, and the staples destined for rust. Wasn't this a pretty ephemeral way to publish such an important sequence of poems? Dorn nodded in reply: 'Yeah.' Implication: the people concerned were considered ephemeral so why be more precious about poems?

Identity is a function of position and position is a function of power. For Dorn, the objection to poverty is an enablement of authority. When you've nothing to lose, nothing can be taken from you, and your freedom to speak has weight because of that. Its effect is neither the exaggeration of frivolity (commonplace in mass media culture), nor rut-stuck, monotonous, self-indulgent, self-righteous complaint.

The dissenting voice was a great tradition in America from the start: what is the voyage of the Puritans, if not an original act of dissent? Here in Scotland, the great dissenter, Hugh MacDiarmid, in *Lucky Poet* (1943), emphasised that, growing up in the Border town of Langholm, he was familiar from an early age 'with Bret Harte (who was Consul in Glasgow for a time), protesting editorially against a massacre of Indian women and children about which the rest of the community thought it expedient to remain silent, and the outgrowing of his "literary" attitude, and beginning to see the creative possibilities in the life about him; Mark Twain...having "a good time in spite of alkali hell and high wind"; Ambrose Bierce, one of the first American writers to portray war realistically, and one of the few satirists who refused to sell out during the Gilded Age...and John Muir, proving to the reluctant scientists his theory that the Yosemite Valley was formed through erosion... All these and American politics and history which, as Bret Harte had the penetration to see, was the essence of that fun which overlies the surface of our national life enthralled my mind and excited my imagination in a way that nothing English has ever done...' In 1959, MacDiarmid wrote an essay for the Edinburgh University students' magazine *Jabberwock*, 'America's Example to Scottish Writers', welcoming Robert

Creeley, Charles Olson and Allen Ginsberg to a new Scottish readership when they visited Edinburgh.

What exactly is being approved here? (1) commitment to speaking out when silence seems more expedient, and taking the life around you as literary material; (2) refusing to sell out to comfort and celebrity; (3) proving the truth by not giving in; (4) sheer exhilaration and 'fun'; and (5) new forms of address in the American poetry of the 1950s and what was to come in the 60s. The key qualities are of hard observation, moral commitment, fierce independence, self-determination, irrepressible humour, ironic flair, a flourishing sense of engagement, and literary and poetic structures to match and convey all these things. They were as essential to Edward Dorn as they were to Hugh MacDiarmid.

Dorn's early poetry and intellectual life comes out of the rise of American imperialism after the Second World War. The 1950s was, generically, the great era of the Hollywood western. At the beginning of Dorn's long, loose-shouldered, casual, flippant, intensely serious yet constantly ironic 1960s poem, *Gunslinger*, we meet the title character and ask where he's going. The Gunslinger says he has a mission: he intends to seek out the inscrutable 'Hughes, Howard' (inscrutable because 'He / has not been seen since 1833'). This mysterious figure represents an establishment against which Dorn's Gunslinger stands in opposition: 'But when you have found him my Gunslinger / what will you do, oh what will you do?'

The reply is one of those perennially haunting and terrible mysteries:

> You would not know
> That the souls of old Texans
> are in jeopardy in a way not common
> to other men, my singular friend.
> You would not know
> of the long plains night where they carry on
> and arrange their genetic duels
> with men of other states –
> so there is a longhorn bull half mad
> half deity
> who awaits an account from me...

It feels like he's talking about the owner of the Turnberry Hotel.

The final confrontation never happens. Real solutions are redundant in a world so committed to the superficial. This makes the proposition of Dorn's late

work both horrific and prophetic. It is a reinstatement of tribal value, grounded in economics but open to human contact, opposed to the foreclosures of the oligarchs. It tells of bad weather ahead, and clearly, it can be trusted.

Dorn's childhood was characterized by deep hunger for education and knowledge, a yearning for guidance he could trust. He grew up in the 1930s, in the Depression. In 1968 he wrote, 'I was never middle class nor were my parents. I mean our safety was never public. Our poverty was public.' Dorn noted later: 'The first truly educated person I ever met...was a preacher who came to visit my church in what would have been about 1948. Scottish Reverend Aldridge was the first preacher I had heard talk to the congregation like they were adults... And in fact it was the first time I ever heard somebody actually address a group of people in that straightforward way without trying to make things easy or softening, or "it's going to be okay." None of that. It's not okay, and it's not going to be okay was the message...'

In the early 1980s, Dorn started a newspaper called *Rolling Stock*. The cover logo was 'an oncoming steam locomotive, full front. The motive of the project was a freewheeling critical resistance'. The paper was intended to act 'as a vehicle to conduct its marginal crew toward the impossible dream of a drifter's hope'. Its 'thematic assertion of the poetic authority of the hobo carried Dorn's old sympathy for the itinerant class-victim who once survived at the margins of the system by a clever and persistent vagrancy.'

In 1992, Dorn confirmed the socio-religious character that gave spine, depth and flexibility to his own intellectual, spiritual and political development: 'The Protestant Revolution precipitated all the other revolutions, and all the other revolutions were failed revolutions. The American Revolution came out of it. The French Revolution came out of it. The basic proposition of the Protestant Revolution was that authority is inherently corrupt. And you know, Machiavelli said that one of the most salient things about Christianity is its pious cruelty. If torture hadn't already existed, the authority of the Church would have had to invent it, to have *something* it could do with heretics.'

In *High West Rendezvous* (1996), Dorn quotes B. Traven, author of *The Treasure of the Sierra Madre*:

> Only Heretics understand heretics
> only heretics can spread heresy
> and only heretics dare
> to help other heretics.

He elaborates: 'It's a lot easier to be a heretic than it used to be. There are more religions willing to kill you, there are more states willing to cooperate with sectarian harassment, there are more laws cranking out more crimes'.

Dorn was diagnosed with inoperable pancreatic cancer in 1997 and his last, posthumous collection, *Chemo Sábe*, is a testament to the courage with which he faced the terminal showdown. The autobiographical location of his utterance is intensified. Its force has the authority of mortal commitment. When he speaks of his own sense of historical identity, he gives America a global context of human solidarity, against its worst excesses. The poem 'Tribe' notes: 'Governments always conspire against / The population and often / This is not even malice; / Just nothing better to do.' Its culmination is thunderous:

> I'm with the Kurds and the Serbs and the Iraqis
> And every defiant nation this jerk
> Ethnic crazy country bombs –
> World leaders can claim
> What they want about terror,
> As they wholesale helicopters
> To the torturers

And it ends like this: 'it would take more paper / Than I'll ever have to express how justified I feel.'

Dorn's prophecy in these last works is of expanding greed and deepening measures of control, where even terminal illness and hospitalization insulates nothing. The world outside becomes the world inside: globalisation indeed. Against it, his own writing and the dissenting voices of those who recognise its affinity, continue to help. We live and learn from them. Edward Dorn is needed more than ever in the era we're facing up to now.

Edward Dorn's *Collected Poems* (2012) are published by Carcanet Press. Tom Clark's biography is *Edward Dorn: A World of Difference* (2002).

In a 1993 interview, Dorn notes: 'Multiculturalism's denial is so monumental, and their refusal to look at the past's complexities so complete, that history has just dropped out of consideration. It has no meaning, and is part and parcel with an intense anti-intellectualism that now rules. So you can't seek to understand the whole transmission of human life without an intellectual distinction. And that, of course, is totally forbidden.' Asked, 'Do you think that's just cultural relativism?' his response is this: 'No, I think it's programmed ignorance. And like religion of any kind, and like the intention of the state, all states, its function is to enslave, capture and enslave. Once that's even partially successful

economically, it's easier to run a kind of blind consumerism which is the engine then of a further economic reality that seeks to manipulate on a global level. This, of course, is the meaning of "corporate world, corporate globe." And its aim is total control and its outward manifestation is consumerism and its mechanism is ignorance.'

See *Ed Dorn Live: Lectures, Interviews, and Outtakes*, edited by Joseph Richey (Ann Arbor: The University of Michigan Press, 2007)

What Can We Learn from Wole Soyinka?

Alan Riach (Friday 8 April 2016)

IN OCTOBER 1952, the Glasgow-based periodical *Scottish Journal* published an essay entitled 'A Nigerian Looks at Nationality' by L.N. Namme (about whom I have been unable to discover any further information), which begins, 'I am in sympathy with Scottish aspirations for home-rule because...a sense of nationality is one of the most potent sources of cultural inspiration among peoples... Scotland is not alone in her desire for home-rule. The political ferment in Africa shows that the fundamental urge for "nationality" is universal. That is why I am in sympathy with Scottish nationalism.'

When this was published, Wole Soyinka was attending University College, Ibadan, Nigeria, before enrolling as a student at the University of Leeds in 1954 and first entering the United Kingdom. Namme's article notes the rising forces of the African National Congress and a general sense of African resistance to British colonial authority. His singular statement relates all this to Scotland. Ben Okri was to echo him in 1986, writing of Scotland in the *New Statesman*: 'It is another country.'

Soyinka has never written extensively about Scotland or Scottish writers. Indeed, his acknowledgement of the magnitude of achievement in the writings of Shakespeare, the music of Beethoven, and the art of Picasso endorses a non-national appreciation of canonically great art in the western European tradition. But while he is keenly conscious of the scale of this achievement, this is concurrent with his sensitivity to the identity imposed by British imperialism in the construction of the nation called Nigeria. His own life, his memoirs and autobiographies speak eloquently of his adaptation, and that of the folk he grew up among, of both Christian and Yoruba ways of understanding the world and the mythologies of different peoples. Reading Soyinka's books, *Aké: The Years of Childhood* (1981), *Isara: A Voyage Around Essay* (1989), *Ibadan: the Penkelemes Years* (1994) and *You Must Set Forth at Dawn* (2007), his essays and cultural criticism collected in *Art, Dialogue and Outrage* (1988), and his seminal study, *Myth, Literature and the African World* (1976), there are profound affinities in the world-view he inherited and

elaborated and what we might think of in Scotland today. It is as if Soyinka in the 1950s was beginning where Hugh MacDiarmid, in *In Memoriam James Joyce* (1955), left off.

Soyinka's career, from his upbringing to the plays produced in London and his study in Leeds, then back to Nigeria for the country's independence in 1960 and the production of his play *A Dance of the Forests* to celebrate and warn of the dangers of the occasion, demonstrates a practical commitment to, and profound hope in, Nigeria's national regeneration, against all odds. What does this hope arise from?

A Dance of the Forests begins with these words: 'An empty clearing in the forest. Suddenly the soil appears to be breaking and the head of the Dead Woman pushes its way up. Some distance from her, another head begins to appear, that of a man.'

The ancestors return to join the living to observe the birth of the newly independent nation but also to remind us of the momentous responsibility of the occasion, and by the end of the play, festivities are tainted by corruption. The promise held forth to the future remains to be fulfilled. This 'Dance' holds poised and ambivalent what the moment might mean for the unborn generations still to come.

Soyinka's ensuing work, in fiction, plays, satires, critical writing, and his personal engagement as an international ambassador for his country, a peacemaker between hostile groups within Africa, a militant protestor, a criminal imprisoned for most of two years, mainly in solitary confinement, a political enemy at one point sentenced to death by his country's government and in exile for his life, all attest to his continuing commitment and hope.

Nigeria is a collection of old kingdoms and clans: over 200 different ethno-linguistic groups were merged in 1914 by British colonizers. Three main groups – Igbo, Yoruba and Hausa – make up most of the population. While English has been the official language since colonial rule, over 250 languages are spoken in the country. Scotland in the early 21st century has a population of around five million, compared to England's 50 million and Nigeria's 148 million: the contrasts are self-evident. The differences between the national identities of Nigeria and Scotland show how utterly useless any single theory of nationalism is, unless it describes specific historic circumstances. One tiresomely familiar reflex, especially within Britain, is to denounce any form of nationalism as if every form replicated that of Nazi Germany. This is nonsense.

The opening pages of Soyinka's memoir *You Must Set Forth at Dawn* are a series of maps delineating the increasing number of political units within the Nigerian state, from the Three Regions of 1955 to 36 States of 1995. Internecine

dividedness is a component of Scotland's history too, between warring clans, between the Lordship of the Isles and the development of the kingdom of Scotland, or between 45% and 55% of the voters in 2014. The Highland/Lowland divide is probably the most famous historical myth. It serves the purposes of those who would 'divide and rule' but it belies the interconnectedness that characterises Scottish identity. Yet this interconnectedness still needs to be effectively built upon, even now. Dividedness is the dark side of diversity, but diversity needs self-conscious affirmation. The degree of self-government desirable in the different island communities of the north and west is a matter of current concern, with specific islanders acquiring their own land rights by purchase to an extent unimaginable in previous centuries. Nicola Sturgeon's visit to Shetland and Orkney in 2016 was to promise exactly this, and given the present political representative of the northern archipelagos, a promise of something better is evidently much needed.

How might a literary artist deal with legacies of internecine violence? Consider Soyinka's great novel *Season of Anomy* (1973). Set during the Nigerian civil war, the story is graphic in its depictions, yet securely based in the classical Greek myth of Orpheus and Euridice, bringing together potent images of conflict and music, a particular civil war and a universal myth of regeneration which links it to such disparate texts as the American composer Charles Ives's orchestral work, *The Unanswered Question* (1906) and the Scottish northern renaissance Robert Henryson's 15th-century poem, 'Orpheus and Euridices'.

In Soyinka's novel, a traditional village community is presented as a practical social organisation in contrast to the international exploitation espoused by the malevolent 'Cartel'. Ofeyi (Orpheus), band-leader and song-writer, is employed by the Cartel until his subversive lyrics make him their target and his girlfriend Iriyise (Euridice) is abducted, prompting Ofeyi's extended journey with his friend, the band's drummer Zaccheus, in search of her. Their quest takes them on an ever-tightening cycle of encounters (including a meeting with a professional assassin known as the Dentist) and a fugue-like descent through cities, slaughterhouses, insane asylums, jungles, until they find and rescue Iriyise, who is injured and comatose. As the book ends, there is hope – its last words are, 'In the forests, life began to stir.' But there is no certain promise of effortless renewal. Regeneration comes at a cost.

The theme is also central to Soyinka's finest tragedy, *Death and the King's Horseman* (1975). At its heart is the conflict between the justice of traditional propriety with all its radical conservatism and the violence brought about by its disruption. The 'Market Queen' Iyaloja's closing words in the play are: 'Now forget the dead, forget even the living. Turn your mind only to the unborn.'

Crucial to the commitment to political regeneration is satire, for example in Soyinka's plays such as *Opera Wonyosi* (1977), itself in a tradition that goes back to Bertolt Brecht's *The Threepenny Opera* (1928) and further, to John Gay's *The Beggar's Opera* (1728) and Robert Burns's 'The Jolly Beggars' (1785). Hugh MacDiarmid's translation of the Brecht play, his own scatological poems and political commentaries in essays and books, are part of the same tradition of serious, anarchic, often riotous political critique.

One other major way in which MacDiarmid and Soyinka addressed the multiplicity of differences within their respective nations was as anthologists, reconfiguring the poetic history of each country in *The Golden Treasury of Scottish Poetry* (1940) and *Poems of Black Africa* (1975). Each took a radical approach, initiating dialogue across differences of themes, languages and geographical disposition. MacDiarmid's book for the first time included significant translations from Gaelic and Latin poems, alongside work in Scots and English. Soyinka's included translations from Swahili, Yoruba, Portuguese and French, as well as English-language poems, arranging material under headings such as 'Ancestors and Gods', 'Cosmopolis', 'Exile', 'Land and Liberty', 'Praise-Singer and Critic', 'Prayers, Invocations'. The essential principle of both books was that any defined geo-political entity, whether nation or continent, was a place of many voices, and no single imperial identity could insist on their uniformity.

In any nation, the borders of languages are plural, porous, but real. To recognise this is to affirm continuing engagement with the people, history and geography of the nation as a viable state with a legislative structure which might endorse an inextinguishable human dynamic. Soyinka emphasised this in his 2004 musings on the fate of Algeria, where in 1992 a disillusioned electorate democratically voted for a dictatorship in perpetuity. Soyinka commented, 'The perennial problem with that proposition of course is that this denies the dynamic nature of human society'. It was surely this dynamic that was and continues to be enacted in the movement towards Scotland's independence.

On Friday 12 June 2009, Soyinka walked into the Scottish parliament building at Holyrood in Edinburgh and commented publicly, 'Forget about your detractors – I think it is a wonderful building!'

He was there to give a lecture entitled 'Enlightenment and the New Enthusiasms' to the annual meeting of the Consortium of Humanities Centres and Institutes under the auspices of Edinburgh University's Institute for Advanced Studies in the Humanities. Essentially, his thesis was that the two children conceived in the Enlightenment who have had enormous influence subsequently were nationalism and enthusiasm, and both had grown into monstrous distortions. Enthusiasm, signifying an extreme belief in something carrying faith

beyond reason, has led in religious terms to fanaticism, and the suicidal murder of innocents in the name of transcendental purpose. Nationalism, carried to excessive levels of dominance, has propelled imperialist power, racism, caricature and economic exploitation.

It would be difficult to take exception to the thesis. Delivered with characteristic eloquence and passion, the occasion was memorable. But pressed on the question of nationalism, Soyinka seemed compelled to warn of the xenophobic evils of 'uber-nationalism' rather than consider the virtues of 'viable states' – although he used that phrase in recognition of the need for political structure, and he referred to the United Kingdom as 'this federation of nations'. Perhaps this was to acknowledge the location of his lecture, but also, it implied that a federation of small nations might be an antidote to the monstrous development of 'uber-nations' and colonial subjugation.

This balance between condemnation of the monstrous authority of uber-nations and affirmation of identity in terms of 'viable states' and national self-determination is at the heart of Soyinka's memoir, *You Must Set Forth at Dawn*. There is lovely sense of national belonging in this book: 'Instinctively, I turn towards the window when the captain announces that we have entered the Nigerian air-space.' Soyinka's irrepressible good humour in that sentence evokes not only warm pride and blessed self-confirmation, delicate and vulnerable as those may be. Far less is it a matter of national superiorism of the racist variety to which some people remain susceptible, in Scotland as elsewhere. It is rather a sense that whatever location we favour or are born with, there is unfinished business here, matters that still need resolution. In politics, cultural production, languages, civil society and habits of life, much remains to be fought for.

Affirmation needs work. Belonging requires more than sentiment. The natural concerns and responsibilities that come with place and connection, are what Soyinka's words help us keep in mind. And they don't go away.

Wole Soyinka in his own words:

From *Myth, Literature and the African World* (1976):

The epic celebrates the victory of the human spirit over forces inimical to self-extension.

Commonly recognised in most African metaphysics are the three worlds... of the ancestor, the living and the unborn. Less understood or explored is the fourth space, the dark continuum of transition...

From *Art, Dialogue, Outrage* (1988)

What we have always insisted upon, and what has been proved in such an irreversible manner, is that dogma should not, should never have usurped the humanistic goals of mankind, should never have become an alibi for raw, naked power lust and contempt for the mass of humanity.

From *The Open Sore of a Continent* (1996)

When, as the fable teaches us, the king of the forest loses all measure of self and demands that its daily prey deliver itself up to him in meek obedience to an agreed-upon roster of consumption, it is time to confront him with the fathomless resource of alternative power and drown him in the arrogance of a delusion... In a more fundamental sense, however, man is a cultural being. Before politics, there was clearly culture.

I accept Nigeria as a duty, that is all. I accept Nigeria as a responsibility, without sentiment. I accept that entity, Nigeria, as a space into which I happen to have been born, and therefore a space within which I am bound to collaborate with fellow occupants in the pursuit of justice and ethical life, to establish a guaranteed access for all to the resources it produces, and to thwart every tendency in any group to act against that determined common denominator of a rational social existence.

Nationalism and Art: Unanswered Questions in Germany

Alan Riach (Friday 29 April 2016)

I ATTENDED A conference in Jena, Germany, to deliver a keynote address with the title, 'Of Foreigners and Friends'. I arrived on April 20 2016, having been advised that there might be some disruption near the railway station because of a demonstration going on that day. There was. The train stopped a few miles outside of Jena, slowly lurched into a small station named Porstendorf, and stopped. We were told that there was no knowing when it might go on. A group of rather muscular, leather-clad, grim-faced young men got up from the far end of our carriage and marched out, carrying banners and rolled-up flags. We watched them go. One was sporting a Union Jack on his jacket.

It turned out these were pro-fascist Nazi demonstrators, heading for Jena to join the crowds. This happened to be Hitler's birthday (he would have been 127.) After a while, and with the kind help of a young émigré Russian, now living in Germany, we got a taxi to take us to the vicinity of the town centre. We walked through a cordon of maybe a dozen police vans, policemen standing all round, armed, flak-armoured and Darth Vader-helmeted. The shouts and chants had gone further down the street.

The following day, the conference got underway. The theme was 'Disrespected Neighbours' and talks ranged across Canada/America, India/Pakistan, Romany people in Europe, sectarian Ireland, Polish and British prejudices during the Second World War, Irish/Welsh/English relations in medieval times, and some other things closer to home. In the evening, I got back to my hotel and turned on the TV news: a report on the celebrations in Britain that had been taking place on April 21: the UK Queen's 90th birthday. How many ironies were layering here? They were all closely connected with the papers and discussions that went on throughout the three-day conference.

Nationalism is so easily equated with fascism, and indeed Nazism. One scholar illustrated his talk with the appalling image from the front page of the *Scotland on Sunday* supplement (April 7 2013) of silhouetted figures on a

hilltop, raising a flag in the blue and white colours of the Saltire, but against the blue background, the white cross was in the shape of the swastika. The caption read, 'Klan Alba', alluding not only to Nazism but also the Ku Klux Klan. My colleagues at the conference, from Germany, Poland, India, Romania, Canada, all over the world, were seriously shocked.

So let's turn it around. How would we show clearly that what we're talking about in Scotland is not conducive to fascism?

In the aftermath of the Second World War, the exclusion of Scottish art from the Edinburgh International Festival resonated for decades with the implication that Scottish art had no international calibre. And the centralisation of the Arts Council in London with a Scottish regional division also emphasised the idea that Scotland was no more than a region. Our institutional education system in Scotland neglected and oppressed Scottish history and literature and the Gaelic and Scots languages (with one exception, Mr Burns), not to mention works of art and music by Scottish artists and composers. But things were changing, and have continued to change, with the establishment of the Saltire Society (1936), the Scottish Arts Council (1967), the Association for Scottish Literary Studies (1970) and the National Theatre of Scotland (2006), and with art galleries established in Orkney (the Pier Arts Centre, Stromness, 1979), in Dundee (Contemporary Arts, 1999), in Lewis (An Lanntair, Stornoway, 2005), the Shetland Museum (Lerwick, 2007). All these initiatives since the Second World War herald new possibilities, new beginnings in particular localities beyond Glasgow and Edinburgh. These institutions, organisations and galleries, sustained by contributions from experts and professionals, were not always there. Yet the legacy of long-standing institutional neglect of, and hostility to, the full inheritance of the arts of Scotland is still with us.

'What is Scottish about Scottish art?' I was asked recently, giving a talk about J.D. Fergusson. 'That's got nothing to do with Scotland,' someone said. 'It's about colour, rhythm and form. That's all.'

It's the old unionist mantra. All art is universal. Nations don't matter. Especially not Scotland because Britain is what counts (especially England) and Scotland's just a wee toty bit of that.

The real and proper answer is, Hokusai is Japanese, Monet is French, Goya is Spanish, Turner is English. You could go on. So, George Jamesone, William McTaggart, Guthrie, Henry, Mackintosh, the Macdonalds, Margaret and Frances, Fergusson, Cadell, Peploe, Joan Eardley, David Donaldson, Alexander Goudie, John Cunningham, Ruth Nicol, are Scottish: they, and their best work, could have come from nowhere else.

And the key thing is this: each of them has possession in their work of particular aspects of Scotland, which their work gives – I mean, *gives* – to anyone willing and able to look at it, study it, and enjoy it closely.

Someone said to me the other day, but it's good that people are discussing these things!

Well, what's so good about going round in circles with a question that has an answer that once you understand it, means you have to do something about it? Sometimes, discussion is distraction. Go away and discuss these matters while we fill up our offshore bank accounts. Or, to put it more aggressively, 'Here's a plastic bag, sonny, away and play at spacemen!'

Great artists are quite normally identified with their nations: Verdi and Wagner, Grieg, Sibelius, Pushkin, Borodin, the French Impressionists. Many were deeply aware of how national cultures interact with one another. Consider Debussy's reaction to German music. Art reflects and represents a nation's self-esteem. Artists present their nation's culture to the world. Think of Italian neo-realist cinema, Satyajit Ray's 'Apu' trilogy, Bergman's film visions of Sweden, and Kurosawa's of Japan. And the displaced artists of the 20th century, Stravinsky, Rachmaninov, Schoenberg, Bartok, remain true to themselves by reinventing their national cultures, rejuvenating them, in all their travels and residences. *The Rite of Spring* may be an international paradigm of Modernism in music, yet Stravinsky chose to give it a subtitle: 'Pictures of Pagan Russia'. These artists and composers aren't 'international' Modernists who came from nowhere in particular. National identity is strengthened, enriched and sensitised by the recognition of difference. Its value, purpose and distinction relies upon such difference: foreignness, indeed. And learning about such differences.

Which was the subject of my lecture: 'Of Foreigners and Friends'.

George Osborne was the Chancellor of the UK's coalition Conservative and Liberal Democrat government when he visited Scotland on February 13, 2014. He was here to tell Scots and the world of his opposition to an independent Scotland, and how his job as he saw it was to stop it coming into existence by ruling out of consideration the prospect of a continuing shared currency between Scotland and the rest of the UK.

Close in on the rhetoric Osborne employed in the high (or low) point of his speech: the moment burnt into the memory of many of us who remember that day. This is what he said to begin with: 'The stakes couldn't be higher or the choice clearer. The certainty and security of being part of the UK or the uncertainty and risk of going it alone. At the very heart of this choice is the pound in your pocket.'

He escalated the rhetoric as he went on – and if you look online at the government webpage where the speech is reproduced, it's fascinating to see how line-breaks are managed, as if the speech were a poem, presumably showing him, as he was reading it, where to pause for the greatest emphasis. At the heart of his speech was this: 'The value of the pound lies in the entire monetary system underpinning it... So when the nationalists say "the pound is as much ours as the rest of the UK's" are they really saying that an independent Scotland could insist that taxpayers in a nation it has just voted to leave...

'had to continue to back the currency of this new **foreign** country

'had to consider the circumstances of this **foreign** country when setting their interest rates

'stand behind the banks of this **foreign** country as a lender of last resort

'or stand behind its **foreign** government when it needed public spending support.

'That is patently absurd.

'If Scotland walks away from the UK, it walks away from the UK pound.'

That's four 'foreigns' in as many lines. Osborne was saying that an independent country would be a foreign country, run by a foreign government. His opposition to that prospect – his absolute 'unfriendliness' – uttered as it was in the erstwhile capital city of that country – was implicitly transferred to the country and city he was in. In other words, he was standing as a native of Britain, the UK, and creating in the imaginations of everyone watching him the context, for a moment, of being in a foreign and unfriendly nation, beyond whose borders, and only beyond whose borders, good government, money, safety and security lay. This is how he concluded: 'There is an alternative, confident, future for Scotland. [...] A future of jobs and prosperity and peace of mind. It's a strong Scotland within a United Kingdom. That is a future worth fighting for.'

And then he walked swiftly out of the building and took the quickest route back to London before anyone could draw breath to ask a question. This was not up for discussion. He was off. He'd done the job. 'Independent' from now on, the word itself, would mean 'foreign'. We – people living in Scotland – were now not to see ourselves as citizens, not even neighbours, but as foreigners. This was an exercise in projection, a double or triple bluff, audacious, surely, and startling in its combination of sophistication and crudity, its appeal and its repulsiveness, its credibility and its absurdity.

I'm reminded of a great poem by Norman MacCaig, one of that brilliant generation of Scottish poets who began writing through the Second World War and wrote their finest works from the 1970s on. Each had their favoured location in Scotland, each one mapping out a territory, charging places with real,

renewable value quite different from the economics that were prioritised in the rhetoric of Osborne and others of his stripe. George Mackay Brown in the Orkney archipelago, Sorley Maclean in Raasay and Skye in the Inner Hebrides, Iain Crichton Smith in Lewis and the Outer Hebrides, Edwin Morgan in Glasgow. For Norman MacCaig, Edinburgh was home but Lochinver, in Assynt, up in the far north-west of mainland Scotland, was the favoured place. And it came with its own geology and its own history. MacCaig returned there every summer for many years, so he was not a tourist or even a visitor but, we might say, an intermittent but regular resident. The poem that answers Osborne's monstrous creation of this 'foreign' country is 'Two Thieves' – an angry poem that stays angry because of its careful organisation of tone in the English language, evoking the Gaelic language in its opening lines: 'At the Place for Pulling Up Boats / (one word in Gaelic) the tide is full. / It seeps over the grass like a robber. / Which it is.'

The tide has robbed the coast of the 'smooth green sward / where the Duke of Sutherland / turned his coach and four' just a few generations ago. MacCaig notes that must have been 'an image of richness, a tiny pageantry / in this small dying place' where every house is now 'lived in / by the sad widow of a fine strong man.' Then the anger starts building: 'There were fine strong men in the Duke's time. / He drove them to the shore. He drove them / to Canada.' And the explosive alliteration and hammer-blow monosyllables in the final lines say it in thunder:

> He gave no friendly thought to them
> as he turned his coach and four
> by the Place for Pulling Up Boats
> where no boats are.

No friendly thoughts were there in our own time either, from George, that day in Edinburgh. Foreigners indeed.

Whether in the verbal, mediated, propaganda warfare of the 2014 referendum, or the long history of imperialism's oppression of linguistic diversity and what are called 'minority languages' – in every case, the examples can only be partial, contingent upon circumstance. The arts are never absolute and finished. As Brecht puts it most memorably, 'How long do works endure? / As long as they remain unfinished.' Equally, what seems like an absolute judgement from political or economic gurus, is part of a larger gambit, takes place in a continuing debate. Norman MacCaig laments the eviction of crofters and the loss of their Gaelic language, but since he wrote his poems, in various locations crofters

have bought out big landowners and repossessed the land, and more people are learning Gaelic now than for generations.

Before we left Jena, we had a free hour or two and wandered into the town square art gallery and happened upon an exhibition entitled 'The Woman in the Mirror' showing a range of work by Bonnard, Braque, Cézanne, Chagall, Degas, Léger, Manet, Matisse, Picasso, Renoir, Toulouse-Lautrec. All this in a small, provincial mid-German town. Maybe the cultural sophistication, civic generosity, multi-ethnic population and university presence in the town had made it a target for the fascist march. I don't know. I do know that the priorities of art and education in the unfinished expression of national identities, building them in free invention, to take further and renew the sensitisation of the world, are at the opposite end of the spectrum of human behaviour, from fascism.

For pre-eminently through works of art, the virtues of national, local and linguistic distinctions are made public, given to people, universally. Foreignness, in this sense, is not a threat or an imposition, but a matter of curiosity, of optimistic enquiry, of engagement and extension of the human spirit. It is what all the arts so freely offer us, what George Osborne has never understood, and what Norman MacCaig so memorably captured in his poems. And it is at the heart of social and intellectual life, what characterises, for me, more than anything else, the unanswered question of Scotland's independence.

As we flew home last Saturday night, I heard the KLM pilot say, 'Ladies and gentlemen, boys and girls, we have just entered the Scottish air space...'

My eyes turned towards the window –

Europe, Scotland and the Celts (Part 1)

Alexander Moffat and Alan Riach (Friday 24 June 2016)

IN THE IMMEDIATE aftermath of the referendum on whether or not the United Kingdom should remain a part of the European Union, it's pertinent to consider what information our cultural history might give us about this question. Nobody on either side said much about this but we believe that the major exhibition, 'Celts: art and identity', which ran at the National Museum of Scotland in Edinburgh until 26 September 2016, still has a lot to tell us.

Scotland has always been in Europe in a way that distinguishes the nation from the cultural politics of the British Empire. That Empire claimed a 'superior' position. It defined itself as a dominant force in global politics, taking the Roman Empire as its most significant precedent. The contrast was with the idea of a number of distinctive national states made of a diversity of regions, languages and forms of cultural production, constituting a broader, more co-operative, unity-in-diversity. To oversimplify, the imperial model is contesting and competitive. The greater the ferocity of the competition, the more bullish the soundbite rhetoric and the more proximate the violence. What we have recently witnessed regarding the EU referendum was an exaggeration of this condition propounded by mass media. The viability of culture as generating distinctive national identity has been unmentionable in the rhetoric of the recent campaigners for 'leave'. The cultural dimensions of this idea have barely been noted by the 'remain' people, although they constitute precisely the same arguments for Scottish independence.

So what we're considering here is the political structure of Europe, the matter of national cultural identities and the international reach of artistic provenance. Despite the alarmist predictions of the 'out' campaign, today's EU is the opposite of a homogeneous super-state – neither a state nor an empire but a union of states and peoples whose policies were arrived at through consensus-seeking and compromise.

It's significant that the Edinburgh exhibition is subtitled: 'art and identity' because how identity is expressed and delivered through works of art is at its heart. What it presents is a vast range of material that confirms not merely 'Celtic' identities scattered around the 'British periphery' but multiple centres thriving throughout northern Europe across centuries. There are many artefacts from Scotland, but if we go along with the exhibition, travelling from the Black Sea, following the course of the Danube, through Rumania, into Switzerland and northern France, to Denmark, and along the Rhine, the first distinction that appears is geographical: this is a multi-faceted but evidently North European tribal world, to be distinguished from the South European, Mediterranean-based cultures of Greece and Rome, and most clearly contrasted against the Roman Empire. In fact, what defines the art and identity of the Celts is perhaps not any unifying character but a sense of difference from Empire and imperialism. There are many centres. There is no single dominating one, no Rome, no Madrid, no London. There is a world changing in time, of tribal territories, of languages, forms of music, religion, literary and visual arts. What gives this world coherence are its human priorities, the relations it presents across geographies and through generations.

Contrast this pluralism with recent political history. The Labour government of the 1940s and early 1950s is generally understood to have initiated the NHS and demonstrated a sense of social value, a prioritisation of good things – but the same rule was also consolidating the Tory-established authority of Churchill's Second World War government. Particularly in foreign policy, it could be argued that both Attlee and Churchill were singing from the same song-sheet. In a similar way, it seemed to many people in the 1990s that Tony Blair was re-establishing Labour priorities when he was in fact consolidating Thatcherism as 'New Labour'. In the 40s and 50s, the development of centralised capital-based power was an imperial project intended to retain, develop and deepen the legitimacy of London that was not to be challenged. The 'Home Rule' movement for Scotland, which had been present from the very beginning of Labour in the late 19th century with Keir Hardy and Cunninghame Graham, was dropped from the Party's constitution and as we know from recent years, its status for Labour remains in contention.

Empire replicates its own authority. Or attempts to, and fails in the attempt, just as the Labour and Conservative parties in Britain today implode into factions in their contest to maintain superior imperial authority.

The example set by the Celts is different. Let's call it a panorama of European tribal-regional identities extending in different forms through many nations, formed and reformed over millennia.

If you see the 19th-century rise of nationalism as leading to imperial con-
tests and world wars, ultimately 'uber-nationalism' and Nazism, the antidote is
already there in the Celts: the proper corrective to unitary, conformist nation-
alism's urge towards imperialism is state regionalism. Which is why Scotland's
independence should explicitly and vigorously favour the constituent identities
of the island archipelagos, all the points of the compass, the diversities of lan-
guage and culture, overlaps and contrasts, all the territories of the nation.

And the only way this emphasis can be fully delivered is through the arts.
Every other priority devalues what the arts are created to give.

This is not utopian. Nobody could say that the artefacts in the Celts exhi-
bition don't exemplify practices of conflict and violence, or that the priorities
of decorative art don't decidedly imply wealth and authority. Yet the quality of
such ancient artefacts speaks of cultural values from which 21st-century tabloid
gutter-mongering and the garish exhibits of bling fashion and catchphrase pol-
itics are surely a long descent.

Nor are the artefacts of the Celts totally resistant to coercive application in
such assertions of power as British nationalism. From the 17th century onwards
attempts to reconstruct a British Celtic past multiplied, often according to spe-
cific national agendas. In England the Celtic past was used frequently for pro-
paganda purposes, to promote and celebrate the British Empire. The exhibition
catalogue edited by Julia Farley and Fraser Hunter illustrates a work by the
English sculptor Thomas Thorneycroft, commissioned by Prince Albert to make
a larger-than-life equestrian statue 'Boadicea and her Daughters' for the 1851
Great Exhibition. It was cast in 1902 and stands on the Thames Embankment,
'remaining to this day an enduring example of British imperial propaganda.'

'"Boudica" was said to mean "victory", providing a symbolic semantic link
between Queen Victoria and the Celtic Queen.' The authority embodied in the
sculpture, British nationalism, the legacy of imperialism, comes to us in the 21st
century through contemporary mass media every day and evening, rolling along
in the 'national' news, unassailable, but devastatingly satirised by James Robert-
son, in his 365–word satire 'The News Where You Are': check it out in his book,
365 Stories, and online: https://www.youtube.com/watch?v=ZhL57cjN8xY

That sculpture has its date and place. Yet all the finest art in this exhibi-
tion is modern – from prehistoric stone sculptures and cave paintings to the
design of bronze-age musical instruments, from pre-Christian figurative art to
the paintings of the 18th, 19th and 20th centuries: everything speaks of, and to,
Modernism. Compare, for example, the two-sided sandstone statue from south-
west Germany (500–400 BC) with Picasso's sculptures of the early 1950s: the
affinities are startling.

When the Celtic Revival moves from the late 19th century into Modernism, it drives forward into real political effect. Expressionism, cubism, surrealism, all the modern movements in the visual arts make the ancient arts of the Celts familiar to us today. No longer are they merely inexplicable: magic, mysterious, mystical depictions of gods and monsters. To anyone well-read in Modernism, they are immediately comprehensible human expressions of aspects and identities people created in a world defined by seasons and geographies, family and tribal relations, languages, festivities, ceremonial occasions and rites of passage. They have their local provenance and human applications, just as surely as they have their resonance and example carrying across millennia. They are as continuingly immediate as Stravinsky, Picasso, MacDiarmid, J.D. Fergusson and Erik Chisholm.

This is the key thing: what artists can do is different from what historical accuracy and painstaking archaeological reconstruction can do. Their practices overlap, but the arts (visual, literary, musical, all of them) re-imagine and rejuvenate. And, carefully and accurately noted in the exhibition, this is what, in very different ways, James Macpherson in the late 18th century and Patrick Geddes in the late 19th century set out to do. For MacDiarmid, Geddes was the key figure, his influence essential.

This is what MacDiarmid drew attention to in his Open Letter to a Glasgow Undergraduate (1946), published in *The National* (May 20, 2016 [reproduced later in the present book]). He quoted Geddes: 'To avoid the Scylla of paleotechnic peace and the Charybdis of War, the leaders of this coming polity will steer a bold course for Eutopia [sic]. They will aim at the development of every region, its folk, work, and place, in terms of the *genius loci*, of every nation, according to the best of its tradition and spirit; but in such wise that each region, each nation, makes its unique contribution to the rich pattern of our ever-evolving Western civilisation'. And then MacDiarmid confirmed the continuity of his own efforts in the 20th century: 'That was why Geddes in the '90s started the Scottish Renaissance. That was why after the 1914–18 War I restarted it (with Geddes's approval and help). That is why I am asking you now to throw all your weight in with us in this great cause. Other countries may be left to their own students, who know them; Scotland is our job.'

Chapter 1 of the exhibition catalogue states that most books on Celtic art seek to show a continuity from prehistory to medieval or even modern times, tracing 'a thread of development': but, we are told, 'This is not our story. We see not one style, but several; not one history, but many. There were links, but also dissimilarities. These Celtic arts – plural – need to be placed into their own histories.'

Noting widespread similarities and regional variations, there is not a single tradition but different arts in different times and places: 'These different Celtic arts were people's way of marking beliefs and expressing power, understanding their own heritage and their place in the world.' The first chapter ends by emphasising the 'relations and connections' between people never completely unified by language, geography or genetics, but reinventing themselves at times of contact and change, as worlds and cultures make contact or collide, trade, take their parts in a truly common market, a human universe. The focus in the exhibition is 'on the period from c.500 BC to AD 800' but extends 'almost to the present day.'

That 'almost' is where we would pick up the traces and bring things to bear upon where we are now.

Among the foremost contemporary Celtic poets, Aonghas MacNeacail (b.1942), in his poem, 'not history but memory' in *A Proper Schooling* (1997), emphasises this point: 'when i was young / it wasn't history but memory'. A monoglot Gael on the Isle of Skye till the age of five, his education was equally monoglot in English, although most of his teachers were also Gaelic speakers. The damage had been done long before. The 1872 Education (Scotland) Act, which introduced compulsory education, did not even acknowledge the existence of Gaelic.

This is the long-term cultural legacy of MacDiarmid's opposition to what he called 'the English ethos': not simply a racist, xenophobic, reactionary response to Empire, but a detailed, nuanced, sensitised journey of understanding those components of human identity that distinguished Scotland, and connected the Scots and Irish peoples and many others in a Celtic European cultural history that had been neglected, co-opted, or deliberately suppressed by the British Empire. Writers and artists in Scotland especially since MacDiarmid have explored and confirmed the multifaceted Celtic identities this exhibition displays so wonderfully.

This should alert us to a much more complex and comprehensive world of relations, influences and interconnections, in all the arts in Scotland, Ireland, Wales and Cornwall, and emphatically throughout Europe, as this exhibition demonstrates, since prehistoric times.

What we can find in this exhibition, if we look closely, are continuing affirmations of ancient ideas of 'renaissance' meaning simply rebirth, decided acts of cultural rejuvenation, a healthy appetite for regeneration, all across Northern Europe, in opposition to reactionary ideals of imperial authority and the foreclosures of conservatism – of either the Cameron-Osborne or the Johnson-Gove varieties. Or any other.

It's time our politicians learnt a bit more about this.

Europe, Scotland and the Celts (Part 2)

Alexander Moffat and Alan Riach (Friday 1 July 2016)

THE CELTIC REVIVAL of the late 19th century, so often disparaged as nostalgic and backward-looking, was in fact the precursor of the modern movement in Scotland. The 'Celts: art and identity' exhibition, currently running at the National Museum of Scotland in Edinburgh, shows us that the emphasis on skill and design and craftwork, central to the revival, led directly to the Celtic Modernism of the 'Glasgow Style' in the work of Charles Rennie Mackintosh, Frances and Margaret MacDonald and Herbert McNair. For The Four, as for many Scottish artists of the avant-garde, the stylised forms of Celtic art provided a pathway to Modernism. At the same time in Edinburgh, the Celtic Revival flourished under the inspirational leadership of the biologist and utopian visionary Patrick Geddes who commissioned male and female artist-designers like Phoebe Traquair to undertake mural schemes, invited artists and scientists to his annual 'summer schools' and encouraged Scottish and French artists and writers to contribute to his journal, *The Evergreen*, published in four volumes from 1895 to 1896. Geddes himself contributed an essay entitled 'The Celtic Renascence' which had a huge influence on the young Hugh MacDiarmid.

In his book *Modern Scottish Painting* (1943), J.D. Fergusson says that the point about the modern movement in painting of around 1903–13, and especially the work of the cubists Picasso and Braque, was to acknowledge 'the resemblances the average person finds in modern painting to ancient painting, I mean Stone Age and that sort of ancientness [...] When things are brought down or come down to fundamentals they do resemble each other in spite of many thousands or perhaps hundreds of thousands of years of time.' Modern painting, or modernism in all the arts, 'was an attempt to get back to fundamentals, and it succeeded [...] So there's nothing *out of order* about really modern painting resembling really ancient painting, which was in its time of course really modern...' Fergusson's magnificent *Danu, Mother of the Gods* uses the symbolism of the Celtic Revival to address a later, distinctly 20th-century world, and in

his drawings and embellishments for MacDiarmid's *In Memoriam James Joyce* (1955), Fergusson brings art, literature and music together in the ancient Celtic Ogham script, just as the poem sings praises of all forms of human creativity throughout time and across the world. When Fergusson was in Paris before the First World War, the city's liberation of his imagination was surely partly due to the fact that he found himself among his fellow-Celts.

Revolutionary modernism for Scotland, as for elsewhere, entailed a revitalisation of rural and non-urban forms of language, social order and communal affiliation. Regenerating older traditions in the modern world was revolutionary in Scotland because it opposed the deadening hand of imperial hierarchy and the pretentiousness of cultural 'sophistication'. It returned the artistic elites to contact with the potential of people, generally, as surely and closely as J.M. Synge heard, internalised, and wrote in the idioms of rural Irish speech through his residences in Wicklow and the Aran islands, or as Jack Yeats saw, sketched and painted the people of Sligo and the west. Their art is no more naive than MacDiarmid's or MacLean's, and as advanced as that of Brecht or Munch.

The significance of this for us is that the artistic and political revolutions enacted in modernism in Ireland in the work of Synge, Joyce, Yeats, Sean O'Casey, Flann O'Brien and others, and in Scotland in the work of MacDiarmid, Lewis Grassic Gibbon, Neil Gunn, Nan Shepherd, Catherine Carswell, Willa and Edwin Muir and others, are, along with the political ideals of egalitarianism, self-determination and opposition to imperialism, all related in their attempts to get back to 'the fundamentals'. Fergusson, like Picasso, is only as 'advanced' as the work in the caves at Lascaux.

The fundamental thing about the Celts might be described as the matter of centralisation and goes back beyond Celtic Christianity. In his book, *Scotland's Music*, John Purser observes that 'it has never been in the nature of Celtic society to centralise' and that the Celtic church may be characterised by its distinctive 'philosophy, organisation, language use, literary style' and other aspects of ecclesiastical practice that had adapted older, pre-Christian belief systems but were overtaken by the centralisation of the church in Rome.

To juxtapose that contentious episode with another equally contentious: the exhibition describes (with admirable and unusual clarity) the popularity of James Macpherson's 'Ossian' books and the hostility shown to them by Samuel Johnson. Johnson, compiling his English dictionary and establishing an authoritative language of cultural power that confirmed imperial superiority, was faced with an upstart Scot propounding a different tradition in the Celtic world going back before Latin. In the wake of Culloden, Macpherson was stating in an immediately popular Enlightenment English that Gaelic Scotland was the cradle

of an ancient civilisation as valid and deep as any and more so than most, certainly more so than that being ruled by the Hanoverian, only recently united, kingdom of Britain. No wonder Johnson hated him.

At one end of the spectrum of national identity we can find vanity (nothing could be better than us); at the other end, self-confidence. This self-confidence might be a fragile, vulnerable thing: we have to be able to take criticism. The anxieties that underlie vanity can be superseded by mature and sensitive self-confidence, an openness, opposed to the closed. Confidence doesn't have to be arrogance. In other words, you neither cringe (we're just not good enough), nor do you vaunt your ego (we're incomparable, always right): rather, you think about it, seriously.

Maybe the lesson is that the best nation state would be one in which people were at ease with their own plurality, and open to revision, able to choose for themselves their own 'elective affinities'. Arguably, this was made possible for us in the turn from the 19th to the 20th centuries, when readership, audience, public sensibility, began to fragment and diversify.

The work of Robert Louis Stevenson addresses local and international readers, children, travellers, colonials, imperialists, tribes of many kinds, just as printed work is becoming more widely available and commercialised interests are exploiting new readerships eagerly. The Celtic Revival contemporary with Stevenson is not really opposed to the rise of modernism: it runs into it, as Declan Kiberd reminds us in *Ulysses and Us: The Art of Everyday Life in Joyce's Masterpiece* (2009). And it resumes with new vigour after the Second World War: bloody revolutionary modernism led to political disasters but the arts show other ways. And in specific works by a range of writers, artists and composers, as the Celts exhibition shows brilliantly, this is evident through the engagement with Celtic myths and identities, from the old gods, through Cuchulain and the warrior cycle, to Ossian and tales of the Fianna.

The legacy evokes heroism, noble ideals, but pomp calls for satire and circumstance for subversion. Oliver Sheppard's magnificent sculpture 'The Dying Cuchulain' was moved to the General Post Office in Dublin in 1935 in preparation for the 20th commemoration of the Easter rising, a solemn emblem. In 1938, in his poem 'The Statues', Yeats asks: 'When Pearse summoned Cuchulain to his side, / What stalked through the Post Office?' He calls upon 'We Irish', born of 'an ancient sect' but 'thrown upon' a 'filthy modern tide' to climb 'to our proper dark' so that the beauty of 'a plummet-measured face', a (perhaps terrible) beauty arising from the depths of history, may be seen in full understanding. The mysteries or ambiguities in these lines are multiple but there is surely commitment to both heroic aspiration and genuine humility. If there is

nobility here, it is vulnerable. Samuel Beckett also invokes Cuchulain in *Murphy* (1957): the hero is now embodied in the statue in the Post Office, and the icon of self-sacrifice is the focus for the novel's suicidal Neary, in a scene that could be described as radically iconoclastic comedy or hideous farce.

Old stories tell of Cuchulain learning the arts of war from Skathach, at Dunskaith, just off the Isle of Skye. This generates a different, fiercely feminist reading of not his but *her* story, centred in Scotland, in Janet Paisley's novel *Warrior Daughter* (2009). The novel is a self-conscious validation of feminist priorities.

The point about all this is that the Celtic myths are durable because they can be used in so many ways.

From pre-Christian oral traditions, to the plantation of Ulster, to Irish immigration into early 20th-century Scotland, national identities are recip-rocal, never wholly cut-off and defined. Thus the Scots language of Burns is shared and branches out among a whole school of Ulster poets. Joyce, prefer-ring Finn and the outlaws (last minstrels, outsiders) rather than warrior-heroes like Yeats's Cuchulain, prefigures MacDiarmid's preference for the 'Hjok-Finnie body' which he describes in the chapter 'A Ride on a Neugle' in his 'autobiogra-phy' *Lucky Poet* (1943).

Ossian the bard is most vivid to us today not only from Macpherson but in the visual arts, from the astonishing drawings and sketches of Alexander Runciman (1736–83) to the montage photographs of Calum Colvin, especially his 'Blind Ossian' (2001). Celtic gods and warriors inhabit the symbolist, figu-rative art of John Duncan (1866–1945), with *The Fomors* and *The Riders of the Sidhe*. The recuperation of the Celtic myths in modernist work was, and is, triggered by the conjunction of abstraction and reality signalled across a century since Easter 1916.

As for connections in specific instances, think of these. In the visual arts in Scotland, the proto-impressionist Gaelic-speaking William McTaggart (1835–1910), in the 1890s, painted a series of major canvases on two major themes: the coming of Columba to Scotland from Ireland, and the leaving of Scotland by emigrants. One theme portends regeneration, in spiritual, social, political reality, most evident in the greatest work ever to rise from what we might call a school of art: Iona's *Book of Kells*. The other depicts immediate and recent catastro-phe, and portends the politics of resistance the 20th century would bring, and this points forward to, for example, the outdoor sculptures of Will Maclean, commemorating the Clearances in Lewis and the western isles.

The exhibition begins with the eye-skinning wonder of Henry and Hornel's gold-framed painting *The Druids: Bringing in the Mistletoe* (1890). If they ever

saw this, Diaghelev and Stravinsky would have been delighted, if not envious. The fact that its portraits may owe something to the native Americans the artists may have seen in Buffalo Bill's Wild West Show (1889) only adds to the contemporaneity of the vision. What history or science would describe as inauthentic, in the work of art becomes valid and speaks about things that are true.

In music, the ancient 'Deirdre's Farewell', sung as she prepares to leave Scotland to return to Ireland, might contrast with 'Fingal's Cave' (1830) by Mendelssohn, celebrating his exhilarating arrival in a Scotland made new by international Romanticism. But then come forward to the American Amy Beach's 'Gaelic Symphony' (1894–96). There's no doubt about the British nationalism embodied by Boadicea on the Embankment, but Edward Elgar's cantata *Caractacus* (1898) might suggest resistance to imperial domination rather than oppressions of imperial rule. Check it out.

And consider Arnold Bax's 'Harp Quintet'(1919) and 'Third Symphony' (1928–29), written overlooking the white sands of Morar. And Granville Bantock's 'Celtic Symphony' (1940), scored for full orchestra and six harps, the most lavish and haunting of his numerous Celtic, Gaelic or Hebridean musical works.

Then come further forward to modernist Scottish composer Erik Chisholm (1904–65), and his 'Ossian' Symphony No.2 (1939; recording 2007) (CDLX 7196), where the Celtic stories evoke opposing forces gathering in the rise of fascism in that decade; or his 'Ossianic Lay' from 'Preludes from the True Edge of the Great World' (1943, recording 2004) (DRD0223); or the dense and complex masterpiece, 'Night Song of the Bards: Six Nocturnes for Piano' (1944–51; recording 1998) (OCD639). These are examples from classical music drawing on the shared Celtic myths with immense conviction and intensity, and infused with modern, contemporary political purpose.

One of the most breathtaking artefacts in the exhibition is the Carnyx, a horn instrument in the form of a long tube culminating in a boar's head. Contemporary composers have allowed us to hear it in newly imagined ways in 'The Voice of the Carnyx' CD (BML016) and John Purser's 'Bannockburn' (JWP030). There's plenty more to track down but start with these.

In the closing lines of 'On a Raised Beach' (from *Stony Limits*, 1934), MacDiarmid wrote this: 'It is not more difficult in death than here / – Though slow as the stones the powers develop / To rise from the grave – to get a life worth having; / And in death – unlike life – we lose nothing that is truly ours.'

In other words, the struggle continues as perennially in humanity as the stony beaches move across geological time, and acknowledging mortality, we still try to achieve an independent, self-determined 'life worth having' in defiance

of all those forces trying to compel us to believe it could never be done. 'To rise from the grave – to get a life worth having' may be the imperative that gives preference to the connotations of a 'rising' (as opposed to a 'rebellion') that applies in Scotland, or anywhere, as much as in Ireland. And it applies across Europe, in every national provenance, and cannot be relegated to history.

Go and study the Celts exhibition. Read widely. What is to be done?

An Excursion to India

Alan Riach (Friday 26 August 2016)

BANKURA UNIVERSITY WAS established in 2014, that auspicious year, and earlier this year the first-ever Indian university courses in Scottish literature were established. Their start was marked by a Scottish-Indian Association for Scottish Studies conference in January, reported in *The National* by Nan Spowart (24 December 2015). I couldn't get to the conference but promised I'd go at a later date. The university Vice-Chancellor, Professor Deb Narayan Bandyopadhyay invited me to take part in the last week of lectures to that first intake of 23 postgraduate students, August 8–12. I thought about it, packed a bag, and went.

Scottish literature is what I profess. I felt obliged. I doubt if I could have prepared for the trip, though. Three days travelling: Ayr to Glasgow, train to London, pause, fly to Delhi, pause, fly on to Kolkata. Driving out from the airport, a huge billboard advert seen from the road on the outskirts proclaimed: 'We can cut anything – except your throat!' Further on, a big sign on the wall of a derelict-looking building read: 'Swastika Hostel for Working Women'. Everything seemed tilted, the cityscape itself creating distortions, disorientations, angled approaches, lines of departure, all coming in from everywhere. Was it just jet-lag? We drove fast, getting out of the city.

Then there was the car journey, Kolkata to Bankura, a 7-hour ride with horns blasting, potholes, cracks, ditches and mud everywhere (this was monsoon season). Our excellent driver, unceasingly vigilant, found the means to get us there and get ahead of the traffic in ways that kept me wide awake far beyond the weight of jet-lag. He would slip off the concrete and drive along the grass verge for a while, or nip over into the oncoming lane of the road and dodge approaching traffic for a while, or on one occasion, to avoid an immense congestion of demonstrators and parked vehicles, nip across the central verge, cross the oncoming lanes, go down a side road, and head back the way, then go through a tunnel under the main road and into a small village, then through what seemed an oceanic puddle, not knowing what might lie beneath, then up, round and back the right way. All this kept the attention from drifting too far. I began to think this experience might be better to look back on than to have.

Then there was the landscape: miles and miles of flat fields of water and green, rice paddies everywhere except where the forest comes in, thick forest, trees clustered and clotted, up close to the road or in long stretches, far distant from it.

I'd watched the new Disney *Jungle Book* film on the plane on the way over. Great visuals, intolerable Yankeedoodle Mowgli cutiepie voice, Idris Elba doing a nice nasty Shere Kahn and a happy ending. Trite as you like. But the real thing's here, not that, of course. Nothing I can describe and nothing you'll read or see on screen gives the sense of what India truly is. On the way, in the car, I mentioned this to one of the lecturers who had joined us for the journey. 'Yes,' he said, 'we've just come past that part of the area where there's an elephant walk. There are a few elephant corridors. If you're very unlucky you see them.'

'Unlucky?' I said. 'You mean they walk right across the road?'

'Yes,' he said, 'and sometimes stop. And you can't get past them. Until they decide to walk on...'

'Hm,' I said. 'Some things you can't argue with.'

'Yes,' he said. 'Deforestation is ruining their world and they can be very angry with human beings. Not a month goes by without an elephant killing someone. But the answer is not to kill the elephants. No, that is not the answer.'

And so to Bankura: through the crowded narrow dust-filled streets, people walking, cycling, driving all sorts of vehicles, cars, taxis, buses, vans, honking horns, or steadily walking carrying all sorts of things in bundles on their heads, past the kiosk-shops, dust-filled, grime-stained, grit-covered. The country all around is pastoral, cultivated, but every few miles there's a cement factory, an iron works, industrial workplaces. So most buildings look as though they've been burned and covered with ash, grey, grimy, brown. Some have collapsed, roofs propped up with thick bamboo poles. Intermittently there are bright new-looking buildings, sheer white and gold or turquoise, and among the dingy street-shops suddenly there's a shiny well-lit motor bike emporium or a computer shop. But the whole town is abundant with life. In fact, if anything is reminding me of the value of this visit, apart from the profession, it's that: here's a living world that says this is how we get on with things even in poverty and whatever circumstances, and it's not the Hollywood *Jurassic* cliché, 'life will find a way': it's that life finds millions of ways, all sorts of things, strategies, methods, practices, all around. And there is no sense of smug, self-righteous resentment: scavenging, salvaging, finding things to help make life possible, is daily practice, everywhere you look.

I taught three long class sessions, gave a poetry reading and had an afternoon's visit to the Hindu temples of Bishnupur over the four days I was there.

I'd been asked to prepare classes giving a summary of the entire story of Scottish literature and culture from prehistory till now. No pressure, then.

The first class was a broad overview of Scottish literature, starting with a timeline, history and myth, caricatures and clichés: Victorian cartoons and the wars of independence, religions and politics, Columba and Wallace, affinities and self-determinations. We slowed down to read closely poems by William Dunbar, Elizabeth Melville, noted the unions, the Jacobite risings, Culloden, and slowed down again with Robert Burns and Walter Scott, and came up through the 19th century to international traveller Robert Louis Stevenson, the 'broad road that stretches and the roadside fire'.

I was asked to devote the second session to the Gaelic tradition. This was a challenge: how to tell this story without recourse to the language of which I know little enough and the students, less. There are ways. The Celtic mythic cycles of the gods (one north European polytheistic world meets another subcontinental one), of the warriors, of the Fianna, and the earliest recorded sources, such as *The Book of Deer* (c. 1150), James MacGregor's *The Book of the Dean of Lismore* (1512–42) and John Carswell's *Book of Common Order* (1567). Main themes sustaining the bardic Gaelic world and the MacMhuirichs, the idea of 'duthchas': the correlations between land, people and culture (which, now that I think of it, was the underlying structural balance of the TV series I was writing about a few weeks ago (*The Promised Land*). And so to Sileas Mac-Donald of Keppoch's 'Lament for Alasdair MacDonald of Glengarry' and then to post-Culloden Scotland, the break-up of the clans, the Clearances, and slow down for Duncan Ban MacIntyre's 'Praise of Ben Dorain' and Alasdair Mac Mhaighstir Alasdair's 'The Birlinn of Clan Ranald'. Take in James MacIntyre's magnificently scornful 'Song to Dr Johnson' and move on to Donald MacLeod's 'Gloomy Memories' and the work of John Murdoch, before coming into the 20th century with the Celtic Twilight, Modernism and new ways of reading, from Sorley MacLean's 'Hallaig' to contemporary poetry by Meg Bateman and Anne Frater.

The third session was in some respects the easiest: 'Modern and Contemporary Scottish Literature'. Pick up where the first session ended, with R.L.S, Scottish to the bone and marrow, international traveler, intrinsically optimistic in his curiosity, essentially open to a range of different readerships in his forms of address. Then consider the cataclysmic disruptions of the First World War, Ireland, Russia, and the long walk towards independence in India. Violet Jacob's poems from India had an airing. We noted Joyce, Eliot, MacDiarmid in 1922. We saw how poems, journalism, anthologies, writing of all kinds, were engaged in re-definitions of self and potential. I read and translated MacDiarmid's poem

'The Sauchs in the Reuch Heuch Hauch' and had the whole class reciting it, delighted at their own new-found ability to be fluent in Scots. Then we came to after the Second World War, with that generation of pre-eminent men: Iain Crichton Smith, George Mackay Brown, Norman MacCaig, and Edwin Morgan leading on to another generation of pre-eminent women: Liz Lochhead, Kathleen Jamie, Jackie Kay. We looked at other genres: Lewis Grassic Gibbon's prose fiction of the 1930s, John McGrath's historical drama, *The Cheviot, the Stag and the Black, Black Oil* of the 1970s, and Alasdair Gray's novel *Lanark* (1981). The third class tied back to the second and first and together all three formed a resumé of the entire course the students had been on since the beginning of the year.

Among their course texts had been Scott's *Waverley*, Stevenson's *Kidnapped*, Barrie's *Peter Pan* and Spark's *Jean Brodie*. The texts I brought were designed to overlap, complement, open out from them, and suggest various ways of reading across a wider range that might help.

At the end of the week, Professor Deb Narayan Bandyopadhyay gave me some details about his own commitment to the Scottish literature course. Most literature taught in India, he said, is traditionally canonical English literature, with extra and optional courses in American, 'New Literatures' and of course literatures in Bengali and Gujarati. Some scepticism from certain quarters had met his proposal to teach Scottish literature as a discrete subject. He had persevered with it for two reasons: first, there was no question about the quality of the material being as good as anything else; and also, the whole history of India and the country's relation to the British Empire was the context for studying the arts of his country. Now, increasingly, this also was understood to be the context for the study of Scottish literature. Such a course would be a study of literature, intrinsically, but it would also prompt questions about political history and future potential that need answers in the world we live in now. These answers only come through art. That value should be evident to anyone, he said.

But I'd been reading Gandhi's *Autobiography* (1929), and marked out for emphasis three quotations: 'I realized that the sole aim of journalism should be of service. The newspaper is a great power, but just as an unchained torrent of water submerges a whole countryside and devastates crops, even so an uncontrolled pen serves but to destroy. If the control is from without, it proves more poisonous than want of control. It can be profitable only when exercised from within.'

Then there was the warning: 'What surprised me then, and what still continues to fill me with surprise, was the fact that a province that had furnished the largest number of soldiers to the British Government during the war, should

have taken all these brutal excesses lying down... [Now] the reader [will be able] to see to what lengths the British Government is capable of going, and what inhumanities and barbarities it is capable of perpetrating in order to maintain its power.'

And finally, there was the point of principle embedded in resistance: 'It was clear that a new word must be coined by the Indians to designate their struggle... Maganial Gandhi coined the word 'Sadagraha' (Sat = truth, Agraha = firmness)... But in order to make it clearer I changed the word to 'Satyagraha' which has since become current in Gujarati as a designation for the struggle.' This implies not only 'passive resistance' or 'civil disobedience' but what is at the core of things that makes it all worthwhile.

India became an independent country at midnight on 15 August 1947. Nearly 70 years ago. A few folk genially said, 'You have some catching up to do, in Scotland.'

Robert Louis Stevenson, from 'Songs of Travel': XI

I will make you brooches and toys for your delight
Of bird-song at morning and star-shine at night.
I will make a palace fit for you and me
Of green days in forests and blue days at sea.

I will make my kitchen, and you shall keep your room,
Where white flows the river and bright blows the broom,
And you shall wash your linen and keep your body white
In rainfall at morning and dewfall at night.

And this shall be for music when no one else is near,
The fine song for singing, the rare song to hear!
That only I remember, that only you admire,
Of the broad road that stretches and the roadside fire.

Part Six: Towards A Manifesto for the
Arts: Education and the State

A National Policy for the Arts: What the State Can Do

Alexander Moffat and Alan Riach (Friday 22 April 2016)

WHAT DIFFERENCE DOES it make? The arts look after themselves, don't they? We certainly don't want government interference, do we?

Well, yes and no. Artists and poets, writers and composers do what they do in whatever ways we can. But if the work is any good, it needs to be enjoyed, appreciated, taken up and learnt from by others. It's there for people. Any artist might be wayward, singular, exceptional, elitist, but the work produced is always open to anyone's approach. This means that education in the arts is essential. And public knowledge of the arts is equally essential. How are we informed? How are we encouraged to be critical? What gives these poems, novels, plays, these paintings, these string quartets and symphonies, these operas, these folk songs, qualities other ones don't have? How would you describe that quality? How do you value what these works bring you?

Sharp critical understanding of our own cultural achievements helps ensure a parity of recognition internationally, to deal nation to nation as equals. The political, educational and cultural stature of national identity can help confirm this vertebrate identity. This is where the cultural investment and institutional foundations are required: museums, galleries, libraries, schools, universities, theatres, orchestras, publishing, media, the whole state-supported system which structures education and cultural understanding, and gives self-worth and dignity a quality of integrity. Or fails to.

With the Scottish election approaching, the *Sunday Herald* (10 April 2016) carried two pages of mini-statements by Culture spokespersons from each of the main political parties, mainly predictable platitudes. Labour, Tories and Lib-Dems made gestures to the BBC.

So often political speeches are given their moment and then forgotten. There's one in recent memory that should be kept in mind.

On Wednesday June 5 2013, Scottish Government Culture Secretary Fiona Hyslop gave a speech at the Talbot Rice Gallery at Edinburgh University, entitled 'Past, Present & Future: Culture & Heritage in an Independent Scotland'. She acknowledged the location in which her lecture was taking place, the Georgian Gallery, a masterpiece by one of our greatest architects, William Playfair, and linked it with her place of work, the Scottish Parliament, the very modern creation of the Catalan architect Enric Miralles. She said: 'These two buildings tell us much about what is great about Scotland – the way that past achievements from the Scottish Enlightenment and other great periods in our history mingle with modern successes and developments – and the way in which our own artistic achievements can be celebrated, along with those from other lands.'

Then she set out five key areas which, she promised, underpin the Scottish Government's approach to culture and heritage in Scotland, and how that approach differs from that of the UK Government in each of these areas.

The first was the value of culture and heritage, in and of themselves, because they bind and connect our past, our present and our future and tell the stories about where we've come from, who we are, and help us reflect on who we could be.

The second was how culture and heritage roots us in place, and helps to empower, enrich and shape our communities.

The third was how culture and heritage in Scotland is of us all and for us all, so requires participation and ways to enable all of Scotland's communities to benefit, not just from the great cultural wealth and heritage of this nation, but also the world's.

The fourth was about the wealth of other benefits that culture and heritage bring to our communities, both social and economic.

And the fifth was an attempt to bring all of this together to address the idea of a shared ambition and vision, to build an independent nation where our cultural and historic life can flourish.

She claimed that the present Scottish Government is the most culturally ambitious government that Scotland has ever had, and that it is founded on the belief that public funding of the arts is a fundamental good.

It's instructive to compare this speech with an earlier one that Fiona Hyslop herself delivered in November 2012 at a major museums and galleries meeting in Edinburgh. On that occasion she failed to name one single artist or describe any work of art, even though she was speaking to a conference of museum and gallery people. Emphasis was placed on the role of art in the economy: 'adding to the social value of museums and galleries is the economic value they bring to the nation'. Without mentioning any painting or portrait, she emphasised the value of calculating the return on arts festivals and the so-called 'creative industries'.

What's wrong with this?

Well, insisting that the arts are primarily instruments for economic purposes damages them. It asks them to do what they can't do directly and ignores what they are. And it alienates the artists. The Talbot Rice speech reflected a very different approach: 'I have said before that it is not the Government's job to tell artists what to paint or authors what to write or craftspeople what to fashion. Nor is it the Government's job to tell people what art to see, what books to read or what crafts to buy. It is our job, however, to create the conditions which enable artists to flourish and as many people, groups and organisations as possible to benefit from and enjoy our culture and heritage.'

Now, that's on the nail. That's the essential distinction, the point that really matters.

She went on: 'The Scottish Government already accepts the case for the role of government in supporting the cultural sector. We actively support the case for public subsidy of the arts. We understand that culture and heritage have a value in and of themselves... So, for this Government, the case has been made.'

What was new and important about this was that Hyslop repudiated all previous Scottish government pronouncements on these issues. When the SNP first formed a government they seemed keen not to talk about the politics of cultural independence – in fact they didn't have a defined cultural policy so they went along with existing New Labour ideas. That included the development of 'Creative Scotland'. At the heart of the official British vision of creativity were the harnessing of culture to the growth of the national economy and a grandiose post-imperial design to make the UK the world's 'creative hub'. The SNP version was the harnessing of culture to the growth of the national economy. Not much difference really, until this speech.

What Hyslop said in this speech was a credo, a manifesto for government.

The question is, did she mean it? Pre-referendum 'bravetalk', or truth?

She said: 'Scotland's cultural life and heritage cannot be reduced to a single style or image; rather, they are a wealth of what we might describe as 'stories' that take many different forms, as diverse as the land, peoples and places of this complex country.'

And then came the crunch: 'There is no one thing that defines us. There are, of course, iconic images, poems, films, artists, writers, performers, compositions, buildings and landscapes that evoke our sense of "Scotland". A Scotland that is steeped in meaning and history but which is continually on the move – engaging with its past, looking beyond borders, seeking new and innovative ways to engage with the world.'

Allowing for sound-bites and the liability of cliché, this is still a crucial statement of intent, a credo of lasting value. We can applaud the Culture Minister for having the courage to change her mind and listen to what artists were saying, and for putting together an arts policy with real vision and substance.

But, so far, of course this is all just words. Who will implement the promise?

The Minister for Culture has one of the most important jobs in the cabinet. We need a strong Culture Minister at the heart of government if the new arts policy is to succeed. Hyslop herself told us why: 'Art is not always comfortable. It does not need to be easy or "feel good". I want us to embrace what's difficult, what's challenging and what's uncomfortable. It is the very measure of the health of our democracy to welcome and embrace the role of artists to challenge our expectations, to nudge us from our comfort zones and encourage us, individually or collectively to reflect on how we could do better and how we could be better.'

Brave words, indeed. So how do they fit? How are things now, do you think?

More brave words: 'History is peppered with stories and ideas that define us. Some give cause for celebration, others almost for lamentation, because any nation's story has its darker moments and these are also part of our heritage – urging us all to reflect on acts that both have harmed us and have done harm.'

We might think of James Robertson's novel, *Joseph Knight* (2003) and Louise Welsh's 'Empire Café' project in 2014, and the exposure of Scots' complicity – no, eager engagement – in the slave trade. We might think of Kirstin Innes's novel *Fishnet* (2015), and its exposure of the sex trade industry, or Karen Campbell's ostensibly thriller-genre novel *Rise* (2015), anatomising sexist abuse, guilt, love, anxiety, all in the ancient landscape setting of what seems unmistakeably like Kilmartin Glen. Moral crusade is not art's only priority but art holds out the possibility of redress of injustice like nothing else. And Hyslop recognised this: 'When Picasso painted *Guernica*, he didn't do so to merely adorn a wall, he did so to make a profound and powerful political statement.'

Pause on that. Has any government minister in London or Edinburgh ever held up the example of Picasso's *Guernica* in this way? Picasso's political work is always avoided. After all, he was a member of the Communist Party. The profundity of the painting is about humanity and the vulnerability of living things in war. The politics of it are always with us. And that international vision was brought home: 'Scotland is more than a nation bound by a border and oceans, it is a nation of ideas and our innovation and creativity is an intrinsic part of our increasingly global lives. A story, a piece of theatre, a stone circle or a song can expand those boundaries and take us beyond borders. To give you a quote from the Canongate Wall, Hugh MacDiarmid asked,

"Scotland small? Our multiform, our infinite Scotland *small*?" Our size is only limited by our imagination, our reach as extensive as our desire and capacity to explore.'

That was a brave thing for a Minister of Culture to say so boldly. It was good to see MacDiarmid quoted there – like Picasso, MacDiarmid was a member of the Communist Party – as well as a founding-member of the National Party of Scotland – so once again what Fiona Hyslop was saying there was that the poets and artists help us protest against what's wrong in the world, to want change, to want a better world. Historical allegiances are what they may be, but the truths of art go deeper and last longer.

The critical thinking needed to create a new framework for a long-term plan for the arts appeared to be in place when she said these words, back in 2014. So we're talking politics as well as culture now – and here's the question:

How will we underwrite the necessary arts in an independent Scotland? What sort of service do we want? Will the Scottish Broadcasting Service support an orchestra as the BBC does? Will it support cultural television channels as France and Germany do? Will it have a cultural radio service like Radio 3?

If the decline in quality newspaper circulation continues, will there be support for first-class investigative reporting? How about extensive reviewing by a range of well-informed critics considering exhibitions, concerts, publications? How will informed critical opinion and reviewing be sustained in journalism? These are unanswered questions.

Will the SNP stick to Fiona Hyslop's promises? Where are the signs of this today? Why have there been no key cultural speeches since 2014? Surely there should be one at least once every year?

We need to hold all politicians to their responsibilities to the arts. That's our job and the job of every responsible citizen in Scotland. For the Culture Minister to make an annual public speech of achievements, failures, and intentions is one way of inviting that accounting. And it needs to be widely and honestly reported.

If we're going to tell the truth to ourselves, about ourselves, and make certain such truth is published, our arts are where that happens, and the Minister needs to be truthful too, not just once, but consistently, and folk need to know about that.

In New Zealand, many years ago, there was a visit from the Irish President, Mary Robinson, and she said this, and it should be a motto for every member of the Scottish parliament: 'The arts are the genius of your country, and education is the key with which you unlock the door.'

Fiona Hyslop in her own words (June 5 2013)

From the Stones of Stenness, built, we believe, to connect our ancestors to their past, through to the fragility and beauty of the work of Scotland's contemporary sculptors such as Karla Black... The connections and threads between our past, our present and our future are flexible and fluid; we both take and create meaning when we look deep into the history of our nation, shaped by those who have settled here and those who have left for faraway shores; our connections with other countries, other peoples all linked by these threads connecting people, forms and ideas... I want Scotland to be recognised as a nation that not only nurtures and is nourished by wonderful songs, poems, stories, drama, dance, paintings, and sculpture but as a nation that welcomes artists and creative practitioners from all over the world to come, to inspire and to be inspired, to innovate and to create.

Hugh MacDiarmid on Education

(Friday 20 May 2016)

ALAN RIACH NOTES: The hand-written manuscript of this essay was generously donated to the University of Glasgow Library Archives & Special Collections Department, where it can be read by arrangement. It was first published in Glasgow University Magazine (vol.57, no.2, November 1946, pages 8–9) and is published here by permission of the MacDiarmid Estate and Glasgow University Library.

So here's the question: Can we confidently and categorically say in 2016 (70 years since) that every positive proposal made here for the improvement of educational policy has been effected in practice, or at least form the priorities of all our educational institutions in Scotland?

An Open Letter to a Glasgow Undergraduate (November 1946)

Hugh MacDiarmid

My dear G.U.

While one has the right, I think, to expect that an undergraduate should be less liable than less well-educated persons to content himself – or herself – with the line of least resistance, it is impossible to deny that in modern Scotland a University education has in the vast majority of cases singularly failed to produce other than truckling conformists and abject yes-men.

One of the main reasons for this must be the way in which our students are insulated from any perception of, or concern with, national realities.

Scotland in this respect, as in many others, presents a unique case for which no other country in Europe, either now or at any previous time, has afforded any parallel.

In every other country, its national history and literature etc. – and not those of some other country with different traditions, tendencies, and problems

altogether – have first place in its schools and colleges, as is natural; and it is in comparison with these – and using these as touchstones – that the student goes on to extend his range, taking in the literatures and histories of other lands and in due course achieving some knowledge of world-history and world-literature. In Scotland alone this natural process is reversed, and Scottish literature and history are not only not placed first but come in at the tail, if at all. The absurdity of this must be manifest when one takes into account the fact that even yet the vast majority of Scottish students must look to Scotland for employment – in the first place at least. Their professional efficiency will be conditioned largely by their knowledge and experience of Scotland, and affected by those particular Scottish traditions – so demonstrably different from those obtaining in other countries – with which they have been enabled to establish only the most partial and ill-informed relations. This extraordinary state of affairs is all the more serious at a time like the present when Scotland has been reduced to such an appalling pass politically, economically and socially. Their chances of employment in Scotland, the emoluments and other aspects of that employment – status, amenities, etc. – and, above all, the content of that employment (i.e. its quality, range, and all its specific bearings) are determined by the position and prospects of the country, both absolutely, and relatively to what obtains in other countries.

There is not only this strange state of affairs in which men and women are expensively prepared for the most responsible professional careers in a country of which they are taught far less than of many other countries in which few, if any, of them can ever hope to work or even travel. As might be expected along with Scotland's political and economic decline there has been a sad falling-off in the quality of University staffs. Hardly any of our professors or lecturers have any reputation at all. They are just hacks – undistinguished donkey-workers. It would be easy to think of several professors of every other European country who have established an international reputation as authorities on some particular subject or subjects. Not so in Scotland. This is a serious matter for Scottish students, and a particularly serious matter for the Arts in Scotland – with which, as you know, I am specially concerned. It accounts among other things for the fact that Honours students are apt to send in to the editors of our University magazines sets of verses no whit better than those submitted to school magazines by the brighter specimens in Junior IV. And it accounts also for the fact that the subsequent attempts of our University educated men and women to contribute to the corpus of Scottish Letters are so pitifully poor and ineffective. No wonder the German poet Holderlin said: 'Wir lernen nichts schwerer, als das Nationelle frei gebrauchen,' (Nothing is so difficult to learn as the mastery over our natural national gifts.)

This state of affairs has naturally in the course of generations during which it has become steadily worse, revolted all the better intelligences which have been subjected to it, and perhaps the best thing you can do if you wish to see yourself in proper perspective in this respect is just to recall a few outstanding figures who could find no place for their great gifts within that school and University sphere increasingly adscripted to gutless mediocrity. You will find that these men broke away from it all in no uncertain fashion and denounced it in the most uncompromising terms; and you will be able to compare the calibre of these men with that of any of the great horde of those who, on the other hand, 'bent the knee to Baal.'

Thomas Davidson, for example – the incidental founder of the Fabian Society; and one of the greatest teachers Scotland ever produced – said: ' The raw material of tuition provided at our universities – young men and women who were preparing to enter the various professions, and were therefore to a large extent tied to ancient methods, some of them with already definitely formed opinions, and who sought at college merely an outfit for professional success – were not the material on which I could hope to work successfully.' In this you will recognise Davidson was sharply differentiated from the whole body of our professors and lecturers today. What proportion of the students are as sharply differentiated from the hopeless material of which Davidson spoke you will be able to estimate yourself. Davidson naturally could not fit into the Scottish university world; he was far too big a man. Excluded from it, as were Professor Sir Patrick Geddes, Mr A.S. Neill, and others, he found his life-work in America; but what he wrote of Higher Education in America in 1899 is at least equally true of Higher Education in Scotland today.

'It cannot be said of our people,' he wrote, 'that they are backward or niggardly in the matter of education. In no country is so much money expended on schools and colleges. And yet our people are very far from being educated as they ought to be. Ignorance is still widespread and not only the ignorant but the whole nation suffers in consequence. In spite of our magnificent system of public schools and our numerous colleges and universities, the great body of our citizens lack the education necessary to give dignity and meaning to their individual lives, and to fit them for the worthy performance of their duties as members of the institutions under which they live. Our public schools stop too soon, while our colleges do not reach more than a small fraction of our population. Moreover neither school nor college imparts that education which our citizens, as such, require – domestic, social, and civic culture. What is imparted is defective both in kind and extent. Even more regrettable is the fact that our schools and colleges for the most part confine their attention to persons who

have nothing to do but study, who are not engaged in any kind of useful or productive labour. This results in two evils: (1) education for the great body of the people must stop at an early age since the children must go to work as soon as possible; (2) education is withheld from those who are in the best position to profit by it; for every teacher with sufficient experience knows that people who have a knowledge of practical life and its duties are far better and more encouraging pupils than those who have not... Thus it comes to pass that the lives of the great mass of our citizens are unintelligent, narrow, sordid, envious, and unhappy. Thus, too, it comes that our politics are base and our politicians venal and selfish. The labouring classes are, through want of education, easily cozened or bribed to vote in opposition to their own best interests, and so to condemn themselves to continued slavish toil and poverty, which means exclusion from all share in the spiritual wealth of the race.'

Geddes, a far greater man and writer and more potent influence than Davidson, and indeed one who is likely to emerge in the near future (if there is one) as one of the master spirits of the 19th and 20th centuries, was at one with all Davidson wrote along these lines. But Geddes went far further. 'Everything I have done,' he said, 'has been bio-centric; for and in terms of life, both individual and collective; whereas all the machinery of state, public instruction, finance, and industry ignores life when indeed it does not destroy it. The only thing that amazes me, therefore, as I look back over my experience, is that I was not caught and hung many years ago'.

Geddes's ideal for education was the renewal and vast extension of *lehrfreiheit and lernfreiheit* – complete liberty of teaching and of learning, i.e. the very antithesis of what obtains in Scotland today, which Geddes described as 'penal servitude in schools of respectable futility' and, again, as 'that verbalistic emaperment upon which for so many centuries we have been specialising'.

And I think, on due consideration, you will find it hard to disagree with Geddes when he said after 1914–18 War (and it is all of incomparably greater urgency today after our Second World War) – that 'the renewal of the universities into active centres of material reconstruction of ruined Europe, for moral re-education of its disillusioned peoples, will be of greater value than any number of peace treaties or imposition of war reparations. Such a university arousal will even penetrate Germany herself and shake her proudest citadels, rise above them, and drop ideas into them more fully than can our airmen. And with her specialisms surpassed because co-ordinated; with her State philosophy overpowered because out-thought, her pride-illusion cured, she will increasingly be brought back to reason, and even to human loyalty, from her fanaticism of an imaginary superiority – thus returning to her good for present evil, and

good for previous good... By deliberate selection from tendencies surviving until the present, and by judiciously planned reconstruction of them, we may shape the future. Hence the first requisite of foresight is true and clear ideas about the past.

Yet sympathy with the cares and anxieties of fellow-beings struggling in the present is and must remain the driving force of noble action. The citizens of the New State will therefore be characterised by the gesture of alternately facing the present, the past, and the future. From the past they will draw sustenance for the mind, from the present fuel for the heart, and from the future resolution for the will. A generation trained in these mental habits will see the hell latent in the paleotechnic peace, patent in war, yet will foresee the third alternative with realistic vision and of set purpose plan and design its advent. To avoid the Scylla of paleotechnic peace and the Charybdis of War, the leaders of this coming polity will steer a bold course for Eutopia [sic]. They will aim at the development of every region, its folk, work, and place, in terms of the *genius loci*, of every nation, according to the best of its tradition and spirit; but in such wise that each region, each nation, makes its unique contribution to the rich pattern of our ever-evolving Western civilisation'.

That was why Geddes in the '90s started the Scottish Renaissance. That was why after the 1914–18 War I restarted it (with Geddes's approval and help). That is why I am asking you now to throw all your weight in with us in this great cause. Other countries may be left to their own students, who know them; Scotland is our job. And do not be put off if that means adventuring in strange directions. I have mentioned Holderlin. Those who condemn synthetic Scots and the modernist experiments of our Scottish Renaissance writers, artists, and composers – as not in keeping with Scottish taste and tradition – ought to remember how as far as the practice of poetry is concerned Holderlin's increasing preoccupation with German national values had its parallel in a change of technique in his poetry. For he abandons the regular classical metres of the great elegies and odes and begins to write in free rhythms. The development is not absolutely contemporaneous with the emergence of his national beliefs in a sharper form. But as his theory of the national, or natural, develops it brings after it the change.

And the writers of the Scottish Renaissance must follow the same course and be able, like Holderlin, to say: 'I think I shall not simply give a commentary on the poets up to our time, but that poetic style altogether will take on a different character, and that the reason why we remain unnoticed is that for the first time since the Greeks we are beginning again to compose in a national, that is, natural, truly original way.'

We in Scotland have not remained unnoticed, but our activities have been, and still are, largely misunderstood and misrepresented. That will be put right. These things take time. You can still come in on the ground floor. We give you a hearty invitation. It is a pity to have had a university education, and not put it to some real use.

Yours for Scotland,
Hugh MacDiarmid

Notes Towards a Manifesto for Uncertain Times

Alexander Moffat and Alan Riach (Friday 16 September 2016; also in the Sunday Herald supplement 18 September 2016)

IN PREVIOUS ARTICLES, we've looked at the work of the American artist Alice Neel and her two Scottish contemporaries, William Gillies and John Maxwell. When they began working, none of them had an audience. They had to endure and trust to the development of fair appraisal. Why was there no immediate public appreciation? As the major historian of Scottish art Duncan MacMillan puts it, 'A nation that does not know its art does not know itself.'

This week we'd like to draw some conclusions about art, education, democracy and cultural identity.

The current political climate prompts us to look for conclusions, things we could be definite about. Everywhere these days, obviously enough, there is uncertainty. Less easily understood is the fact that uncertainty is a tactic. Not a self-conscious strategy, because it's been generated by people who don't know what they're doing or how to control it, much less how to make something good come out of it, but a tactic in which they are caught as much as their victims. Once you understand this, the question is how to oppose it. And there's only one answer: with certainty. Patience is part of that, but a clear understanding of value is its necessary sustenance, the core and driving force. The practice of doubt, questioning everything, is in itself part of this certainty. Don't take anything for granted but ask yourself, what do you know, for sure? And what do you want, exactly, and why? How do you say clearly what it is? Persuasion only goes so far. If the case is solid and good, state it, stand by it, and let it sink in.

The question of democracy depends on education and a fair representation of the people.

Education is important because democracy offers you choices and you need to know what you are choosing between. But the nature of education and the relation between education and democracy has changed since the 1950s. The Irish scholar Declan Kiberd makes this point with regard to that international

army of jargon-led, over-professionalised academics specialising in the works of James Joyce, when he says in *Ulysses and Us: The Art of Everyday Life in Joyce's Masterpiece* (2009): 'Many of them reject the notion of a national culture, assuming that to be cultured nowadays is to be international, even global, in consciousness. In doing this, they have often removed Joyce from the Irish context which gave his work so much of its meaning and value... The middle decades of the 20th century were the years in which the idea of a common culture was abandoned – yet *Ulysses* depends on that very notion.'

So does all great art. Joyce described himself, Kiberd reminds us, as: 'a socialist artist and a believer in participatory democracy – that everyone, whether wealthy enough to have a higher education or not, should have equal access to this common culture. He would have agreed with R.H. Tawney's contention that 'opportunities to rise are no substitute for a general diffusion of the means of civilisation,' something that was needful for all, both rich and poor.'

When Joyce was writing *Ulysses* (1922), the world was only beginning to experience the possibilities of mass literacy and the emergence of reading libraries for working people. H.G. Wells's *Outline of History* sold more than two million copies when it was published in 1920. Just after the First World War there was a decline in the authority of church and state and an assertion that working people possessed innate human dignity. Democracy meant that anyone might enjoy and understand Shakespeare. But after the middle of the 20th century, the idea of a common culture was to be generally replaced by the creation of specialist élites. Democracy was no longer seen as sharing in a common range of reference but rather as a provision of access to those élite groups. So, Kiberd concludes, today, the aspiration is usually towards the inclusion of gifted individuals in the dominant part of the structure, rather than the revolutionary transformation of social relations.

This is very close to what was diagnosed by George Davie in his books, *The Democratic Intellect* (1961) and *The Crisis of the Democratic Intellect* (1986). Davie analysed the decline of the educational ideal of being a student of all the main branches of human culture, and the rise instead of categorical specialisation, which would deliver a world in which no-one talks to each other and there is no touching. Specialised expertise is necessary, but it must be grounded, earthed, in a democracy of human understanding, a general sense of what it is to be human. In his appreciation of Davie in *The Herald* (28 March 2007), Lindsay Paterson asked: 'Who, inspecting the details of our educational curricula, or the quality of our media, or the banality of our political discourse, could not feel acutely that Davie was prescient? But, by having taught and having written, he has also ensured that an older and more distinguished tradition would remain

available to us – a belief that intellectual rigour, more widely practised than seems possible today, is democracy's only secure basis.'

We want to see that tradition realised in an independent Scotland. There is hope for it here. The worst of what has been described by Kiberd and Davie is what we want to help bring to an end, because the current situation is exactly what *Ulysses*, and Davie, and all great art, oppose: a stranglehold over educational, social and media institutions of all sorts, and a specialist stranglehold over Joyce and so many other so-called 'difficult' writers, poets, artists or composers. That's especially true in the world of the visual arts, where the élite groups are totally commercialised. How do we break that down?

The first thing is to act according to your priorities, once you're sure of what they are, but modestly, silently, with cunning, and in exile from the 'central powers' or management, whatever authority is in charge. Make it evident to those you are among what your priorities are and how they can be realised in personal and local terms, not through ordination from on high. Use every opportunity the days bring. An openness to serendipity allows teachers and artists and writers and anyone, really, to renew styles and themes in every work, and in every generation. 'Cease to strive,' Leopold Bloom advises Stephen Dedalus. Or as Ed Dorn puts it, 'My motto is: / Achieve the inevitable.' It is not through 'growing the economy' or 'striving for excellence' or 'working for progress' that you get anywhere at all. All good teaching is mainly asking questions.

Why?

'Democracy educates and education democratises.' Otherwise, both fail. Once again, Declan Kiberd reminds us of the relation between social transformation and artistic change, revolutions in form: 'Most writers believe that by changing language and style you may in time alter thought; and that by altering thought you may transform the world itself. The painters who worked alongside Joyce in Paris believed that they might yet challenge other media as exponents of the dominant visual form.'

Kiberd says that they lost that battle to film, television and the music video – yet it is not true that they failed entirely. Kiberd says that Joyce issued a similar challenge to newspapers and didn't completely fail, and that is true. Witness *The National*. In any case, the challenge itself, with regard to any great artist, is far from preposterous. Anyone who has been deeply engaged in the works of great artists is changed by that experience, because great art has things that matter to give us, any one of us. All great art is on the side of humanity. Yet the ideals of democracy in the social structures that give access to the arts must have effect for the arts to realise that gift, and for people to receive it.

And this is keyed to national identity, because through that, social structures are generated.

But what is the reality of democracy in Scotland?

The saturation of society by technology and mass media has had a transformational effect. It may be that the people of a country are less able now than ever to absorb and enjoy, to take to their hearts, the great works of major poets and artists, simply because they have less critical information about them. Generations ago access was denied because of mass illiteracy and ignorance. Now there is much more widespread literacy and easier access to knowledge, but people are blocked from details and the practise of critical value by mediating walls of conventional and formulaic cliché. Screen media is screening and information technology is misinforming. That's a rather pessimistic thought as regards the arts, but it has a parallel consequence regarding participatory democracy.

In England in the 21st century, the NHS is being privatised, commercialised, sold off to the market economy. Scotland is trying to keep the egalitarian ideal of democratic health provision as a birthright. Isn't that just as important for the arts? So the question then becomes, at what point did the balance tip from seeing the value of the arts as humanly worthwhile, to allowing them to be at the beck and call of commercial priorities, market forces, the ethic of 'what sells is good'?

That ethic is opposed to democracy because it prioritises making money over human beings as thinking and sentient creatures. It endorses the 'material' and denigrates or liquidates the 'immaterial' upon which human well-being depends.

Michael Fry, in his history of Scotland 1815–1914, *A New Race of Men* (2013), admirably gives significant space to the arts – architecture, painting, literature, philosophy – as well as economics and social history. He sees them as essential in the stories of the people who have lived in this nation. When he comes to the late 19th-century 'kailyard' writers of popular, sentimental stories of small-town Scotland with inbuilt moral reassurance and sweet nostalgic warmth on every page, he recognises that there are depths and complexities in some of their works, but he makes this important speculation: 'Perhaps for structural reasons, in the nature of the literary market rather than the quality of the literary product, Scotland was already being suffocated by the imposition of British norms,' and he says that this was to be another feature of the 21st century as well. Now, with 'North British' haggis, strawberries and shortbread, the point remains pertinent.

Scott, Hogg, Galt and Stevenson, the major Scottish writers of the 19th century, were not 'limited by any pandering to their readers.' They 'did not give

us a static Scotland', as many 'kailyard' writers did. The great writers made fictions 'that they knew would challenge their readers, so these might out of the encounter change their ideas about their country. It was a high standard for successors to try to live up to, and the general state of Scottish culture did not always favour it – then or now.'

The purpose of writers and artists is not to manufacture comfort. As Ezra Pound says, 'the arts give us our best data for determining what sort of creature man is.' Man and woman, human kind. That data is valuable. Without it, your health will be bad and your weakness grow profound. So the arts are essential to democracy.

A fair democratic representation of the people depends on the number of people who vote in a constituency. All the constituencies in the United Kingdom deliver the vote for central government. In this structure, Scots will always be outvoted.

If you believe in the democratic unity of Britain, Scots will always be outvoted. Why should we oppose this? Because the cultural distinction of Scotland means that the people of Scotland have their own distinctive priorities. Who cares about these priorities? In the state structure of the United Kingdom, the people who live in Scotland and care most about Scotland and the lives of their families and friends and neighbours will always be outvoted. Always. Because in the United Kingdom there are around five million people in Scotland and 55 million people in England. The vote that put Thatcher in power, the vote to take us out of the European Union, were the results of functioning democracy. No-one in Scotland has an argument against that unless you believe there should be a separate state in which we can vote for whoever we choose, within Scotland. The gulf between rich and poor is a direct result of this UK 'democracy' and it applies to knowledge of the arts every bit as much as to money.

Cultural distinction defines democratic representation. That's why it's crucial for the education of people. In our essays in *The National* on the artists, the Scottish women painters, John Bellany, J.D. Fergusson, and most recently Neel, Gillies and Maxwell, in John Purser's articles on the neglected Scottish composers, and in the essays on the poets and writers, we've tried to introduce something of the range and calibre of some of Scotland's cultural production. It's an open world. There's a lot more to take in. This is just the beginning.

Full List of National Articles, January 2016–February 2017

(1) 'Not Burns – Dunbar!' by Alan Riach (Friday 22 January 2016)

(2) 'Not Burns – Fergusson!' by Alan Riach (Friday 29 January 2016)

(3) 'Not Burns – Duncan Ban MacIntyre!' by Alan Riach (Friday 5 March 2016)

(4) 'Not Burns – Alasdair Mac Mhaighstir Alasdair!' by Alan Riach (Friday 12 February 2016)

(5) 'Not Burns – Elizabeth Melville!' by Alan Riach (Friday 19 February 2016)

(6) 'Modernist Montrose: Scotland's 1920s Capital of Culture!' by Alan Riach (Friday 26 February 2016)

(7) 'Modernist St Andrews: What Really Happened in the 1930s?' by Alan Riach (Friday 4 March 2016)

(8) 'Modernist Shetland: MacDiarmid's Quest' by Alan Riach (Friday 11 March 2016)

(9) (9a) Jackie Kay: Scots Makar by Alan Riach (Wednesday 16 March 2016)

(10) 'J.D. Fergusson – Art and Nationality' by Alan Riach and Alexander Moffat (Friday 18 March 2016)

(11) 'John Bellany, Elsie Inglis and the Scottish Women's Hospitals' by Alan Riach and Alexander Moffat (Friday 25 March 2016)

(12) 'What can we learn from Edward Dorn?' by Alan Riach (Friday 1 April 2016)

(13) 'An eloquent and articulate voice that offers insight' [On Wole Soyinka] by Alan Riach (Friday 8 April 2016)

(14) 'Modern Scottish artists shine a light on barriers women faced' [On the exhibition at the Scottish National Gallery of Modern Art, 'Modern Scottish Women Painters & Sculptors 1885–1965'] by Alan Riach and Alexander Moffat (Friday 15 April 2016)

(15) 'How the state has a role in linking people to the arts' by Alan Riach and Alexander Moffat (Friday 22 April 2016)

(16) 'The question of national identity's link to the arts...' [On 'Of Foreigners and Friends' conference in Jena, Germany] by Alan Riach (Friday 29 April 2016)

(17) 'A satirical to and fro with students and MacDiarmid' [On education, Scotland and Glasgow University Magazine in the 1940s] by Alan Riach (Friday 13 May 2016)

(18) 'MacDiarmid's rally cry on education' by Hugh MacDiarmid (Friday 20 May 2016)

(19) 'How music is attuned with our very identity' [On national music] by Alan Riach (Friday 27 May 2016)

(20) 'How a dying father gave Scotland a musical great' [On Alexander Campbell Mackenzie] by John Purser (Friday 3 June 2016)

(21) 'Shipowner's son sets sail for musical majesty...' [On Hamish MacCunn] by John Purser (Friday 10 June 2016)

(22) 'A musical genius with the Borders in his blood' [On John Blackwood McEwen] by John Purser (Friday 17 June 2016)

(23) 'Many Celtic connections in the fight against reactionary imperialism' [On the exhibition 'Celts: art and identity' at the National Museums of Scotland] (1) by Alan Riach and Alexander Moffat (Friday 24 June 2016)

(24) 'How the Celts opened a gateway to a wider world' [On the exhibition 'Celts: art and identity' at the National Museums of Scotland] (2) by Alan Riach and Alexander Moffat (Friday 1 July 2016)

(25) 'The legacy of Hopkins lives on in his poetry' [On Gerard Manley Hopkins, Hugh MacDiarmid and George Mackay Brown] (1) by Alan Riach (Friday 8 July 2016)

(26) 'One poet...many worlds' [On Gerard Manley Hopkins, George Mackay Brown, Edwin Morgan and Margaret Tait] (2) by Alan Riach (Friday 14 July 2016)

(27) 'New eyes on old questions' [On John Keats, Herman Melville and Arnold Bax] (3) by Alan Riach (Friday 22 July 2016)

(28) 'Unanswered questions, unfulfilled potential...' [On the TV series 'The Promised Land'] (1) by Alan Riach (Friday 29 July 2016)

(29) 'Igniting the creative spirit' [On the TV series 'The Promised Land'] (2) by Alan Riach (Friday 5 August 2016)

(30) 'A soaring talent that wretched poverty could not keep down' [On Frederic Lamond] by John Purser (Friday 12 August 2016)

(31) 'Romantic, poetic and tinged with Gaelic folk music' [On Helen Hopekirk] by John Purser (Friday 19 August 2016)

(32) 'Nothing I can describe and nothing you'll read or see on screen gives the sense of what India truly is' by Alan Riach (Friday 26 August 2016)

(33) 'Personal, powerful, political...overlooked' [On Alice Neel] by Alan Riach and Alexander Moffat (Friday 2 September 2016)

(34) 'Friends in high places' [On William Gillies and John Maxwell] by Alan Riach and Alexander Moffat (Friday 9 September 2016)

(35) 'Notes towards a manifesto for uncertain times' by Alan Riach and Alexander Moffat (Friday 16 September 2016)

(36) 'Putting our identity into our own words' [On literature, languages and common humanity] by Alan Riach (Friday September 23 2016)

(37) 'Reading between the laughter lines' [On humour in Scottish literature] by Alan Riach (Friday 30 September 2016)

(38) 'Mongrel nation: Healthy curiosity and zombie priorities' [On nation, freedom, geography] by Alan Riach (Friday 7 October 2016)

(39) 'Mapping the landscape of our literature' [On the big themes and other approaches] by Alan Riach (Friday 14 October 2016)

(40) 'Visions beyond violence' [On modernity and war] by Alan Riach (Friday 21 October 2016)

(41) 'The pacifist who made music in the thick of war' [On Erik Chisholm] by John Purser (Friday 28 October 2016)

(42) 'A tragic silence' [On William Wallace] by John Purser (Friday 4 November 2016)

(43) 'A genius & a hero' [On Cecil Coles] by John Purser (Friday 11 November 2016)

(44) 'The most deadly weapon in the world; the power of mass persuasion' by Alan Riach (Friday 18 November 2016)

(45) 'A flyting philosophy distilled from books' by Alan Riach (Friday 25 November 2016)

(46) 'Screening literature' [On Scottish literature, mass media and politics] by Alan Riach (Friday 2 December 2016)

(47) 'Rolling along on the digital superhighway' [On Scottish literature and new media] by Alan Riach (Friday 9 December 2016)

(48) 'Henryson: One of the greatest poets' by Alan Riach (Friday 16 December 2016)

(49) 'The Bruce, The Wallace and the Declaration of Arbroath...' by Alan Riach (Friday 23 December 2016)

(50) 'Transports of delight' [On Scottish travel writing in Scotland] by Alan Riach (Friday 30 December 2016)

(51) 'Home & away' [On Scottish travel writing furth of Scotland] by Alan Riach (Friday 6 January 2017)

(52) 'A lasting legacy...' [On Walter Scott] (1) by Alan Riach (Friday 13 January 2017)

(53) 'Masterly studies of divided loyalties' [On Walter Scott] (2) by Alan Riach (Friday 20 January 2017)

(54) 'Bringing out the best in us...' [On Walter Scott] (3) by Alan Riach (Friday 27 January 2017)

(55) 'The art of contrast' [On Joan Eardley] (1) by Alan Riach and Alexander Moffat (Friday 3 February 2017)

(56) 'At one with being at odds with nature' [On Joan Eardley] (2) by Alan Riach and Alexander Moffat (Friday 10 February 2017)

Luath Press Limited

committed to publishing well written books worth reading

LUATH PRESS takes its name from Robert Burns, whose little collie Luath (*Gael.*, swift or nimble) tripped up Jean Armour at a wedding and gave him the chance to speak to the woman who was to be his wife and the abiding love of his life. Burns called one of the 'Twa Dogs' Luath after Cuchullin's hunting dog in Ossian's *Fingal*.
Luath Press was established in 1981 in the heart of Burns country, and is now based a few steps up the road from Burns' first lodgings on Edinburgh's Royal Mile. Luath offers you distinctive writing with a hint of unexpected pleasures.
Most bookshops in the UK, the US, Canada, Australia, New Zealand and parts of Europe, either carry our books in stock or can order them for you. To order direct from us, please send a £sterling cheque, postal order, international money order or your credit card details (number, address of cardholder and expiry date) to us at the address below. Please add post and packing as follows: UK – £1.00 per delivery address; overseas surface mail – £2.50 per delivery address; overseas airmail – £3.50 for the first book to each delivery address, plus £1.00 for each additional book by airmail to the same address. If your order is a gift, we will happily enclose your card or message at no extra charge.

Luath Press Limited
543/2 Castlehill
The Royal Mile
Edinburgh EH1 2ND
Scotland
Telephone: +44 (0)131 225 4326 (24 hours)
email: sales@luath. co.uk
Website: www. luath.co.uk